MECHADEMIA

Emerging Worlds of Anime and Manga

Mechademia
An Annual Forum for Anime, Manga, and Fan Arts

FRENCHY LUNNING, EDITOR

Mechademia is a series of books, published by the University of Minnesota Press, devoted to creative and critical work on anime, manga, and the fan arts. Linked through their specific but complex aesthetic, anime, manga, and the fan arts have influenced a wide array of contemporary and historical culture through design, art, film, and gaming. This series seeks to examine, discuss, theorize, and reveal this unique style through its historic Japanese origins and its ubiquitous global presence and manifestation in popular and gallery culture. Each book is organized around a particular narrative aspect of anime and manga; these themes are sufficiently provocative and broad in interpretation to allow for creative and insightful investigations of this global artistic phenomenon.

MECHADEMIA 1

Emerging Worlds of Anime and Manga

FRENCHY LUNNING, EDITOR

UNIVERSITY OF MINNESOTA PRESS MINNEAPOLIS • LONDON

http://www.mechademia.org/

The University of Minnesota Press gratefully acknowledges the Minneapolis College of Art and Design, whose Faculty Enhancement Grant 2005 helped support this project.

"The Japan Fad in Global Youth Culture and Millennial Capitalism" was originally published in Anne Allison, *Millennial Monsters: Japanese Toys and the Global Imagination* (Berkeley: University of California Press, 2006).

"*Kurenai no metalsuits*, 'Anime to wa nani ka/What is animation'" originally appeared as "What Is Animation?" in Ueno Toshiya, *Crimson Metal Suit: Anime as a Battlefield*, translated by Michael Arnold, Michigan Monograph Series in Japanese Studies (Ann Arbor: Center for Japanese Studies, University of Michigan, 2006); reprinted with permission of the publisher.

Anime timeline by Brian Ruh. Manga timeline by Patrick Drazen. Spot illustrations by Ke Jaing.

Published by the University of Minnesota Press
111 Third Avenue South, Suite 290
Minneapolis, MN 55401-2520
http://www.upress.umn.edu

ISSN: 1934-2489
ISBN-10: 0-8166-4945-6 (pbk.: alk. paper)
ISBN-13: 978-0-8166-4945-7 (pbk.: alk. paper)

Printed in the United States of America on acid-free paper

The University of Minnesota is an equal-opportunity educator and employer.

12 11 10 09 08 07 06 10 9 8 7 6 5 4 3 2 1

Contents

Review and Commentary

Anifesto

FRENCHY LUNNING AND CHRISTOPHER BOLTON

ILLUSTRATED BY SARA POCOCK

TWO GROUPS THREAD A PATH
LIKE SHY LOVERS—IN TANDEM,
BUT ALONE—AWARE

INTENT, THE ONE, EXAMINES
EACH LEAF THAT BLOWS
FROM THE EAST

THE OTHER, THE WINDS
BRING BREATH, SPIRIT, MOVEMENT,
AND A NAME: OTAKU

AS SHARED FURTIVE LOOKS REVEAL
DIFFERENCE, BUT SHARED PASSION

ARDOR SMOLDERING
IN DRY-LEAVED FIRES DRAWS THE TWO
TOWARD AN EMBRACE

LIT BY AN ANIME MOON
BORN UNDER A SAILOR'S STAR:

MECHADEMIA—
OFFSPRING OF THEIR FATED TRYST,
IRON CHILD OF LEAVES.

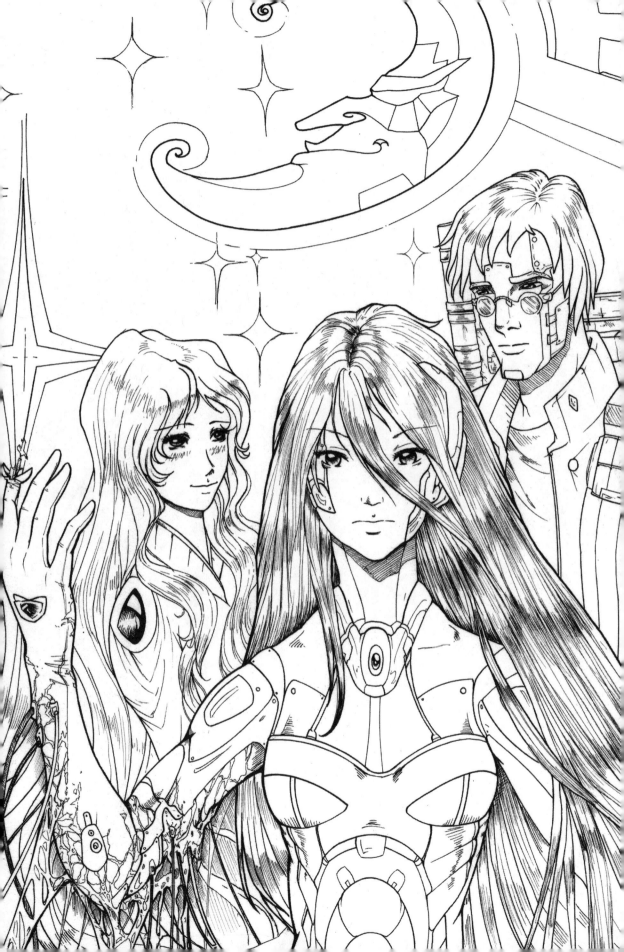

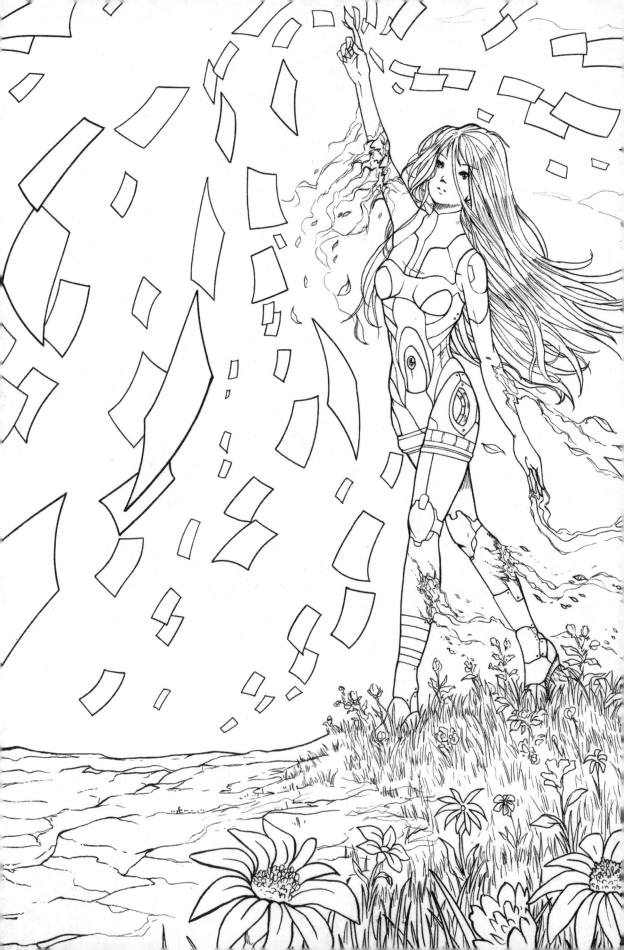

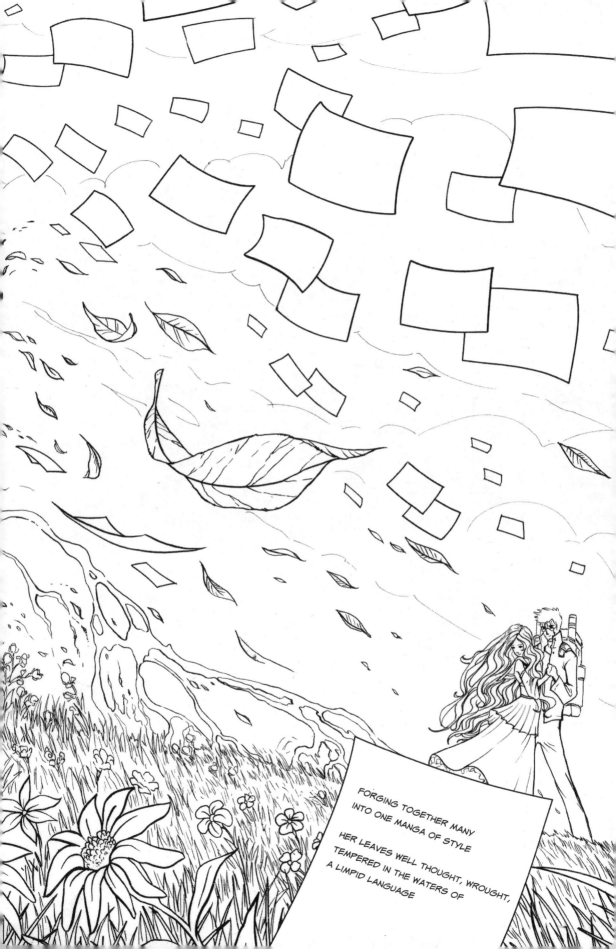

FORGING TOGETHER MANY
INTO ONE MANGA OF STYLE

HER LEAVES WELL THOUGHT, WROUGHT,
TEMPERED IN THE WATERS OF
A LIMPID LANGUAGE

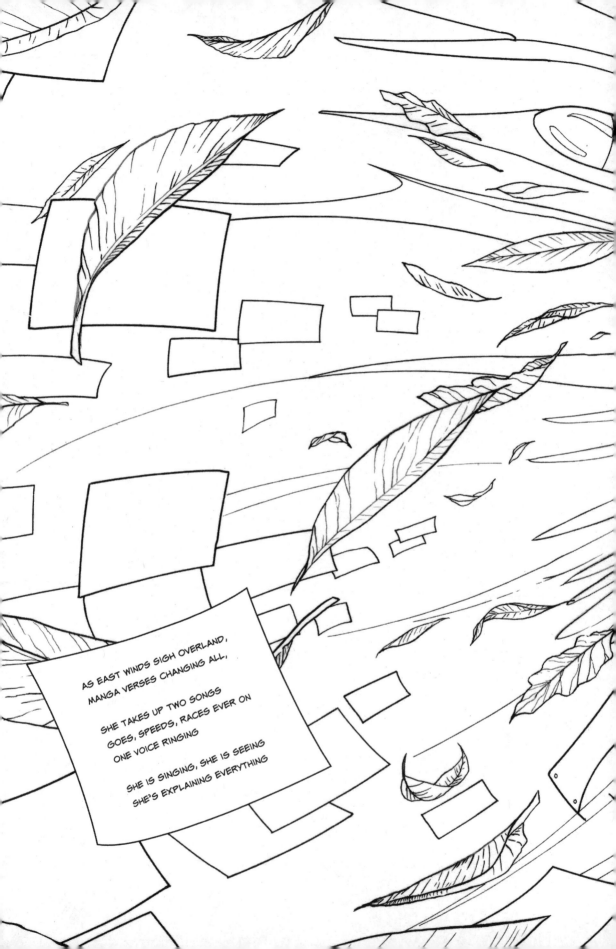

AS EAST WINDS SIGH OVERLAND,
MANGA VERSES CHANGING ALL,

SHE TAKES UP TWO SONGS
GOES, SPEEDS, RACES EVER ON
ONE VOICE RINGING

SHE IS SINGING, SHE IS SEEING
SHE'S EXPLAINING EVERYTHING

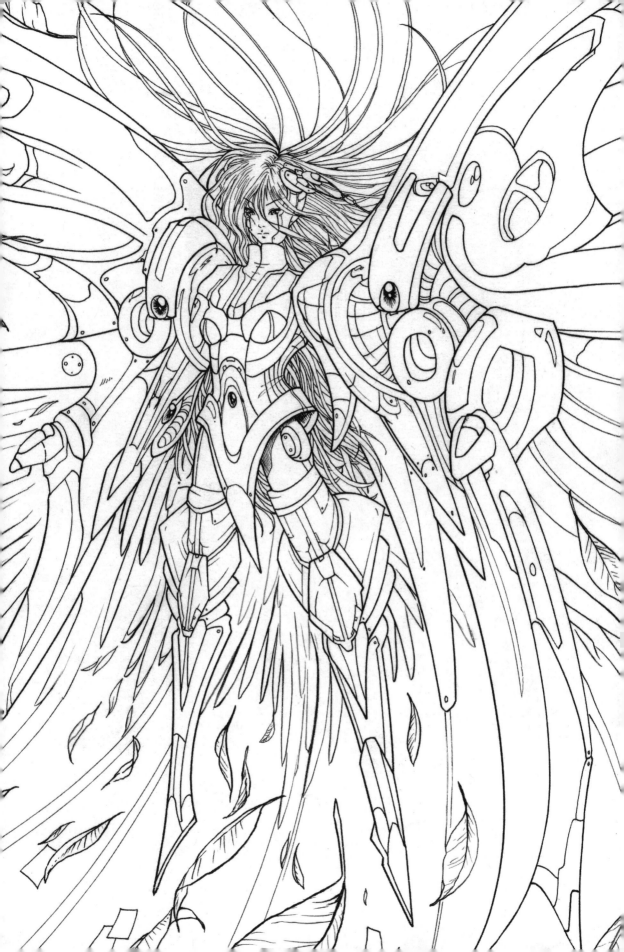

ANNE ALLISON

●●●

The Japan Fad in Global Youth Culture and Millennial Capitalism

In the Hollywood hit of 2003, *Lost in Translation*, Tokyo is the backdrop for a tale about modern-day angst and cultural dislocation. As shot by the film's director, Sofia Coppola, the screen fills with scene after scene of a searingly beautiful Tokyo: neon-lit Shinjuku, a pristine sushi bar, the quietude of a temple, a nightclub's jagged excesses. All of this is filtered through the perspective of two American travelers who are as lost in this foreign culture as they are in their personal lives back home. Strangers when they first meet, the two connect over shared insomnia and malaise. Both are reluctant visitors to a country that neither one is interested in; both find Japan utterly strange. Yet the strangeness inspires not only gaffes and gaps in cultural (mis)communication but also intimacy between the two. By the time they part, Japan has acquired a new attractiveness and meaning for them. Yet neither character exhibits greater knowledge or understanding of the country: they are as clueless as when they first checked into their hotel. Indeed, the film's audience shares the same position, as strangers "lost" in a culture that, while quirkily and sensuously beautiful, is foreign and outside "translation."

In 2004 ABC aired an episode of the long-running children's television show, *Mighty Morphin' Power Rangers*, with a story that referenced Coppola's

movie. Titled "Lost and Found in Translation," this story of a cross-cultural encounter is played with a twist: here the protagonists will not only lose but also find their way in(to) a different culture. The episode opens in the United States with the rangers—teenagers who morph into superheroes to fight alien monsters and defend the earth—in their everyday garb, working on a social science project comparing two cultures. On television, they discover a program from Japan that turns out to be a version of *Abarangers* (that season's variant of *Power Rangers*) dubbed into English. Two of the three Americans are riveted, fascinated by the cyborgian upgrades and fighting stances of the Japanese rangers. But the third dismisses the foreign show as inauthentic, saying that they "got it all wrong" and discounting the enemy as a "guy in a rubber suit." His pals, however, remind him that it's just a TV show and urge him to use his imagination. Sitting back and watching more, he gets into the action and admits that it's "kinda cool." The episode ends with a message about cultural difference voiced by the new convert. "We're not so different after all, just a slightly different interpretation." Returning to his homework assignment, he announces the title to the others: "Japanese versus American Culture—Closer Than We Think."

> THE GLOBAL MARKET IN JAPANESE YOUTH PRODUCTS HAS SKYROCKETED. THESE EXPORTS NOW EXCEED WHAT HAD BEEN THE LEADING INDUSTRIES IN JAPAN'S POSTWAR ECONOMY, AUTOMOBILES AND STEEL.

Both the above stories, produced by U.S. cultural industries in the new millennium, feature Americans who are discomforted in their encounters with a foreign culture. In both cases, that culture is Japan; in both cases, the discomfort is dispelled. The reasons for this, however, are different. In the former, a blockbuster movie for and about adults, the characters are dislocated from home in a cultural milieu they feel lost in. But, in what has been called a love story, the couple uses the alienness of Japan to bridge their own personal alienation in the company of one another. And, in this, the setting could be anywhere, reviewers have suggested, and Japan acts more figuratively than literally to signify a sense of dislocation in the world at once uneasy and potentially pleasurable. The story line in "Lost and Found in Translation"—an episode for a children's television show featuring kids—is quite different. Here, the tale is set in the United States, where the foreignness Americans confront is on the screen instead of the street. Fictional and unreal, the ranger escapades constitute popular culture: something that American youth take very seriously. And it is in these terms that the U.S. rangers

on the show come to read and appreciate the differences of their Japanese counterparts. Bearing a style that the Americans find cool in its own right, the show's cultural logic doesn't defy translation as much as yield a different interpretation.

I use these two tales of imaginary encounters between Americans and Japan/ese to reflect on the rise of manga, anime, video games, and various play trends around the world, including the United States. Starting in East and Southeast Asia in the 1980s and other parts of the world such as Western Europe, Russia, Peru, and the United States in the early to mid-1990s, the global market in Japanese youth products has skyrocketed. Called the country's GNC (gross national cool) by the American reporter Douglas McGray (2002), these exports now exceed what had been the leading industries in Japan's postwar economy: automobiles and steel. Having tripled in the past decade—a time of a nagging recession precipitated by the bursting of the Bubble economy in 1991—the industry of cool culture is bringing much-needed capital to Japan, both real and symbolic. Taken seriously these days even by the Japanese government, which hopes to channel it as a form of "soft power," J-cool raises questions about what precisely the nature of its appeal is around the world; what, if any, influence it is having on global culture; and how exactly "Japan" figures in any of this. Concentrating on the United States here because of how its own cultural industries have dominated the global imagination, I consider how Japanese properties are entering not only the marketplace and play habits of U.S. kids but also the imaginary of Americans more generally. In a place where storytelling has been so ethnocentric, the omnipresence of Japanese cartoons on Saturday morning TV, for example, and the shelves of manga sold in chain bookstores like Borders (many printed right to left in Japanese style) are striking. Does this really represent a shift, however, from the global (cultural) power of Americanization? Further, what do we make of the fact that this fad, so driven by youth, is also so incomprehensible to American adults, that "culture" here comes in the register of virtual, fantasy worlds, and that J-cool trades in an image of Japan more imaginary than so-called real?

The influence of Japan on American pop culture is hardly new. *Godzilla*, of course, was a huge hit in the 1950s, with its endless sequels and incarnations that have survived until the new millennium. Japanese television shows like *Astro Boy* and *Speed Racer* have been broadcast on regional stations since the 1960s, Japanese metal robots and transformers have sold in American toy stores since the early months after World War II, and entertainment technology such as the Sony Walkman and Nintendo Game Boy has

been so popular with American kids as to become almost ubiquitous. Since the 1990s, however, there has been a palpable shift in not only the number and types of Japanese youth properties imported to the United States but also their mainstreaming into American youth culture.

The example of "Lost and Found in Translation" is illustrative. It was broadcast in the twelfth season of *Power Rangers* on U.S. television, a show based on the Japanese *renjaa* series that has aired on Tôei television since 1975. Acquiring rights to its U.S. broadcast in 1985, Haim Saban—a U.S.-based entrepreneur—tried for eight years to interest a U.S. television network in the show. All refused on the grounds that it had a foreign flavor and a kitschy aesthetic that wouldn't catch on with American kids (whose tastes, it was thought, were more sophisticated). When Margaret Loesch, who had been raised on Japanese television shows, signed it on for Fox Kid's Network, however, *Power Rangers* became an immediate success: it outranked all other children's television programs in the United States and soon became the number one children's program internationally. But to appeal to American kids, the network deemed it necessary to transform the show and reshot all the scenes when the rangers are ordinary (in-the-flesh) teenagers with American actors in a California studio. Splicing the Japanese action scenes when the rangers have morphed into warrior costume with the American footage and renaming the hybrid *Mighty Morphin' Power Rangers*, the network not only reinvented the show but Americanized it. Indeed, as one Saban executive said to me in a 1996 interview, *Power Rangers* is "an American classic." Several people in the children's entertainment business have confirmed that a Japanese show like this could never have been mainstreamed on network TV in the United States with actors who were Asian instead of American or with credentials that openly announced their origins as "made-in-Japan." Indeed, most of the American youth I interviewed about the program in the late 1990s never knew it originally came from Japan.

Power Rangers started as an American/Americanized show in 1993. Eleven years later the episode "Lost and Found in Translation" aired with what would appear to be a notable shift. While the show is still reshot with American actors and reculturalized to appeal to American tastes, explicit reference is now made to the fact that there is also a Japanese version of *Power Rangers*. From a show that once was entirely Americanized, a nod is now made to its Japanese counterpart. And this shift is self-consciously acknowledged in the episode's title, which proclaims—for itself and for its audience of American youth—that it has "found" a way not to be "lost" in the world of cultural/Japanese difference. Implicitly, a contrast is being made with the adults as

clueless about Japan as those in *Lost in Translation:* an attitude that has accompanied the J-craze in the United States where adults have remained mystified by the appeal, nature—and by association—the Japaneseness of play fads like *Pokémon*. Virtually all but one of the adults I interviewed at the height of U.S. "pokémania" in 1999, for example, proclaimed not only ignorance but utter mystification as to the very logic of this fantasy-world. "I simply don't get it," I heard time and time again from parents bemused by children fixated on collecting stacks of pokémon cards or spending hours with Game Boys trying to master virtual landscapes to capture all 151 (and now over 300 with later game editions) of pocket monsters.

> JAPANESE TELEVISION SHOWS TODAY ARE BROADCAST IN THE UNITED STATES WITH OVERT SIGNS OF THEIR JAPANESE ORIGINS IN PLACE. RATHER THAN TEMPLES, CHOPSTICKS, OR JAPANESE SCRIPTS BEING ROTOSCOPED OUT THEY ARE HIGHLIGHTED AS THE VERY HOOK TO REEL KIDS IN.

In contrast to such adult confusion are the attitudes of youth who, in the face of more and more Japanese properties entering the U.S. market and claiming trendy popularity, are both more comfortable with and even active proponents for a Japanese style identified as the latest in "cool." As I was told recently by (another) Saban executive, Japanese television shows today are broadcast in the United States with overt signs of their Japanese origins in place. Rather than temples, chopsticks, or Japanese scripts being rotoscoped out (or rice balls being altered to appear as doughnuts—devices still used in the U.S. broadcast of *Pokémon* cartoons, nonetheless), they are highlighted as the very hook to reel kids in. Such signs of Japaneseness signal, in part, an authenticity that is taken even further by avid fans of anime and manga whose preferences for the nontranslated or dubbed originals are driving the study of Japanese language in university (and high school) classes across the country. Sought and fetishized is some rubric of cultural/Japanese difference.[1] For example, in *Duel Masters*—the newest media mix of card game, cartoon show, manga, video game—the keyword of this play universe is *kaijûdô*, or "the way of monsters" (*dô* for "the way," as in the way of bonsai or the way of karate, and *kaijû* for monsters). Players aim to become *kaijûdô* masters by learning to manipulate their cards, strategies, and moves in order to battle, and defeat, the powerful monsters ruling five magical worlds. As one of the official guidebooks puts it, players must adopt a samurai-like code of discipline and resoluteness: "I make no excuses. My actions are my voice. . . . I have no enemies." It further explains that "when most anime is imported

to the U.S., nearly anything Japanese gets changed or dubbed over. This is untrue with *Duel Masters*. While battling, characters shout out their commands in Japanese, giving *Duel Masters* a much more distinct Eastern flavor" (Wizards of the Coast 2004, 5).

What do such play figures—*kaijûdô* as played by American kids in a game-set peppered with Japanese, or U.S. power rangers viewing their Japanese counterparts on split (American/Japanese) TV—tell us about the issues I've laid out in this chapter? One observation to make here concerns the juxtaposition but not jumbling together (or eradication altogether) of different cultural codes. Immediately before the *Duel Masters* guidebook claims that the inclusion of Japanese commands gives a "distinct Eastern flavor," it has noted the card game resembles the U.S.-made *Magic: The Gathering* and adds that the same American company, Wizards of the Coast, has, in fact, produced it. As the anime and manga come from Japanese creators (produced by Shôgakakan and Mitsui-Kids), *Duel Masters* is a joint production, distributed—as is now commonplace for such Japanese products that get exported to the West—differently in Japan/Asia versus in the United States and all territories outside Asia. In terms of production, this (as well as other U.S./ Japanese fare such as *Power Rangers* and *Pokémon*) represents a model of global power different from that associated with Americanization. The property is jointly produced, differentially distributed, and culturally mixed. Unlike McDonaldization, with its Fordist formula of one size fits all or even with the globalization it now travels with—a global commodity that gets localized differently in differing locale—the J-craze is both "Eastern" and not, a globalized fantasy whose intermixture of the foreign and familiar is not localizable in/to any one place.

As a twenty-two-year-old American male put this from the fan's perspective, what is appealing to American youth about Japanese cool today is its utter sense of difference. "It could be Mars," for the strangeness of the setting, story lines, and characters. But equally important is knowing that this all comes from a real place: from a Japan that actually exists, which inspires some fans at least into learning about Japanese culture, language, or history. "Japan" signifies something important here, but the signifier is shifting: a marker of phantasm and difference yet one anchored in a reality of sorts— a country Americans can study and visit. So fantasy and realism are both at work here, the one serving as the alibi for the other in what Roland Barthes (1957) describes as the construction of myth. Japan's role in the current J-craze among American youth is mythic: a place whose meaning fluctuates between the phantasmal and real, the foreign and familiar, the strange and

everyday. Many fans of Japanese anime, manga, card games, and toys I have talked with in the United States voice their attraction in similar terms: of having their imaginations piqued by the complexity and strangeness of an alternative (non-American) fantasy world equally enjoyable for the fluency they strive to master in it (by learning some Japanese, downloading pirates of the Japanese originals, acquiring knowledge about the cultural references). The first part of this is not so different from the depiction of foreignness in *Lost in Translation*—a quirky and bizarre otherworld. But, in contrast to the adult perspective taken in the film, American youth-fans of J-cool want to be "found" rather than "lost" in this terrain (by keeping the edginess of its difference yet acquiring the savvy of a global traveler/citizen to speak the language).

At work here is a new kind of global imagination, or new at least in the way it differs from an older model of Americanization. Joseph Nye has defined the latter in terms of what he calls soft power, the "ability to get what you want through attraction rather than coercion or payments," which "arises from the attractiveness of a country's culture, political ideals, and policies" (2004, x). Power of this nature comes from inspiring the dreams and desires of others through projecting images about one's own culture that are broadly appealing and transmitted through channels of global communication (such as television and film). Thus far, only the United States has had the soft power—in the strength of its cultural industries and the appeal of a culture that has translated around the world as rich, powerful, and exciting—to dominate the global imagination. But not only is America's soft power ebbing today because, in part, of the global unpopularity of such U.S.-led initiatives as the Iraq war, so too is the desirability—even in the United States—of a more monolithic, monochromatic fantasy-world. As the film critic A. O. Scott wrote recently about the 2004 Toronto film festival, the global currency of films made in India, China, South Korea, and Japan is increasing, defying the prediction that Hollywood "would take over with its blockbuster globalism dissolving all vestiges of the local, particular and strange" (2004, 86).

As Scott sees it, Hollywood is stuck in making movies that, while technologically impressive, project "counterfeit worlds" that spectacularize fantasies out of sync with the lived emotions of people in the twenty-first century. By contrast, movies filmed and produced elsewhere (his example is *The World*, by the Chinese director Jia Zhangkhe) are often smaller scale but more emotionally real. Stories of ordinary people struggling to make it in Beijing, Seoul, Calcutta, Taipei, where they are both dislocated and at home in these cities in jagged transition, project "the anxious, melancholy feeling of being

> "JAPAN" OPERATES MORE AS SIGNIFIER FOR A PARTICULAR BRAND AND BLEND OF FANTASY-WARE: GOODS THAT INSPIRE AN IMAGINARY SPACE AT ONCE FOREIGN AND FAMILIAR AND A SUBJECTIVITY OF CONTINUAL FLUX AND GLOBAL MOBILITY.

simultaneously connected and adrift" (Scott 2004, 86)—a state deeply recognizable to postindustrial subjects the world over. Of course, Hollywood filmmaking embedded with attractive images of American culture remains ever popular both at home (though theater attendance has slipped in recent years) and even more perhaps overseas (where revenues for films like *Titanic* are much greater). But, as the film critic Charles Taylor observes, what characterizes the emotional condition of the millennial era is "being in a world where the only sense of home is to be found in a constant state of flux" (quoted in Scott 2004, 86)—a state conjured up through mobility, nomadism, travel, the foreign. This is a descriptor, in fact, of *Lost in Translation* and also of much of the J-craze so popular in the United States today from the continual battles/dramas of the *Power Rangers* and *Sailor Moon* to the nomadic travels of the portable *tamagotchi* and would-be *Pokémon* masters.

With this, I make three final observations. The first, certainly well known already, concerns the diminishment, even collapse, of American soft power as the hegemonic center of global culture (what Iwabuchi Kôichi [2002] has called the "recentering of globalization"). The second is about new models of the global imagination today that, in the case of J-cool and its popularization around the world, carries an attractive power, but not one that is driven by or generates an attraction in others for the actual place or culture of the producing country. "Japan" does register in all this: itself a recent shift from the time when Japanese cultural products were marketed worldwide by "deodorizing" their roots (a cultural influence that a number of Japanese critics have referred to as invisible colonization and Iwabuchi (2002, 33) as cultural deodorization. But, as described above for American youth, it is not so much Japan itself as a compelling culture, power, or place that gets signified (despite the fact that this is precisely what the Japanese government is trying to capitalize on in all the rhetoric and attention currently given to Japan's new "soft power" in the globalization of J-cool). Rather, "Japan" operates more as signifier for a particular brand and blend of fantasy-ware: goods that inspire an imaginary space at once foreign and familiar and a subjectivity of continual flux and global mobility, forever moving into and out of new planes/powers/terrains/relations.

This is my third observation about the relationship between Japanese toys and the global imagination: that the current popularization of J-cool

around the world is best understood in terms of its fantasy formation that, in turn, lends itself so productively to capitalistic marketing in the new millennium. As I argue elsewhere (Allison 2006), key here are the two qualities of polymorphous perversity: continual change and the stretching of desire across ever-new zones/bodies/products, and techno animism, the foregrounding of technology that animates spirits, creatures, and intimacies of various sorts. What emerges is a fantasy of perpetual transformation (humans who morph into rangers, icons that "grow" into virtual pets) that, extended into the cyber frontier, promises (new age) companionship and connectedness, albeit in a commodity form. Resonant with the fluctuation, fragmentation, and speedup facing postindustrial youth across the world, such a fantasy also becomes addictive, compelling players to keep changing and expanding their play frontiers through a capitalism of endless innovation, information, and acquisition.

If, indeed, the nature of today's global culture is shifting away from one dominated by the United States, it makes sense that cultures more on the periphery would take the lead in a new kind of decentered global imagination: one premised on dislocation and flux and on "losing" but also "finding" one's way in a terrain of endless change and regeneration. In the case of Japanese pop culture, what could be called its national imagination—mass fantasies reflecting the times intended primarily for domestic versus global sales (as so many manga and anime artists claim is their primary target, as was also true of the original *Pokémon* game designed for Japanese boys)—is filled with the same theme of uprootedness and disconnectedness. The 2004 television anime *Môsô Dairinin (Paranoia Agent)* by Kon Satoshi, for example, traces the parallel, and colliding, paths of two adolescents, both riding the cusp of making and losing it in mainstream society. One, a young woman and the successful designer of the latest fad in cute toys, is cracking under corporate pressure to come up with a successor. The other, a teenage boy and former star baseball player (and popular kid) at school, gets accused of being the latest youth killer (the *shônen batto*, a roller skater who attacks with a bat). In this story, fantasy toys and violent acts run together (the designer gets attacked by the killer, and the boy's reality disintegrates into violence), standing for both phantoms and real humans, imaginary play pals and corporate cannibalism.

The protagonists in *Môsô Dairinin* are characterized by yearning, loss, and the struggle for recognition. The same could be said of the less obviously edgy (and globally distributed) *Pokémon*: nomadic characters on the eternal quest to be the world's greatest pokémon master. This path is always somewhere

but nowhere and full of conquests but also contests that never end. There is something promising but also chilling in this capitalistic dreamworld. For, while the drive to progress is ever present—winning more battles, keeping *tamagotchi* alive longer, getting (and getting) additional pokémon—one can never actually or definitively reach the goal, given that it is a frontier stretching continually further—into more Power Rangers toys, countless Pokémon Game Boy games, never-ending Sailor Moon play equipment. This is the formula for capitalism, of course: endless desire and deferment coming together in a cycle of consumptive repetition. And, in this, there is nothing new or particularly promising. Indeed, as noted in a 2003 report by Hakuhôdô Research Institute on Japanese youth (Hakuhôdô Seikatsu Sôgô Kenkyûjo 2003), a sense of "paralysis" about the future and interest in nothing beyond the immediacy of consumption characterizes girls (but less so boys) who have grown up in the anxious years of the post-Bubble (the report labels them the "*shûkuri sedai*," or "sugar generation"). Such a paralytic sensibility is part of the capitalistic imagination at play in the properties described in this chapter and exported far beyond Japan.

But there *is* something more promising and possibly new(er), as well, in the imaginative strategies that Japanese toys like *Pokémon* bring to the lives—both fantasy and real—of children who play with them in the United States and elsewhere. Continually morphing and disassembling (and reassembling) its parts is the signature of a *Sailor Moon* or *Yu-Gi-Oh!* play world: one that offers kids a way to deal with—and learn how not to get stuck in—a world/identity premised on flux. This, too, though, could be said of most Marvel comics produced in the United States. More distinctive in the Japanese brand of morphability is techno animism that involves two components. First is the high degree of interactivity in the equipment that makes fantasy play ever more personally customizable and also prosthetic: games that get carried in one's pocket and whose (electronic/virtual) portal to the world is continuously open. Second is the profusion of polymorphous attachments: of nomadic humans finding new kinds of transhuman attachments whether with digitalized pets, iconicized pokémon, or monsterish trading cards. And kids I know, both in Japan and the United States, admit to finding in all of the above not only hours of great pleasure but also a fantasy world that has sustained and nourished them through what are often tough and lonely times.

Finally, of course, there is the significance/signification of Japan in the creation of a global imagination no longer dominated (or at least not so completely) by the United States. The attractive power at work here may be less for a real place than for the sense of displacement enjoined by the post-

industrial condition of travel, nomadism, and flux—generated and signified here by somewhere not-the-United States but within the orbit of the globally familiar. Still, American hegemony is getting challenged in the symbolic, virtual medium of fantasy making. And, in this, I see a positive contribution being made to the cultural politics of global imaginings in the current J-craze in the United States.

Note

1. Such fans also tend to prefer that the anime and manga they consume are as unchanged from the original Japanese as possible: subbed (subtitled) rather than dubbed, for example, with no adulteration being rendered on the text, characters, or plotline at all. Distributors and marketers of J-cool vary on the localization strategies adopted for the U.S. marketplace. In the case of *Pokémon*, the movies were considerably changed to suit what the U.S. producers considered to be American tastes (the need for the story lines to have a clear good versus evil plotline, for the background music to be American, etc.), the cartoons were rotoscoped to erase explicitly foreign items, and many pocket monsters were given more American-sounding names. By contrast, on the cable television network *Cartoon Network*, the broadcasts of *Fullmetal Alchemist* and *Paranoia Agent*, for example, are almost entirely intact without modification to names, plotline, or characterizations (yet the anime are dubbed rather than subbed).

References

Allison, Anne. 2006. *Millennial Monsters: Japanese Toys and the Global Imagination*. Berkeley: University of California Press.

Barthes, Roland. 1957. *Mythologies*. Translated Annette Lavers. New York: Noonday.

Hakuhôdô Seikatsu Sôgô Kenkyûjo. 2003. *Seikatsu shinbun: Kodomo no seikatsu—shû-kuri sedai (Newspaper of Daily Life: Children's Lives—the Sweet Generation)*. Tokyo: Hakuhôdô.

Iwabuchi, Koichi. 2002. *Recentering Globalization: Popular Culture and Japanese Transnationalism*. Durham, NC: Duke University Press.

McGray, Douglas. 2002. "Japan's Gross National Product of Coolness." *Foreign Policy*, May–June, 44–54.

Nye, Joseph S., Jr. 2004. *Soft Power: The Means to Success in World Politics*. New York: Public Affairs.

Scott, A. O. 2004. "What Is a Foreign Movie Now?" *New York Times Magazine*, November 14, 79–86.

Wizards of the Coast. 2004. *Duel Masters*. Renton, WA: Wizards of the Coast/Shôgakkan/Mitsui-Kids.

WENDY SIUYI WONG

Globalizing Manga: From Japan to Hong Kong and Beyond

Many modern societies produce a form of visual and narrative art that contains a series of printed pictures, usually though not always with text.[1] In English, readers may call it sequential art, comics, comic books, cartoons, cartoon strips, or graphic novels. The French term is *bande dessinée (BD)*, literally, "strip drawing." In Chinese, commonly used terms are *manhua, lianhuantu,* and *car-ton*. The written Chinese characters for *manhua* are the basis for both the Japanese and the Korean terms for comics, which are, respectively, manga and *manhwa*.

No matter what it is called, this visual art form in various countries and languages has similarities and differences. Scott McCloud points out that this art form is a communication medium able to convey information and to produce aesthetic pleasure for readers.[2] As a part of the globalization of media, American comics and animation have a long history of exporting such works. Studies find that American comics played an important role in introducing modern comics to Asia, as in Hong Kong in the 1950s and 1960s.[3] In Japan, the great comics artist Tezuka Osamu openly acknowledged the influence of early Walt Disney and Max Fleisher animation in his work.[4] Japan's comics

and animation industry was the most developed among countries in Asia in the early 1960s. John Lent's study of the American animation industry and its offshore factory development in East and Southeast Asia confirmed that Japan was the pioneer in the field in the region at that time.[5] Indeed, when comics started to take off in Japan in the early 1960s, the influences of manga began to spread to its neighbors, and American influence started to wane in the region.

Manga is "one of the features of mass culture in present-day Japan. In 1994, 2.27 billion manga books and magazines were published, making up 35 percent of all material published."[6] The manga market in Japan is big, and genres are highly diversified. However, when examining the exportation of Japanese cultural products, including comics, the cultural economist Dal Yong Jin points out that these products "have hardly penetrated worldwide to the same degree as its [Japan's] economic power and the domestic culture market."[7] It was not until approximately fifteen years ago, partly because of Japan's economic recession, that the Japanese manga industry began to grant copyrights to overseas publishers in Asia and to explore the transnational development of its cultural products.

The influence of manga in Southeast Asian societies is obvious. Outside Japan and Asia, the visibility of manga is clearly emerging into the mainstream media.[8] Comics scholars and cultural studies scholars are optimistic that Japan can be "consider[ed] as another centre of globalization" because of the current global development of manga and anime.[9] This chapter aims to investigate the flow of manga as a cultural product in the global market, from its country of origin, Japan, to the neighboring region and then to the rest of the world. Because of the influence of American and Western comics in manga, one may find that Japanese manga are

> undoubtedly deeply imbricated in U.S. cultural imaginaries, but they dynamically rework the meanings of being modern in Asian contexts at the site of production and consumption. In this sense, they are neither "Asian" in any essentialist meaning nor second-rate copies of "American originals." They are inescapably "global" and "Asian" at the same time, lucidly representing the intertwined composition of global homogenization and heterogenization, and thus they well articulate the juxtaposed sameness and difference.[10]

I am interested in exploring these globalization flows by focusing on manga. To begin the inquiry, I open with a brief review of the concept of globalization.

GLOBALIZATION'S THEORETICAL ISSUES

Globalization is one of today's hottest buzzwords. Stuart Hall reminds us that this phenomenon is nothing new and can be traced back through the long history of Western imperialism.[11] Following this Western imperialism, many people in non-Western countries had experienced different degrees of colonialization over the past few centuries. Anthony Giddens sees globalization as the consequence of modernity in which European nations employed their military and economic power to conquer and rule tribal societies and inferior countries, thus gaining raw materials and securing new markets.[12] Because of its historical origins, globalization was dominated first by Europeans and later Americans. However, as "the emergence of new global communicational technologies has facilitated the questioning of the previously taken-for-granted Western cultural superiority,"[13] the stage of contemporary globalization that David Held, Anthony McGrew, David Goldblatt, and Jonathan Perraton see is becoming possible. For people today, it is "becoming increasingly impossible for them to live in that place disconnected culturally from the world."[14]

How has cultural globalization occurred in the contemporary context? The well-established anthropologist Harumi Befu sketches out the two routes that cultural globalization has taken, based on the Japanese example. The first route is through the "sojourner—emigrants, students, businessmen, and others" who leave their homelands and settle somewhere else. This circle of native carriers creates a network of global enthnoscapes, "as individuals necessarily take their culture with them." The second is "the non-sojourner route, through which cultural products spread abroad without native carriers." Befu explains how "culture carried abroad by sojourners is then taken up by locals," and "human dispersal is itself part of the globalization process, and the two processes are intricately intertwined, rather than empirically separate and distant." Thus, to complete studies of how cultural globalization proceeds, he emphasizes that "both routes need to be examined together."[15]

Befu provides us with another model for understanding the spread of cultural products outside American and European influences. Globalization is "an outcome of capitalism in the modern period."[16] Cultural products, often considered as additional consumer commodities, are being marketed and promoted like any other products. In the case of anime, Jiwon Ahn notes that "anime can be more fully understood within the web of influences organized according to the successful 'media mix' strategy," which started,

although not necessarily in a chronological sense, from the original manga (comic book) series, then the manga is adapted to animated television series or film features or both formats; also video production of the animated series follows. . . . Almost simultaneously, various goods related to the manga and anime, including original soundtrack CDs, paperback books, fanzines, and numerous character merchandises like action figures, toys, stationery goods, confectionary products, etc., are distributed in the market. Also, the release of computer games based on the manga and anime follows, which in turn increase the sales of the original manga series, magazines, books and videos, and spurs the creation extended.[17]

Similar "media mix strategy" analysis can also be seen in the work of other scholars such as Susan Napier, Mary Grigsby, and Anne Allison on manga studies.

To study the global flow of cultural products such as manga, Befu reminds us that in "non-diasporic cultural globalization it is important to distinguish between the 'structural and institutional' and the 'agency' levels of discourse." "Structural and institutional" levels of discourse refer to "government regulations" and "a certain level of economic well-being and lifestyle, including middle-class aspiration and the availability of sufficient disposable income to enjoy imported cultural products."[18] Arjun Appadurai identifies his five famous flows of structural and institutional factors: ethnoscapes, technoscapes, financescapes, mediascapes, and ideoscapes.[19] All these aspects, Befu points out, "constitute the structural backdrop for agents to act out their volition, the two are interconnected and influence each other in the realm of cultural globalization."[20]

> TO JAPANESE READERS, FOREIGN COMICS REPRESENTED EXOTIC CULTURE. IT WAS THE ARTISTS WHO LEARNED FROM THE FOREIGN COMICS FORMAT AND ADAPTED THEM FOR READERS.

Within these theoretical considerations of globalization, I am interested in seeing how "structural and institutional and the agency levels of discourse" in manga interact with each other in different cultural settings and societies in the contemporary globalized landscape. What made manga able to travel from Japan to the rest of the world? What factors and elements made manga able to communicate across cultures? In Asia, "when considering Japan's globalization, one normally does not consider black markets. But the huge volume of black marketeering of Japanese products suggests the importance of this process. Copyright infringement is a great loss to

the Japanese economy, but it is an aspect of Japan's globalization."[21] However, in North America and Europe, that case may not be applied. Consider the recent phenomenon of "Asianization of the West," in which we "witness japonisme—diffusion of manga and anime, Japanese cuisine, karaoke, and the like. There is no name for this phenomenon, but it is an obverse of 'Japanization of the West.'"[22] "Precisely how power is woven into the globalization of Japanese-made images . . . are issues few have studied," as Allison points out.[23] This study shares her view. With the understanding of "the assumption that globalization emanates from the West, and that the rest of the world is its recipient," this chapter hopes to contribute "an empirically grounded approach that would avoid these Western-centered assumptions and relativize the overall view."[24]

ANOTHER CENTER OF GLOBALIZATION

The Context of Manga in Japan

Japan is an island country that has long been open to outside influences, especially China. In the case of manga, Frederik Schodt points out, "no one knows exactly when the first Japanese tried his or her hand at cartooning,"[25] but he sees the possibility that the adaptation of this art form was influenced by early Chinese civilization. The now widely used term for comics and cartoons, *manga*, came into popular use around the mid-1700s, with the print artist Katsushika Hokusai's (1760–1849) work—*Hokusai* manga. Western influences on manga can be traced back to when Japan opened up to the Western world in the Meiji period (1868–1912), in which the first Western-style humor magazine—the *Japan Punch*—was published in Yokohama from 1862 to 1887 by a British artist, Charles Wirgman.[26]

The modernization process in Japan began in the Meiji period, when the country began to look for advanced Western models to adapt for all walks of life. Various Western countries influenced the modern Japanese comics in the form of manga. Leading cartoonists traveled abroad frequently, mostly to the United States, but also to European countries. In an example from 1937—"A New Year's Party for the World's Most Popular Comic Characters"—drawn by members of the New Cartoon Faction Group, we can see "Japanese artists were well acquainted with American comic strips."[27] To Japanese readers, foreign comics represented exotic culture. It was the artists who learned from the foreign comics format and adapted them for readers. As Schodt points out, "Japan's relative cultural isolation has always allowed her

to be more choosy about foreign influences and then to adapt them to her own tastes. . . . Foreign comics were exotic but, in the end, alien."[28] The most famous children's monthly magazine, *Shônen Club*, was established in 1914; *Shôjo Club* formed in 1923.[29] The prewar period marked the beginning of the modern comics of Japan—manga.

After World War II, manga picked up where they left off before the war and rose to a new height. This period (1950s to 1960s) saw the flourishing of science fiction and the rise of "the God of manga," Tezuka Osamu. Tezuka's "Atomu Taishi (Ambassador Atom), later changed to Tetsuwan Atomu (Mighty Atom) and then made into animated television as Astro Boy," marked a milestone in manga history in Japan. This development "reflected the movement to a mass society and the influence of American culture and marked the rise of the manga of contemporary Japan."[30]

Today, "manga culture is well developed in Japan because of the massive scale of the manga industry, and children and adults alike have achieved a high level of manga literacy."[31] This culture has "enormous circulation of comic magazines and the large number of stories these magazines carry. Comic magazines fall into some broad categories that can be subdivided into genres."[32] These genres are classified according to the age and gender of the target readers, as well as personal preferences and tastes. Manga marketed to different readers by age include those for teenage boys, known as *shônen;* teenage girls, *shôjo;* children, *yônen;* women, *josei* (or *redikomi,* and *rediisu*); and men, *seinen.* Other main genres included *garo* (alternative, underground, and avant-garde manga), *gekiga* (dramatic pictures), *mahô shôjo* (magical girl), *mecha* (giant robots), *moe/mahô kanojo* (magical girlfriend), *shôjo-ai* (lesbian romance), and *shônen-ai* (gay romance).[33] All the genres appear in magazines containing multiple series of manga by various artists—and some become *tankôbon,* a compilation paperback-sized volume of a single series originally published in the magazine.

Internally within Japan, manga plays a role to "'release tension' from the controlled work/school environment" and "is a silent activity that can be carried on alone" in a relatively small space without bothering others.[34] As Grigsby observes, "There is a long tradition linking manga to the world that is separate from the rationalized work-a-day world and locating it in a space that is removed from the usual constraints of Japanese society."[35] She points out the social function of manga in Japan is to provide readers with

> information about the beliefs, values and practices of the culture in which
> they are conceived; it is important to recognize that the relationships of

the creators and readers to the larger social, economic and political systems within which a given comic is created, published and made available for purchase are key elements in the production of the comic and in the reproduction of culture.[36]

Japanese manga publishers enjoyed huge domestic successes throughout the decades after World War II. They therefore had little incentive to develop international licensing systems for their manga.[37] The successful exportation of manga within Asia first started in Hong Kong, Taiwan, Korea, and other Southeast Asian countries, and black markets operated in individual locales to distribute pirated copies. To most Asian nations, Japanese modern culture represents a hybrid identity of Western and Asian influences. Like other Japanese cultural products, such as Japanese *dorama* (dramas), manga offers "the possibility of modernity in an Asian image," and for the Asian audience "with a similar cultural-economic experience, these images become highly identifiable and accessible."[38]

It was not until the domestic market for manga started to decline in the mid-1990s that publishers began to search for a new market. With the initiation started by other Asian locales in the mid-1960s, Japanese publishers finally organized and made international licensing a part of their business with Asian partners in the late 1980s. Then, with the success of licensing in Asia and Europe, publishers "started to focus on their last resort: entry into the remaining market, the United States, where the population of children is twice as big as Japan's."[39] The following section investigates the different time frames of the transnational flow of manga as cultural products to the rest of the world.

MANGA IN HONG KONG AND SOUTHEAST ASIAN COUNTRIES

When studying the global flow of manga, one has to acknowledge that "a pure 'Japaneseness' has gone hand in hand with the acceptance of significant Western influence," and manga has the characteristics "representing the juxtaposed sameness and difference."[40] Thus this feature contributed a great deal to the cultural flow globally of manga, but different readers may have different degrees of identification. For Japan's Asian neighbors, manga can be considered to represent the new image of "Asian." Befu points out that the "similarity of the cultural assumptions and background—undeniably

makes it easier for some Asian countries to understand and empathize with performances and characters. Physical or biological similarity between the Japanese and neighboring Asians also plays a part."[41] However, the spread of manga in this region was not smooth. Leo Ching describes the tension surrounding Japanese mass culture in Asia:

> Japan's economic expansion has brought fear to its Asian neighbors, mainly because of the great suffering Japan has inflicted on other Asian countries during World War II and because of Japan's persisting reluctance to face up to its wartime responsibilities. These concerns are genuine in light of Japan's prevailing prejudice and insensitivity toward its neighbors. Unlike the Germans, the Japanese government has never sincerely or formally acknowledged and apologized for its wartime brutalities and atrocities.[42]

Because of this unsettled past, especially the Japanese government's non-admission of guilt, both Taiwan and Korea banned major Japanese cultural products for decades,[43] and so Hong Kong became the earliest outlet of the global flow of manga from Japan.

Hong Kong also benefited from being a British colony after the war; free of political turmoil, capitalism was able to flourish. In the 1950s the territory saw an influx of people, including talented artists and entrepreneurs, from the People's Republic of China.[44] As the economy progressively recovered, newspapers became more affordable, and demand for four-panel cartoons strips began to pick up. With the increasing demand for cultural products, the first comics boom in Hong Kong occurred from the mid-1950s to the mid-1960s.[45] The best-selling serial comics, known locally as *manhua*, were Wong Chak's *Master Q* (1964), Hui Guan-man's *Uncle Choi* (1958), Ng Gei-ping's *Boy Scout* (1960), and Lee Wai-chun's *13-Dot Cartoons* (1966). Also, children's magazines such as *Children's Paradise* (1953), *Little Angeli* (1954), and *Little Friends Pictorial* (1959) played an important role in Hong Kong's *manhua* history. This first boom was led mainly by local artists previously trained in mainland China and influenced by the United States and Europe. For example, the character of *Little Angeli*, created by the Bao brothers, was modeled after *L'il Abner*, *Popeye*, and other American cartoon characters. Lee Wai-chun, known as the "master of girls comics" in Hong Kong, admitted that she was not keen on the "old-style" Chinese *manhua* drawing style. Instead, she modeled her main character, Miss 13-Dot (Figure 1), after fashion magazines such as *Mademoiselle*.[46]

The introduction of Japanese manga to Hong Kong began around the mid-1960s through pirated copies of the Chinese versions. Works such as

Tezuka Osamu's *Astro Boy*, *Princess Knight*, and *Phoenix*, as well as Mochizuki Mikiya's *Wild 7*, Yokoyama Mitsuteru's *Tetsujin 28-go*, and many others, were directly reproduced from the originals without mention of the artists' names or were completely redrawn by local artists. Many classic manga titles were introduced to Hong Kong through this channel. Fujiko Fujio's *Doraemon* was

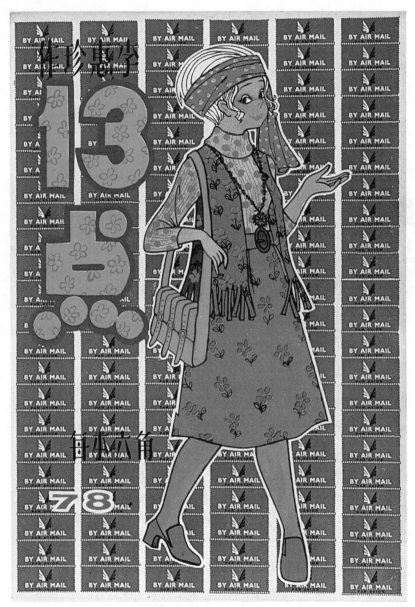

FIGURE 1. Lee Wai-chun, Miss 13-Dot Cartoon, 1966. Hong Kong.

known as "Ding Dong" (in Cantonese) for a long time until 1999. *Doraemon*'s first appearance was in *Children's Paradise* in 1975, in which the manga was redrawn completely in full color and all the characters were given Chinese names (Figure 2). The 1970s saw the waning influence of American cartoons on Hong Kong's *manhua* and the emerging major role played by manga in both local artists and share of readership. Together with the worldwide "kung-fu fever" led by Bruce Lee, Wong Yuk-long's (also known as Tony Wong) biggest hit—*Siulauman* (*Little Rascals*)—became the unique Hong Kong martial arts–styled *manhua* (Figure 2). Wong was strongly influenced by Mochizuki in drawing style, but like Japanese *mangaka* (manga artists), Wong learned the format and expression style from manga and gave the story a Hong Kong context to suit the local flavor.[47]

FIGURE 2. Wong Yuk-long, *Siulauman* (*Little Rascals*), 1970s. Hong Kong.

After Wong Yuk-long's success, Japanese manga became the main inspiration source for local artists. The younger generation artists in the 1980s, such as Ma Wing-shing, Li Chi-tat, and Szeto Kimquo, were manga fans themselves and loved titles like Ikegami Ryôichi's *Crying Freeman*, *Men's Gang* (*Otokogumi*), Masamune Shirô's *Ghost in the Shell*, Yoshikazu Yasuhiko's *Kidô Senshi Gundam—The Origin*, and Ôtomo Katsuhiro's *Akira*.[48] The kung fu genre started to decline in the mid-1990s, partly because Japanese publishers' international licensing system was well in place by the time and the genres of other locally produced *manhua* were becoming more diverse. New genre comics such as "car racing (e.g. *GT Racing*), soccer (e.g. *Monk Soccer*) and yoyo (e.g. *The King of Yoyo* and *The Star of Yoyo*) published since 2000 are modified from the best-selling Japanese manga, *Initial D*, *Captain Tsubasa* and *Beyblade* respectively."[49] "Elements of manga penetrate different forms of the comics industry of Hong Kong,"[50] as the Japanese studies scholar Wai-ming Ng observed.

Major local *manhua* publishers owned by local artists, such as Wong Yuk-long's *Jade Dynasty* and Ma Wing-shing's *Jonesky*, also published licensed Chinese-version manga to diversify their revenue sources. The biggest of these publishers, Culturecom Comics, has published more than three hun-

dred licensed manga titles since its establishment in 1992. Chinese-version manga has a significant market share in Hong Kong's *manhua* industry, and its influences have become more dominant. Typical Hong Kong *manhua* are published weekly, with an average of thirty-two to forty-eight pages in full color, on 7.5" x 10.75" paper. Now, more and more local artists have adopted the manga book format, with about two hundred pages, black and white, printed on 5" x 7" paper and published monthly. Also, various forms of manga culture, such as comics rental shops, comics Internet cafés, *dōjinshi* (amateur comics), and cosplay (costume play) are common in Hong Kong.

The other major consumption center, Taiwan, also has various forms of manga culture. Because of the government's official ban on Japanese songs, films, and other cultural products before the mid-1980s, the penetration of manga into Taiwan was later than Hong Kong. However, in the 1970s pirated Chinese-version manga were widely published and circulated in Taiwan. Some of the Taiwanese pirated titles traveled to Hong Kong, Singapore, and Malaysia as well. Thus Taiwanese readers were familiar with Japanese manga though various unofficial channels. By the mid-1990s, "despite the official ban, Japanese songs and video programs [could] be heard and rented in every record and video rental store."[51] Top comics magazines featuring Japanese comics, such as *New Youth* and *Youth Express*, have circulations larger than 100,000 copies per issue.[52] Unlike Hong Kong, Taiwan does not have long-running, locally produced comic titles like Wong Yuk-long's *Lung Fun Mun* (*Oriental Heroes*), formally known as *Siulauman*, or Ma Wing-shing's *Chungwah Yinghung* (*Chinese Heroes*), or a unique comics style like the kung fu genre. For Ng, "Taiwan comics are the most Japanese of all Asian comics. Many Taiwanese comic artists copy the Japanese style faithfully and one can hardly find any Taiwanese elements in their work."[53] Perhaps the one outstanding exception is Zheng Wen, who "skillfully combined Japanese (particularly Ikegami Ryōichi and Kojima Goseki's), and Western comic styles with Chinese painting and calligraphic skills in his comics."[54] His best-known works are *Stories of Assassins* (*Cike Liechuan*) in 1985 and *Stories of Eastern Zhou Heroes* (*Dong Zhou Yingxiong Chuan*) in 1990.

> IN KOREA, MANGA ARE ALSO WIDESPREAD, EVEN THOUGH THE GOVERNMENT'S OFFICIAL POLICY STATED THAT "PRODUCTION OR DISTRIBUTION OF JAPANESE DRAMATIC MOVIES, VIDEO FILMS, COMICS, CDS, AND RECORDS AS WELL AS THE PUBLIC PERFORMANCE OF JAPANESE POPULAR SONGS ARE NOT ALLOWED."

> TODAY, THE PRESENCE OF MANGA IN ASIA IS EVERYWHERE. IN AREAS OF HEAVY CHINESE INFLUENCE THE CONCEPT OF "CULTURAL SIMILARITY" OR "CULTURAL PROXIMITY" CAN EXPLAIN WHY MANGA IS MORE POPULAR THERE.

In Korea, manga are also widespread, even though the government's official policy stated that "production or distribution of Japanese dramatic movies, video films, comics, CDs, and records as well as the public performance of Japanese popular songs are not allowed."[55] Like Taiwan, Korea was a Japanese colony; both are under strong Japanese influence, but at the same time are very cautious of being culturally colonized. As for decolonization, "sometimes it meant ruthless galloping into economic development in an effort to catch up and 'compete' with Japan."[56] Despite that, pirated Korean-version manga still developed into major reading material for the people. And locally produced Korean comics—(manhwa)—very much mimic Japanese manga in style and technique. Korean comics and animation artists learn skills firsthand from Japan through offshore animation factories. Both Taiwan and Korea have these factories, which provided opportunities for the local talent to learn from the Japanese directly.[57] With that skill set as the foundation, Korea is now eager to develop its own manga and animation. Korea is particularly successful with online animated short pieces such as *Mashimaro* and *Pucca*. These two product lines became popular in Asia and competed with Japanese ones worldwide. Despite the competition, there is a trend for Korean and Japanese artists to collaborate in comics and animation. For example, *Comic Punch*, a Japanese comics magazine published by Shinchôsha, started to publish in both Japanese and Korean in May 2001. And in 2002 a leading *manhwa* artist, Yang Kyong II, collaborated with Hirai Kazumasa to produce *Zombie Hunter* (*Shiryôgari*) in Japan.

Hong Kong, Taiwan, and Korea are the first group of countries to experience the transnational flow of Japanese manga outside Japan; the other Southeast Asian countries and the newcomer, China, make up the second group. More than 75 percent of Singapore's population is of Chinese origin, the rest being Malays, Indians, and others. According to Ng's March 1999 survey, 68 percent of Singaporeans prefer Japanese manga, 14 percent prefer Hong Kong *manhua*, 13 percent prefer English comics, and 5 percent favor Taiwanese *manhua*.[58] Ng points out that "racial composition, cultural background, value system, religion, and state censorship" have all contributed to the different level of acceptance of manga in Southeast Asian countries.[59] Before the legal licensing of the 1990s, Malaysia and Taiwan were the major sources of pirated Chinese-version manga in Singapore, starting in the early

1980s. Readers are familiar with classic titles like *Astro Boy*, *Jungle Emperor*, *Princess Knight*, *Candy Candy*, and *Doraemon*. However, Hong Kong's kung fu manga also garnered significant attention from readers. Starting in the mid-1980s, Japanese manga began to secure the leading role in the comics markets of Singapore and Malaysia.

One might wonder why Southeast Asian nations were slower to pick up manga. According to Ng, Singapore and Southeast Asia have been strongly affected indirectly by Hong Kong and Taiwan, rather than by Japan directly. In addition, Southeast Asian countries, except for the Philippines, do not have their own mature comics culture and local comics production tradition to counterbalance Japanese manga. Finally, the entry of animated TV series into cable and Malay channels occurred much later than in East Asia.[60] As for China, the country has opened up only relatively recently after decades of communism and isolation, and its economy has been growing rapidly in recent years.

In contrast to Hong Kong's tradition of foreign influence, artists in the People's Republic of China (PRC) have not been able to freely embrace the influence of Japanese manga. Because of government policy, the PRC's *manhua* artists "are under pressure from the government and publishers or production companies to cut down Japanese influence in order to develop Chinese-style comics and animation. Regardless of official policy to promote Chinese-style works, Japanese influence is getting stronger in Chinese comics and animation."[61] Chinese-version manga are becoming more accessible in the PRC, and artists are not shying away at all from having their work seen as mimicking Japanese manga.

Today, the presence of manga in Asia is everywhere. In areas of heavy Chinese influence, such as Hong Kong, Taiwan, Korea, and maybe Singapore, the concept of "cultural similarity" or "cultural proximity" can explain why manga is more popular there, "but for Southeast Asia it is not a convincing explanatory tool."[62] It is not known how much Chinese and non-Chinese manga readers in Asia look to Japanese manga, as Japanese readers do, for the release of tension because of work and societal stress, or how much they share the "beliefs, values and practices of the culture" that are projected in the manga.[63] Iwabuchi provides the concept of "culturally odorless," as "Japanese media industries seem to think that the suppression of Japanese cultural odor is imperative if they are to make inroads into international markets." He points out that "Japanese popular culture has been deeply influenced by American media. Rather than being dominated by American products and 'colonized' by America, Japan quickly localized these influences by imitating and partly

appropriating the originals."[64] Thus, in general, Japanese cultural producers have believed that the foreign influences of their products in Asia will eventually be integrated into locally produced ones. Cultural products such as manga and *dorama* are "the trans-local agents, breaking cultural boundaries as they bring to the fore the essential human desire for love, fantasy and aspiration, which might be veiled in the urban reality."[65] For most Asians, Japanese manga, like other Japanese cultural products, are the "hybridization of modernity (that has been stereotyped as 'Western') with more traditional attitudes (that are identified as 'Asian')," as well as "the representation of modern living."[66] Therefore, although Asians are in general cautious about Japan's past colonization in the region and the invasion of cultural imperialism, they feel they are "completely 'free' and apparently autonomous agents who make choices without any ideological assumptions in itself as ideology."[67]

THE PRESENCE OF MANGA
IN EUROPE AND NORTH AMERICA

We can easily ascribe the reason for the popularity of manga in Asia to Japanese "cultural similarity" or "cultural proximity" to its Asian neighbors. However, this explanation cannot be applied to manga's penetration of non-Asian cultural markets, such as Europe and North America. For regions with strong Asian communities, like Hawai'i, the West Coast of the United States, and two major Canadian cities, Vancouver and Toronto, manga have been dispersed via Asian immigrants. In that case, the effects of cultural similarity can still apply to those Americans and Canadians with Asian ancestors. The nonsojourner route of how manga spread beyond Japan and Asia into European and North American markets in the 1990s is interesting to study. Japanese media industries by that time had already utilized the "culturally odorless" principle in their manga and animation-related products in Asian markets, toning down the "Japaneseness" of their products. Now they were ready to explore the possibilities in non-Asian markets.

Non-English-speaking European countries, such as France, Germany, Spain, the Netherlands, and Italy, have their own comics cultures and are relatively open to outside cultural influences, compared with the United States. In the mid-1990s, it was not a surprise when the Japanese company Bandai, handling *Sailor Moon* distribution worldwide, became successful with *Sailor Moon* animation and products in most of Europe.[68] On the other hand, *Sailor Moon* was considered "ultimately failed" in the U.S. market because "it never

really registered with the tastes and desires of American girls. In short, Sailor Moon was perceived as being too 'different,'" as Allison observed.[69]

Without a doubt, the American market is less tolerant of "alien" cultural products, and almost all foreign cultural products must be adapted and altered to suit local tastes. Even though the Japanese media industries are well trained in "culturally odorless" awareness, it still required a certain learning curve. As some prominent comics scholars point out, the acceptance of Japanese manga and animation by the American audience has been changing in recent decades. This trend reflects the successful marketing mix strategy employed by the Japanese cultural producers since the 1990s. It was also because the domestic manga market in Japan has been declining since the mid-1990s, making publishers seriously push for international licensing and start to focus on the U.S. market.[70]

The new generation of Japanese publishers now has a more conscious marketing strategy and is eager to build distribution networks with local comics publishers, which makes manga books and magazines more accessible to potential readers. Indeed, international licensing for translation in different languages and enhancement of distribution networks are important factors for the global flow of manga. In France, comics are highly respected as an art form and have a long tradition. With a strong and diverse comics market, there are more than ten established French-version manga distributors. Since the 2000s, manga has received more attention, and many titles have reached France. This market is not restricted to the more popular offerings but also includes some nonmainstream genres in Japan. Independent *mangaka*, such as Taniguchi Jirô, are good examples of this phenomenon. In addition, there is a recent local movement, known as *la nouvelle manga*, started by Frederic Boilet, who combined the French and Japanese comics traditions into his comics.[71]

Germany also has German-version manga distributors in place, including Tokyopop Germany, established in summer 2004, and Carlsen Comics, which introduced *Dragon Ball* to Germany in 1997. The first German manga magazine, *Banzai*, targeted at boys, was published in autumn 2001; the second manga, *Daisuki*, intended for girls, was published in the beginning of 2003.[72] The April 2005 issue of *Banzai* (Figure 3) includes popular stories like *Hunter X Hunter*, *Shaman King*, *Is*, *Hikaru no Go*, and *Naruto*. Other manga-related activities such as fan clubs, fan art, and manga shops are active in Germany. Italy has at least seven major Italian-version manga distributors.[73] Spain has at least two Spanish manga distributors, with current popular titles including *Naruto*, *Saint Seiya*, *Samurai Deeper Kyo*, and *Inu Yasha*, distributed by Glenat.

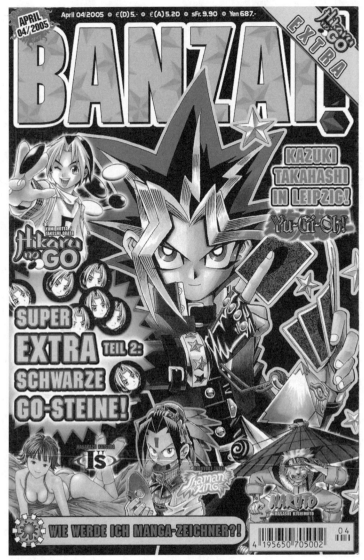

FIGURE 3. *Banzai,* April 2005. Germany.

Even a newly opened-up Eastern European country like Poland has the most current popular manga titles available in Polish through the international licensing system.

In the United States, there is an obvious increase of licensing publishers and titles in response to the demands of the past five years. The English-version manga, known as graphic novels, are now available not only from specialty stores but also in the regular bookstores, typically with a separate shelf and section. The Los Angeles–based publisher Tokyopop released two hundred titles in 2002 and doubled its number of titles in the next year. In November 2002, San Francisco–based VIZ Media, a major American manga

publisher, published the first Japanese manga magazine in English, *Shonen Jump*, in the United States. Like the original Japanese version, the magazine contains serial stories to build reader loyalty. The initial issue, which sold out 250,000 copies instantly, has seven serial stories, including three hit TV animation programs in the United States: *Dragon Ball Z, Yu Gi Oh!* (an alternate romanization of the Japanese title *Yû gi ô*), and *Yu Yu Hakusho* (an alternate romanization of *Yû Yû Hakusho*). The May 2003 issue's distribution was 350,000 copies, and the magazine's distribution is expected to increase to 1 million in three years. The marketing objective of the American version of *Shonen Jump* is to make manga another style of comic known to as many Americans as possible.[74] For female readers, the first American *shôjo* manga, *Shojo Beat*, hit American newsstands in July 2005 (Figure 4). That issue includes six of the hottest *shôjo* manga from Japan: *Absolute Boyfriend, Baby & Me, Crimson Hero, Godchild, Kaze hikaru,* and *Nana*.[75] Both specialized American manga magazines continue the same formula used in Japan; when the serial stories are finished, an independent edition in the format of a "graphic novel" will be published for the fans to own the whole story in one volume (*tankôbon*). This strategy has successfully cultivated manga culture in Japan for decades. American comics publishers are now experiencing booming sales in graphic novel titles, and sales have been increasing rapidly since 2002.[76]

Studies on how Japanese cultural products are consumed by non-Asian audiences beyond Asia are still limited. American scholars such as Susan Napier, Mary Grigsby, Anne Allison, Kaoru Misaka, and Jiwon Ahn have contributed to an introductory understanding of how the American audience circulates and consumes manga and anime. In her summary of Napier's studies on anime, Allison says that American "fans are engaged in a relatively new form of spectatorship, that of the committed fan, whose interaction transcends issues of national boundaries." She found both children from Japan and the United States "say much the same thing; those characters and stories they like the best are the ones in which they can see or feel something of themselves—by identifying, for example, with a lead character—but that also have the power to transport them to another world—a fantasy or dream world."[77] Her observation echoed with Napier's conclusion that the "issue of Japaneseness is not the major attraction of anime for most of the respondents."[78]

In fact, less "Japaneseness" is better for the transnational circulation of manga and anime, which Japanese cultural producers learned from *Sailor Moon*'s failure and *Pokémon*'s triumph. It is the "culturally odorless" that Japanese publishers wanted to see—a "creation of imaginary world(s) that strike fans with a mixture of familiarity as well as fantasy."[79] For the American

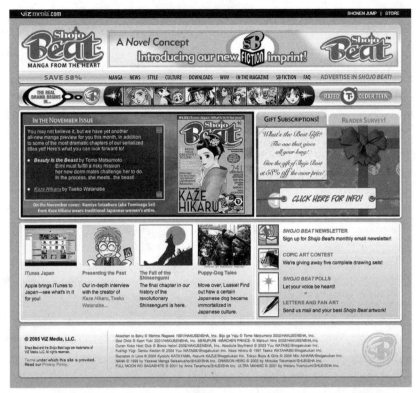

FIGURE 4. *Shojo Beat,* the first American *shôjo manga* magazine, 2005. United States.

audience, they might have found "a mixture of familiarity" in Japanese manga from their imaginations and the collective memories within their own cultural context. Indeed, Japan has a long history of learning from American comics, cartoons, and animation. What matters are the forms of manga and the "structures of common difference"[80] that capture "one's imagination yet also 'makes sense.'"[81] Like manga readers in Asian countries, both European and North American manga and anime audiences "can take on Japanese culture without loving Japan. This becomes clear when one realizes that Japanese presence and influence are structural phenomena. Loving or not loving Japan is a matter of individual response."[82] However, there is still no fixed successful formula on "familiarity and fantasy" that can be guaranteed to work every time. To Japanese cultural producers, the transnational flow of its products is still a hit-and-miss event, although the success rates have been increasing.

CONCLUSION

To continue the inquiry into the cultures of globalization, Ahn seeks inspiration from Appadurai's "hopeful vision of the political future of the imagined

communities of global media reception, which he believes to be capable 'of moving from shared imagination to collective action' and of 'creating the possibility of convergences in translocal social action that would otherwise be hard to imagine.'"[83] Indeed, we can now see the emerging global communities of manga where readers share certain collective action, such as reading the same manga titles at the same time, collecting the same trading cards, mimicking the hottest *mangaka*'s work, and so on. According to Ahn, the medium of anime is "the most personal yet social activity, and the most schizophrenic yet possibly liberating experience in the context of globalization."[84] Manga can certainly fit well into her observation. Also, Allison discovered that American children who play with Japanese cultural products have "a greater openness towards, and awareness of, Japan."[85]

Given the long worldwide domination of American cultural products, the challenge being posed by manga and anime can be seen as a good sign that the world is developing more balanced and tolerant practices. At the moment, Japanese cultural products are the only major alternative choice outside the American cultural hegemony. Although the future of Japanese cultural products seems promising, some critics such as Dal Yong Jin are not too optimistic about the future of Japanese global cultural power. Jin reviews Japan's overall global economic power and concludes:

> Japan's GDP stood in second place with $4.75 trillion in 2001, and Japan was the world's second largest exporter of high-technology products. In the 1998–99 fiscal year, Japan exported $126 billion worth of high-tech products, just behind the US with $206 billion. . . . Japan boasts the second largest cultural consumption market in the world. . . . Japanese cultural products, however, have hardly penetrated worldwide to the same degree as its economic power and the domestic cultural market. Japan's revenue from cultural product exports is relatively low compared to other Western countries and several East Asian countries. . . . The general notion that cultural power is quite comparable to economic power does not seem to be applicable in the case of Japanese cultural influence in the global cultural market.[86]

He points out that "there are several reasons for the weakness of Japanese cultural power—political and economic as well as cultural reasons: Japan's experience of colonialism; the US's cultural dominance; language and limited diasporas; and the paucity of government cultural policy."[87] He sees "there is only a slight possibility that Japanese cultural products would penetrate worldwide within at least 10 years, mainly because the Japanese economy is

still in its worst economic recession. For the Japanese government, cultural product development and export are not a high priority. After the recovery of its economy, Japan's second major priority is preparing for the silver society," and "Japan will be on the edge of the global cultural business in the near future."[88]

However, he does acknowledge, "Japanese cultural products have increased in their influence in international communication over the past decades."[89] Nowadays, it is safe to say, "Japan is a manga superpower. It has replaced the United States as the world's largest exporter of comics and animation."[90] It is still impossible for a lot of other Japanese cultural products, such as *dorama*, pop songs, and movies, to penetrate the American market without severe alteration and localization. The global phenomenon of manga triggered discussion of the possible Japanese challenge to American cultural hegemony. Here I share the view of Harumi Befu, who sees "Japan as another center of globalization," and agree that "by examining Japan's cultural globalization we should be able to uncover processes of globalization that will help to build a general theory of how globalization occurs."[91] We should question, like Befu, "why 'universal theory' or concepts applicable globally must be born out of Western experience" and why not "developed out of Japan's globalizing experience, to be applied to the rest of the world."[92] Befu argues that "'Japanization' is a unique concept with little use in analyzing other cases of globalization, but it is parallel with such concepts as 'Westernization' and 'Americanization,' which have sometimes been equated with globalization. If they represent an aspect of globalization, so does Japanization."[93] He foresees that "sinicization" may be the next global cultural power after "Japanization," as China emerges as an economic superpower. His prediction of the penetration of Chinese cultural products in the global market may take some time to actualize. The role of Japanese manga in counterbalancing Western cultural imperialism and understanding of globalization theory cannot be overstated. More than just an alternative to the hegemonic position of the West, the global flow of manga is the new era of "imagined communities of global media reception.[94] Without question, more studies on this aspect of globalization are needed.

Notes

1. Roger Sabin, *Adult Comics: An Introduction* (New York: Routledge, 1993).
2. Scott McCloud, *Understanding Comics: The Invisible Art* (Minneapolis: Sagebrush Education Resources, 1994).

3. Wendy Siuyi Wong, "Hong Kong Comic Strips and Japanese Manga: A Historical Perspective on the Influence of American and Japanese Comics on Hong Kong Manhua," *Design Discourse*, inaugural preparatory issue (2004): 22–37.

4. Frederik Schodt, *Manga! Manga! The World of Japanese Comics* (Tokyo: Kodansha International, 1986).

5. John Lent, "The Animation Industry and Its Offshore Factories," in *Global Production: Labor in the Making of the "Information Society*," ed. Gerald Sussman and John Lent (Cresskill, NJ: Hampton, 1998), 239–54.

6. Mary Grigsby, "'Sailormoon': 'Manga (Comics)' and 'Anime (Cartoon)' Superheroine Meets Barbie: Global Entertainment Commodity Comes to the United States," *Journal of Popular Culture* 32 (1998): 65.

7. Dal Yong Jin, "Globalization of Japanese Culture: Economic Power vs. Cultural Power, 1989–2002," *Prometheus* 21 (2003): 337.

8. See, for example, Susan Napier, "Panic Sites: The Japanese Imagination of Disaster from Godzilla to Akira," *Journal of Japanese Studies* 19 (1993): 327–51; Grigsby, "Sailormoon"; Jiwon Ahn, "Animated Subjects: On the Circulation of Japanese Animation as Global Cultural Products," *Spectator—The University of Southern California Journal of Film and Television* 22 (2002): 10–22; Anne Allison, "A Challenge to Hollywood? Japanese Character Goods Hit the US," *Japanese Studies* 20 (2000): 67–88; Allison, "Portable Monsters and Commodity Cuteness: Pokemon as Japan's New Global Power," *Postcolonial Studies* 6 (2003): 381–95.

9. Harumi Befu, "Globalization Theory from the Bottom Up: Japan's Contribution," *Japanese Studies* 23 (2003): 19.

10. Koichi Iwabuchi, *Recentering Globalization: Popular Culture and Japanese Transnationalism* (Durham, NC: Duke University Press, 2002), 16.

11. Stuart Hall, "New Cultures for Old," in *A Place in the World? Places, Cultures, and Globalization*, ed. Doreen Massey and Pat Jess (Oxford: Oxford University Press, 1995), 175–214.

12. Anthony Giddens, *The Consequences of Modernity* (Cambridge: Polity, 1990).

13. John Beynon and David Dunkerley, eds., *Globalization: The Reader* (New York: Routledge, 2000), 10.

14. Quoted in Beynon and Dunkerley, *Globalization*, 10.

15. Befu, "Globalization Theory," 4.

16. Beynon and Dunkerley, *Globalization*, 4.

17. Ahn, "Animated Subjects," 12.

18. Befu, "Globalization Theory," 4.

19. Arjun Appadurai, "Disjuncture and Difference in the Global Cultural Economy," in *Global Culture: Nationalism, Globalization, and Modernity*, ed. Mike Featherstone (London: Sage, 1990), 295–310.

20. Befu, "Globalization Theory," 5.

21. Ibid., 11.

22. Ibid., 20.

23. Allison, "Challenge to Hollywood?" 70.

24. Befu, "Globalization Theory," 3.

25. Schodt, *Manga! Manga!* 28.

26. Ibid., 39.

27. Ibid., 46–47.

28. Ibid., 45.

29. Ibid., 51.

30. Grigsby, "Sailormoon," 64.

31. Befu, "Globalization Theory," 12.

32. Grigsby, "Sailormoon," 65.

33. Wikipedia, s.v., "manga," http://en.wikipedia.org/wiki/manga (accessed May 4, 2005).

34. Anne Cooper-Chen, "Sex, Violence, and Hierarchy in Japanese Comics," in *Comics and Ideology*, ed. Matthew McAllister, Edward Sewall, and Ian Gordon (New York: Lang, 2001), 106.

35. Grigsby, "Sailormoon," 62.

36. Ibid.

37. Kaoru Misaka, "The First Japanese Manga Magazine in the United States," *Publishing Research Quarterly* 19, no. 4 (2004): 23–30.

38. Lisa Leung Yuk Ming, "Romancing the Everyday: Hong Kong Women Watching Japanese Dorama," *Japanese Studies* 22 (2002): 66.

39. Misaka, "First Japanese Manga Magazine," 25.

40. Iwabuchi, *Recentering Globalization*, 55, 16.

41. Befu, "Globalization Theory," 7.

42. Leo Ching, "Imaginings in the Empires of the Sun: Japanese Mass Culture in Asia," *boundary 2* 21 (Spring 1994): 205.

43. Befu, "Globalization Theory," 8.

44. Siuyi Wong, "Hong Kong Comic Strips and Japanese Manga."

45. Wendy Siuyi Wong, "Manhua: The Evolution of Hong Kong Cartoons and Comics," *Journal of Popular Culture* 35, no. 4 (2002): 25–47.

46. Wendy Siuyi Wong and Lee Wai-chun, *An Illustrated History of 13-Dot Cartoon: The Work of Lee Wai Chun* (Hong Kong: Ng Hing Kee Book and Newspaper Agency, 2003).

47. Wendy Siuyi Wong, *Hong Kong Comics: A History of Manhua* (New York: Princeton Architectural Press, 2002).

48. Siuyi Wong, "Manhua"; Wai-ming Ng, "Japanese Elements in Hong Kong Comics: History, Art, and Industry," *International Journal of Comic Art* 5 (2003): 184–93.

49. Ng, "Japanese Elements," 189.

50. Ibid., 31.

51. Ching, "Imaginings," 210.

52. Wai-ming Ng, "A Comparative Study of Japanese Comics in Southeast Asia and East Asia," *International Journal of Comic Art* 2 (2000): 45–56.

53. Wai-ming Ng, "The Impact of Japanese Comics and Animation in Asia," *Journal of Japanese Trade and Industry*, July–August 2002, 30–33.

54. Ibid., 31.

55. Seung-mi Han, "Consuming the Modern: Globalization, Things Japanese, and the Politics of Cultural Identity in Korea," in *Globalizing Japan: Ethnography of the Japanese Presence in Asia, Europe, and America*, ed. Harumi Befu and Sylvie Guichard-Auguis (London: Routledge, 2001), 205.

56. Ibid., 197.

57. Lent, "Animation Industry."

58. Ng, "Comparative Study of Japanese Comics," 55.

59. Ibid.

60. Ibid.

61. Ng, "Impact of Japanese Comics and Animation," 31.

62. Befu, "Globalization Theory," 8.

63. Grigsby, "Sailormoon," 62.

64. Iwabuchi, *Recentering Globalization*, 94, 95.

65. Leung, "Romancing the Everyday," 73.

66. Ibid.

67. Ching, "Imaginings," 218.

68. Allison, "Challenge to Hollywood?"

69. Ibid., 78.

70 Misaka, "First Japanese Manga Magazine."

71. Wikipedia, *Franco-Belgian Comics*, http://en.wikipedia.org/wiki/Franco-Belgian_comics (accessed May 4, 2005).

72. Carlsen Verlag GmbH, *Carlsen Comics und Manga Portal*, http://www.carlsencomics.de/cc (accessed May 4, 2005).

73. Wikipedia, list of manga distributors, http://en.wikipedia.org/wiki/List_of_manga_distributors (accessed May 4, 2005).

74. Misaka, "First Japanese Manga Magazine."

75. VIZ media, news, press room, 2005 Press Releases, http://www.viz.com/news/newsroom/2005/02_shojobeat.php (accessed May 4, 2005).

76. Misaka, "First Japanese Manga Magazine."

77. Allison, "Challenge to Hollywood?" 84, 85.

78. Ibid., 85.

79. Ibid.

80. See Allison, "Challenge to Hollywood?" 85.

81. Ibid.

82. Befu, "Globalization Theory," 9.

83. Ahn, "Animated Subjects," 20.

84. Ibid.

85. Allison, "Challenge to Hollywood?" 87.

86. Jin, "Globalization of Japanese Culture," 336–37.

87. Ibid., 339.

88. Ibid., 342, 343.

89. Ibid.

90. Ng, "Impact of Japanese Comics and Animation," 30.

91. Befu, "Globalization Theory," 19.

92. Ibid., 20.

93. Ibid.

94. Ahn, "Animated Subjects," 20.

SUSAN NAPIER

● ● ●

The World of Anime Fandom in America

What I think the various fan subcultures do is provide a space for community. They allow people of diverse background and experience to form bonds around a common interest. They let people know that they are not alone in their likes and their passions. Fan subcultures provide the sense of belonging that used to be common among most American communities and families prior to the 1980s. Today kids are raised by day-cares and public schools. Parents are too busy working and building careers to devote significant time for family building and family life. Kids are just one of the many entries on the day planner. . . . Fan subcultures help to provide a space for community where people can come and be accepted for who they are. In a society as fragmented as America has become, fan subcultures can provide an oasis for the weary soul.

—Thirty-eight-year-old utility company tech support worker and member of the Miyazaki Mailing List

Miyazaki's film is about social interaction, historical context, responsibility, and coordination within a society. Towards the end, the story is about a certain consensus—a group coming together to agree and rally around a certain set of values, experiences, goals.

—Mike A, member of the Miyazaki Mailing List

Q. What's the fascination of Hayao Miyazaki?

A. Even though Hayao Miyazaki is so successful, he seems to prefer to work hard and earnestly with people rather than distancing himself from people with walls of money and bureaucracy. He shares his wonderful stories of hope and courage with his audiences. He earnestly cares for the environment and helps young and old people share the enthusiasm for the real and imaginary parts of nature as large as a forest full of Catbuses and as small as a tree under which one Totoro stands in the rain.

—Michael Johnson, owner, Miyazaki Mailing List

In his landmark book *Bowling Alone: The Collapse and Revival of American Community* (2000), the political scientist Robert D. Putnam charts the increasing decline of what he terms "social capital" in contemporary American society. Chronicling the fading of civic groups, union organizations, church socials, and sports clubs, Putnam paints a picture of American society (and, by inference, other postindustrial societies) growing ever more disconnected and fragmented. He makes a strong case for how these trends lead to alienation and passivity, including offering a melancholy vision of 2010 where future Americans will spend their leisure time "sitting passively alone in front of glowing screens."[1] While he does acknowledge the potential role of the Internet as a facilitator of communication—quoting the sociologist Barry Wellman, who maintains that "computer-supported social networks sustain strong, intermediate and weak ties that provide information and social support in both specialized and broadly based relationships"—Putnam also worries that overuse of the Internet will lead to "single strand" cybercommunities and "Cyberbalkanization" in which individuals speak only to a circle of "like-minded intimates."[2]

This essay examines one such "single strand," the Miyazaki Mailing List, an international group of fans devoted to the works of Miyazaki Hayao, who is Japan's, and arguably the world's, greatest living animator. I discuss this group not only in terms of its status as an Internet community but also in relation to anime fan culture overall, one of the world's fastest-growing subcultures, and in relation to the question of Japanese "soft power," what Douglas McGray defines as "the art of transmitting certain kinds of mass culture."[3]

I have chosen the Miyazaki Mailing List (MML) for a variety of reasons. First, it is one of the oldest ongoing groups of Internet anime fans, begun at Brown University by Steven Feldman in 1991 and now being run out of Seattle, Washington, by Michael Johnson. Second, its members are a particularly articulate, engaged, and varied group, encompassing a wide range of ages and

a fair number of female participants and representing numerous countries, from Australia to Belarussia. Finally, and most important, the objects of their interest—Miyazaki, his partner Takahata Isao, and everything related to their animation studio, Studio Ghibli—comprise an impressively rich range of materials from which to draw discussion. These materials include approximately a dozen or so feature films, including the American Academy Award–winning *Spirited Away;* several television serials; and a new and immensely popular museum, the Ghibli Museum, in Tokyo. Most important of all are the less tangible aspects of what I call MiyazakiWorld, an overt ideological agenda encompassing environmentalism, humanism, and what might be called "Ghibli (or Miyazaki) family values," and a concern with

> MIYAZAKI MAILING LIST MEMBERS ARE A PARTICULARLY ARTICULATE, ENGAGED, AND VARIED GROUP, ENCOMPASSING A WIDE RANGE OF AGES AND A FAIR NUMBER OF FEMALE PARTICIPANTS AND REPRESENTING NUMEROUS COUNTRIES, FROM AUSTRALIA TO BELARUSSIA.

presenting works of a psychological and moral complexity unusual not only in animation but in most cinematic offerings today.

These latter concerns are particularly interesting in relation to the global transmission of cultural values. In "Japan's Soft Power and Public Diplomacy," Kondô Seiichi, a Japanese diplomat, argues that "the Japanese do not find it easy to project their ideas in the form of values. Japan's ideas are better conveyed by being translated into cultural products through the mediation of feelings than by being translated into logical strings of words through the mediation of language." In fact, Studio Ghibli films contain much articulate and intelligent dialogue and some memorable phrases (perhaps the most famous one is the exhortation "To see with eyes unclouded" from Miyazaki's 2001 film *Princess Mononoke*). It is probably true, however, that it is initially the extraordinary beauty of the artwork (Miyazaki still does his original drawings by hand), the sumptuous music, and the gripping stories which first attract the viewer. Once attracted to MiyazakiWorld, however, the viewer is often drawn further in by the subtle yet rich emotional palette (giving rise to a far more complex range of emotions than most Hollywood films), the complex characterizations of the protagonists (who are frequently female), and the willingness to deal with powerful themes, from environmental and social collapse (*Future Boy Conan, Nausicaa, Princess Mononoke, Spirited Away, Grave of Fireflies, Ponpoko*) to heartfelt coming-of-age tales (*Only Yesterday, Totoro, Kiki's Delivery Service, Spirited Away*). Even in simpler, more child-oriented

fantasies, the studio never fails to evoke what the *New Yorker* in a profile on Miyazaki calls "a sense of wonder."[4]

From the viewpoint of fan studies, there is one other particularly intriguing aspect of MML members: how in many ways they differ, not necessarily from most anime fans, but from critical and conventional expectations of the kinds of people who comprise fandom. Reviewing the literature on fandom, one is struck by how much space and energy is spent on what Lisa Lewis calls the "fan pathology," the sense that "fans operate from a position of cultural marginality."[5] As Lewis says of how fandom is presented in cinema, "Fandom is overwhelmingly associated with adolescence or childhood, that is, with a state of arrested development or youth-oriented nostalgia. Furthermore, the fan impulse is presented as feminine."[6]

MML fans on the whole do not fit this stereotype, not only because many of them are older, male, and well educated but because their online discussions reveal them to be notably mature and thoughtful people whose attraction to Studio Ghibli products seems less a case of "arrested development" or "youth-oriented nostalgia" than a considered response to the complexities and problems of the contemporary world. In fact, on finishing a rough draft of this essay and reviewing the literally hundreds of pages of discussion I had examined, I became aware that I was drawing something more than a portrait of a particular fan community (and indeed some members of the MML resist even being called "fans"). Instead, the members' words and thoughts came to constitute a portrait of our contemporary millennium society, at least as seen by thoughtful people hoping to do the right thing in the face of a world that seems increasingly captured by consumer capitalism, the desires of the powerful (and the concomitant alienation of the powerless), and frightening environmental problems. The fact that these are all problems explored in detail in the works of both Miyazaki and Takahata is of course why people are drawn to Studio Ghibli's output.

As such, I cannot argue that the MML members are exactly "typical" fans, but in a sense they are typical in their atypicality, at least among anime fans. In my research into anime fandom over the last five years, I have found it increasingly difficult to draw a portrait of any one "typical" anime fan, especially as anime has become more and more pervasive in American culture. What was once, even five to ten years ago, a rather small and tight-knit community—largely male, frequently Asian American, and most often found on either of the coasts or else in big cities—has blossomed into a remarkably diverse group of fans, both demographically and geographically (including enthusiastic aficionados in the heartland states), and with a remarkable span

of political and religious beliefs (from conservative evangelical Christians to a self-described "Atheist/Shintoist anarchist").

This essay attempts to profile the MML and to show how the mailing list itself has become a form of virtual community. This community might be called a "sacred space," to use Roger Aden's term from *Popular Stories and Promised Lands*, a site for fans not only to discuss their specific interests in Ghibli products but also to deal with larger philosophical, intellectual, and political issues arising from the Ghibli oeuvre and Miyazaki's pronouncements, and, occasionally, emotional and personal ones as well. Just as fan conventions provide fellowship and solidarity by offering a means for fans to interact in a liminoid space outside their "regular" lives, the MML provides a liminoid virtual space where fans can enjoy the fellowship of others who appreciate visiting MiyazakiWorld, a world that is frequently seen by the members as more ethically, aesthetically, and intellectually appealing than the world around them.

Aden describes these virtual visits on the part of fans in general to their favorite fictional sites (such as J. R. R. Tolkien's Middle-earth or George Lucas's *Star Wars* fantasies) as "symbolic pilgrimages" in which "individuals ritualistically revisit powerful spaces that are symbolically envisioned through the interaction of story and individual imagination."[7] Indeed, the MML members sometimes jocularly refer to making "pilgrimages" to the Ghibli Museum, but it is their imaginative interaction with the sacred space of Studio Ghibli films that particularly concerns me here. By interacting with others who share their interest in appreciating and interpreting MiyazakiWorld, the members participate in actively constructing what Lawrence Grossberg calls "mattering maps" or, more simply, what Mihaly Csikszentmihalyi terms the "making of meaning," which, among other things, includes "learning to unite with other entities around us without losing our hard-won individuality."[8]

While MiyazakiWorld is not as all-encompassing as the realm of *Star Wars*, which Will Brooker describes as "for some people . . . the most important cultural text of our lives. . . . a culture: a sprawling detailed mythos they [the fans] can pick through with their eyes closed"; it also can be said to represent a detailed alternative reality that, as Joli Jensen says of fan culture in general, can present "an implicit critique of modern life."[9] It should be emphasized, however, that Studio Ghibli's works, while often fantasies, are far from simply escapist. In comparison with the *Star Wars* offerings, they are often much more downbeat, eschewing the grand heroics and triumphant endings crucial to Lucas's universe (and to much of Hollywood cinema in general).

In comparison with most anime fans, the MML community has a particu-

> ANIME, MANGA, VIDEO GAMES, AND, TO A LESSER EXTENT, JAPANESE POPULAR MUSIC ARE ALL EXAMPLES OF THIS NEW POWER THAT, FOR A VARIETY OF REASONS, HAS BEGUN TO WIELD AN ENORMOUS INFLUENCE IN THE WORLD'S CONSUMPTION OF POPULAR CULTURE.

larly intimate quality to it. A 1995 article in *Wired* magazine mentions how "anime otaku [a word roughly equivalent to *nerd* or *geek*] [were] one of the more computer networked subcultures around."[10] This is certainly the case for the MML, a large percentage of whom are involved with computers and technology. As Brooker says of *Star Wars* fandom in relation to the Internet, "The Internet enabled many fans to take their first step into a larger world."[11] Even among dedicated fans, however, the MML stands out, not only for its longevity, high volume of traffic, and international makeup but for the generally high and remarkably civil level of discussion.[12] While the members may not be physically in a room interacting around a scratchy tenth-generation videotape, as the original anime fans were forced to do back in the early 1980s, the sense of immediacy, the enthusiasm and depth of the discussion, and the palpable feeling of fellowship on the part of many of the fans suggest that in some ways they still are gathered together. In fact, a number of MML members actively shy away from conventions and more typical fan activities, citing their dislike for the commercialism and frivolity of these engagements.

Of course, even in the MML, commercial aspects of MiyazakiWorld also play a more important role than perhaps they used to. Postings from fans include many references to finding Miyazaki collectibles, such as the various dolls in the shape of Totoro, a cuddly spirit-animal who is one of Miyazaki's most felicitous creations; key chains with figures from *Spirited Away;* and vintage posters from *Nausicaa*, Miyazaki's first major film and one for whom the actual net part of MML is named (Nausicaa.net). Furthermore, virtually all the members are concerned with getting the latest and best DVD releases from Studio Ghibli (several threads concern the question of when a release will appear on the market and how attainable it will be).

On the whole, however, commercial and marketing aspects are small in comparison with other types of discussion, which can range from a dispute over the frame counts of a particular scene to intense interactions over the philosophy, imagery, and overall message of a particular film. In fact, rather than calling them "consumers," a term often used in the literature of fandom,[13] I would prefer to call the Miyazaki fans "appreciators and interpreters," since so much of their discussion is on an emotional and intellectual level rather than a material one.

This brings me to a basic question about fandom: what do the fans get out of their fan behavior? In the case of the MML, the more specific question would be: what is it about the imagined community that I call MiyazakiWorld that attracts such a variety of people? This question is particularly intriguing for two reasons: the first is that, like other fantasies, such as those of George Lucas and perhaps Gene Roddenberry, the creator of *Star Trek* (or, on the literary front, Tolkien), MiyazakiWorld offers a definite worldview—even, to some extent, an ideology—and we can assume that, to some degree or another, the fans are responding to it.

Much work has been done on the notion of fandom as a form of compensation for the disappointment of the quotidian world. This notion is not always presented negatively. Aden speaks of fandom as a form of escapism that is "purposeful play" in which we symbolically move away from the material world to an imaginative world that is in many ways a *response* to the material.[14] As the MML's list owner, Michael Johnson, says of anime in relation to U.S. animation, "American cartoons browbeat the viewer with pithy platitudes and morals-of-the-story. Japanese cartoons engage the viewer and let or force hir [*sic*] to watch actively and arrive at hir [*sic*] own conclusions." What is intriguing here, and this brings up the second reason why Miyazaki-World is so interesting, is that Americans, Europeans, South Americans, and Asians feel comfortable in engaging in an imaginative world created by a Japanese director and targeted, initially at least, at an exclusively Japanese audience. In an age of increasing fragmentation and growing nationalism, what is it about Miyazaki's message that has struck a chord with so many people around the globe?

Part of the answer to the second question is undoubtedly related to what McGray in a famous article in *Foreign Affairs* refers to as Japan's new "soft power," by which he means essentially cultural and economic rather than military strength. Anime, manga, video games, and, to a lesser extent, Japanese popular music are all examples of this new power that, for a variety of reasons,[15] has begun to wield an enormous influence in the world's consumption of popular culture. Certainly, Miyazaki's popularity is linked with the general rise of interest in anime over the last decade. To explain the depth, breadth, and longevity of Miyazaki's popularity, however, is a more complicated task involving both his fans and the nature of MiyazakiWorld.

First, Miyazaki is hugely popular in his own country. Many of his films, including his three most recent, have broken box office records, appealing across generation and gender. The richness of his imagination, along with his essentially wholesome vision, makes his works perfect for family viewing.

It is, therefore, not surprising that Miyazaki's films should be appreciated internationally to some degree. What is interesting, however, is that, at least among the members of the MML, their favorite works of his are often the most "Japanese" of his oeuvre, specifically *My Neighbor Totoro*, *Princess Mononoke*, and *Spirited Away*.

Koichi Iwabuchi has suggested that one reason for the proliferation of Japanese popular culture is that it has been rendered "culturally odorless" through such products as Hello Kitty or Pikachu, whose origins cannot easily be traced back to Japan.[16] To a certain extent, many of Miyazaki's early works do take place in relatively "odor free" cultural contexts, in some cases postapocalyptic future worlds (*Future Boy Conan*, *Nausicaa*) or Europeanesque fantasy worlds (*Kiki's Delivery Service*, *Porco Rosso*), but this can certainly not be said of the three mentioned above, all of which deal with Japanese traditions, the Japanese landscape, and (in *Princess Mononoke*'s case) Japanese history. It should also be noted that several members of the MML list also particularly love the films of Miyazaki's partner Takahata Isao, such as *Grave of Fireflies*, *Only Yesterday*, and *My Neighbor Yamada*, all of which are clearly specific to Japanese culture.

We need to go beyond the "odorless" explanation to understand the appeal of MiyazakiWorld. One way to do this is to examine the makeup of the MML. I have developed the following portrait based partly on information provided by Michael Johnson, partly on my own years as a "lurker" on the list and a detailed examination of discussions that took place from January to April of 2003 (not coincidentally, the period when *Spirited Away* won the Academy Award and the war in Iraq began), and partly on the responses I received to a questionnaire mailed out by my research assistant Michael Roemer in February and March of 2005. I have been using this questionnaire over the last five years to survey anime fans throughout the country; for the MML members, I added a few specific questions. Although the list membership technically comprises over a thousand, only a relatively small percentage of members are active on the list. In any given week, perhaps ten members are actively vocal, with another ten chiming in more occasionally. We received sixty-four questionnaires from the list, and, although self-selected, they seemed to be a reasonably representative sample.

To anyone with knowledge of fandom in general or anime fandom in particular, one of the most surprising aspects of the MML is the relatively older age of the members. Twenty-six percent of the fans were between forty and forty-nine years old, 23 percent were between thirty and thirty-nine, and 14 percent were between fifty and sixty. The second largest group was between

twenty and twenty-nine, however, comprising 25 percent of the respondents; the remaining 10 percent were between sixteen and eighteen. While this result may partially be explained by the possibility that young people are less likely to fill out questionnaires, the age demographic accorded well with the members' own perceptions of themselves as an older, more mature group than the average anime online mailing list.

The older age of the fans may also be responsible for the fact that our respondents were 75 percent male. Although, in the early days of fandom, anime fans tended to be overwhelmingly male,[17] this has changed enormously over the last several years. From observation at conventions plus exposure to other anime fan groups, I would say that female fans are getting close to 50 percent of fandom, at least among younger fans.

Background as to race and nationality was a little more complicated to ascertain, since non-American list subscribers sometimes didn't identify themselves ethnically. Of the American members, thirty identified themselves as white, four were Asian American, one was African American, and one was Hispanic American. The other twenty-three (40 percent of the total respondents) were not Americans but, judging by their names and countries represented (five from Australia, four from Canada, two from Sweden, two from France, and one each from Mexico, Ireland, Spain, Belarussia, Norway, and one "BrazilianDutch"), it seems reasonably safe to conclude these members were largely Caucasian (although there was one self-identified Chinese Australian), which was another slight surprise, since, early on at least, many members of anime clubs were Asian American, and, at least on the West Coast, Asian Americans still constitute a fairly high percentage.

Also intriguing was the relatively high education level of the respondents. Forty-five percent (25) had received a BA; 20 percent (11), an MA; and 5 percent (4), a PhD. This statistic also accords well with the members' perceptions of themselves as

> ALTHOUGH TECHNOLOGY WORKERS AND ARTISTS ARE PROBABLY STILL SOMEWHAT OVERREPRESENTED IN COMPARISON WITH THE GENERAL POPULATION, THE INCREASING PERVASIVENESS OF ANIME AND THE INCREASE IN FEMALE FANS HAVE LED TO A MUCH BROADER REPRESENTATION OF OCCUPATIONS AND INTERESTS.

"better educated" and "more informed" than the average anime fan group. As one respondent, a fifty-year-old female artist, put it: "I think they are more intelligent and polite. They can argue without rancor for the most part. They cite scholarly examples, they are loyal to the genre. They're a lot more fun and

cheerful than most grownups!" Another member called the list "an island of sanity and fascinating discussion in wild anarchy that was the world of the usenet and nowadays, message boards."

Initially less surprising was the most represented occupation: 33 percent were in computers and engineering (and 39 percent had majored in computer sciences or engineering in college). This statistic accords well with profiles of science fiction fans, many of whom have a technology background. But perhaps more interesting was the variety of other occupations represented. These included a video producer, two stay-at-home mothers, a number of artists (or students majoring in art), an attorney, a janitor/translator, a retired helicopter pilot, and a worker for the IRS. The diverse occupations and interests seem much in accord with the face of anime fandom in general. Although technology workers and artists are probably still somewhat overrepresented in comparison with the general population, the increasing pervasiveness of anime and the increase in female fans have led to a much broader representation of occupations and interests.

But I also suspect that the wide variety of occupations may have something to do with Miyazaki's appeal that can be seen as both broad and specific. The superior aesthetic quality of his and Takahata's films undoubtedly attracts artists and designers. The relatively wholesome nature of Studio Ghibli's stories, as well as the emphasis on children, clearly attracts a family audience (several respondents mentioned that they were parents who enjoyed watching the films with their children, although, as one person wryly remarked, "My children are grown now and I can't use them to hide behind"). Finally, Miyazaki and his partner's concerns about the state of the world, the environment, and the future resonate with thoughtful people regardless of occupation.

The stereotype of fans in general has often been that they tend to be on the edges of society, resolutely nonmainstream. In my interviews with midwestern fans, however, I have been interested to see a relatively high (although by no means the majority) percentage of conservative fans, including fundamentalist Christians. My questionnaire for the MML included a section on religious beliefs, and here, too, the results were somewhat surprising. Although 54 percent could be described as liberal to left wing (twenty-seven Democrats and three socialists), 9 percent were center-to-Republican, one person was a libertarian, and 22 percent (often the younger respondents) described themselves as having no politics at all. In terms of religion, results varied widely as well. Twenty-one percent were practicing Christians (including two members of the Church of Jesus Christ of Latter-day Saints), almost

20 percent were atheists (including one "atheist with some Ghiblist influences"), and 20 percent said they had no religion or were agnostic, while 28 percent said that they had some religious feelings but did not belong to an organized faith (a number of these mentioned an interest in Buddhism or Shintoism), and one respondent was a practicing Jew. Interestingly, several respondents reported having been raised in a strong religious faith (generally Jewish or Catholic) but had lost faith over the years.

The respondents were more in agreement when it came to the question of how they saw their beliefs in relation to American mainstream values and what they thought were the good and bad aspects of American culture. Fully 68 percent saw themselves as outside American mainstream values, while 26 percent saw their values as mainstream, and 6 percent (presumably foreign) said they didn't know. The answers to the questions about values were often intense and elaborate. The most often-cited negative aspects of America were consumerism and materialism, followed closely by various permutations of "arrogant" or "bullying." (It should be noted that, while the non-American residents were often critical of the United States, the harshest critiques were from American respondents, including one who was "ashamed of being American.")

Often these responses were some of the longest in the questionnaire. One person summed up the negatives as "anti-intellectual bias, the problems of bigotry and sexism, the loss of community, the loss of the value of the family, and tendency to think of those we disagree with as the enemy." A fifty-two-year-old bureaucrat/attorney cited "familial breakdown, lack of community ties, lack of genuinely humane values, arrogance, selfishness," while a forty-eight-year-old bookseller (also male), mentioned "selfishness, short-sightedness, smugness, religiosity, hostility to the imagination." One respondent, a forty-one-year-old female novelist, described the worst aspects of American society as our "attempting to enforce a system of privilege that finds poverty and human suffering acceptable, so long as the results are that they live a wealthy life that supports and leaves unchallenged their sense of righteousness in holding their privileged position." Another woman, a forty-seven-year-old software engineer, brought up "rampant anti-intellectualism, an incredible over-regard for money and material things, a lack of respect for or interest in other cultures—parochial and arrogant." A conservative respondent, a twenty-three-year-old Mormon tech support worker, mentioned that Americans are "lazy and self-centered."

The above statements are illuminating in light of Aden's theory about how the "imaginative world [of the fans] is a *response* to the material" (i.e.,

outside world). In contrast to an America (and also, as some of the members readily admit, much of the industrialized world) that is materialistic, bullying, narrow, self-centered, and in danger of losing all human connection, MiyazakiWorld, as shown not only in the films of Studio Ghibli but in interviews with Miyazaki and Takahata, is seen as expansive, open to new possibilities—be they ideas or new creations—family oriented, and, to use one of the members' favorite words, "humanistic." Where America and other industrialized societies are perceived as bent on destroying (the environment, the human soul, the family and community), MiyazakiWorld is seen to be about cherishing (traditions, family ties, natural beauty). This cherishing is never pursued simplistically or sentimentally, however. Many of Studio Ghibli's films have at least a metaphorical apocalyptic subtext, but the final message is always one of at least the *possibility* of hope and redemption on the part of ordinary human beings.

One consistently sees in both the questionnaire responses and in conversational threads a feeling that Miyazaki and Takahata value down-to-earth human values as opposed to technological or commercial ones. Thus one respondent commented on an early Miyazaki film, *Laputa: Castle in the Sky*, that "the film delves deep into the flaws of what high technology may bring to mankind in today's world." A long-running thread from around the time of *Spirited Away*'s opening in America concerned whether Miyazaki was attacking American consumer values or those of the Japanese when he showed the heroine's parents transforming into literal pigs of consumption. After much discussion, one member summed up what seemed to be the general consensus, that "concern about gluttony in *Spirited Away* was about consumption and greed. . . . Any supposedly civilized culture would rue losing its traditions and watching their people become ignorant of the things that should be cherished."

The comments on the positive elements of American culture and society were more uniform but also in line with a worldview that we might expect from fans of Miyazaki. Both American and non-Americans found U.S. society to be optimistic, energetic, and (somewhat surprisingly, given the many criticisms of "bullying") altruistic. A French PhD student wrote approvingly that Americans "don't seem to shy away when it comes to faith." Many commented on the tolerance and diversity of American society, although a significant minority saw Americans as "not open to accepting different cultures," as a twenty-six-year-old Chinese American responded.

This minority view may tie into an aspect of fandom that is often noted among scholars of fan theory: the feeling, on the part of some fans at least,

of being an outsider from a mainstream society that they see as bullying or rejecting on a personal level. Thus a thirty-six-year-old Spanish journalist described himself as "a music fan, cinema fan, anime fan" but went on to insist that "I will never kick in the face another person because they cannot love anime films, and soccer fanatics can use these kind of attitudes." Many other members seemed comfortable in describing themselves in terms that could be considered pejorative. One respondent summed himself up as a "nerd, otaku, trekkie, goth witch, net junkie," and a number of others simply answered "nerd" or "geek."

On the other hand, another member described himself more prosaically as a "married nearly-middle-aged father of two who lives in the suburbs and works in the movie business." Many others, however, saw themselves in positive terms and in ways that seemed particularly appropriate for Miyazaki fans. These included "a pragmatic romantic," a "bit of a dreamer," "someone who likes unique and unusual things," "a little more culturally aware than most," and "a science/technical major (recent UC Berkeley graduate) with a foreign background, a rationalist/technical technological mindset, and a strong attraction toward the humanist message e.g. Hayao Miyazaki, Isao Takahata, Yoshitoshi Abe's Haibane Renmei series, and from literature, Charles Dickens, Ursula Leguin, Phillip [sic] Pullman." This last self-description, which notes an interest in other "world building" artists (*Haibane Renmei* is an anime series that takes place in a fantasy world that people go to after death), again suggests that these highly colored fantasy realms are both compensations for and critiques of a less-satisfying real world.

At the same time it should be emphasized that members of the list are not simply escaping a disappointing reality. Many are extremely aware of the problems of the real world and see in Miyazaki's environmental and humanist message a call for action. One respondent described himself as "a research scientist who values peace, justice and wanting to make this a better world." Many (a majority) of respondents mentioned the environment as being the most significant issue of the day. As a female thirty-year-old Swedish student writes: "I think the environment question is the most important one for our survival as a species and is likely to remain so for the next hundred years at least." Miyazaki and Takahata's emphasis on environmentalism is seen as something that could change the world. A twenty-two-year-old Norwegian student suggests that "Miyazaki Sama [*sama* is a highly honorific form of address] puts messages in his story that I believe is something the world should listen to."

Overall, however, the MML does not see MiyazakiWorld ideology as being simplistic. A major thread of discussion throughout the lifetime of the list

has been Miyazaki's approach to good and evil. Many consider one of Studio Ghibli's major offerings to society to be precisely the lack of a clear-cut vision of good versus evil. One twenty-two-year-old French student compared Studio Ghibli with American animation, saying that "the difference . . . may come from Miyazaki (and Ghibli) producing movies that display real imaginative universes and do not need to show violence eroticism and manicheanism to please the audience. . . . thus, people who like Ghibli may have a more reflective approach to animation." When a member of the list mentioned that "one of the most refreshing aspects of this movie *Spirited Away* is that Good and Evil are not delineated with simple and obvious cues that we often get from pop culture," several members leapt in to say that one attraction of Studio Ghibli offerings was the fact that they refuse to paint characters as purely good or purely evil. As one respondent said in another context, "Miyazaki's films contain too much ambiguity towards concepts of good and evil to be understood as recognizably didactic."

> WHILE MIYAZAKI AND TAKAHATA REMAIN INTENSELY JAPANESE IN THEIR STORYTELLING, THEIR THEMES AND IMAGES ARE UNIVERSAL ENOUGH TO TOUCH PEOPLE AROUND THE GLOBE. IN THIS THEY RESEMBLE OTHER CREATORS WHO HAVE ATTRACTED GREAT FANDOM, FROM RODDENBERRY AND LUCAS TO J. K. ROWLING OF THE *HARRY POTTER SERIES.*

Clearly, it is Miyazaki's and Takahata's willingness to entertain a worldview that acknowledges the ambiguity of life but at the same time exists within a moral framework that is one of MiyazakiWorld's major attractions. For example, David, in answer to another member's claim that "Christian themes abound in *Spirited Away*," asserted that "these themes are much older than Christianity itself" and cited "baptism/redemption/resurrection/temptation/healing/love" as being "all over the place in every religion and culture, popular stories, myths, legends, etc. What makes SA universal is precisely the fact that despite its very 'localized' settings and characters (everything is clearly by/for Japanese) it manages to tap into universal themes where everyone will recognize themselves."

Not all the discussion is on such an abstract level. One of the most passionate and emotionally resonant threads that I have seen occurred against the background of the beginning of the Iraq war, a war described by one member as "the elephant in the doorway throw[ing] a shadow on everything."

A young male student wrote in to talk about his feelings of shame and powerlessness at being unable to do anything about the war beyond organiz-

ing teach-ins on his campus. In an affecting passage he wrote, "Considering how Miyazaki's words are amongst those who have brought me to tears even before the bombs started falling, I wish Miyazaki could see these words."

The response from the MML was swift and heartfelt. Laying aside their own personal politics, many of them framed their words of encouragement in terms of what they thought Miyazaki could offer. One respondent wrote, "One of [Miyazaki]'s talents as a director and a writer is in his ability to make us examine our own views of the way things are, the way they should be and what we should do towards those ends. In *Princess Mononoke* the forest-god is killed despite the best efforts of the main characters. The death of the forest god resulted in a devastating catastrophe that looked as though it would undo all that was done in the course of the film. Yet his death . . . was merely the beginning of a new era, with the promise of learning from the past and forging a new world. . . . The heroes don't always have to be the ones saving the world, they can be the ones that live every day doing for others what they would hope for themselves. Sacrifice isn't always glorious, but it is often necessary, and that is another Miyazaki lesson. :)."

Another member responded that "the issue of power and powerlessness is an interesting one and perhaps there is even a Miyazaki connection to be made here. . . . we all have the ability to clean up some little corner of our world in some small way. We all have the ability to love. Mei and Kiki and Chihiro are not heroes because they have whole-heartedly devoted themselves to some giant CAUSE . . . but because they do their best to be decent to those around them."

Akito, a member from Japan, recommended "a book of human's liberation" that Miyazaki had cited as an essential influence on him. Jonathan, who described himself as proud to be an American and an Italian, told him to "think about *Nausicaa* for a moment: Their valley was one of the few safe places on earth. They were surrounded by hostile nations. The toxic jungle was creeping up on them. Yet did they fear? No!"

Sharon, a long-time member, went back to Miyazaki's own dialogue, telling the student that "in Princess Mononoke even with death happening all around them, even though San thought the world was over, Ashitaka corrected her that it was not over because they were still alive. Live like Ashitaka and see with eyes unclouded. He didn't regret being human, he didn't regret being cursed. Don't regret being who you are."

The responses of these fans reveal how the appeal of MiyazakiWorld becomes far more than enjoyable entertainment. While Miyazaki and Takahata remain intensely Japanese in their storytelling, their themes and images are

universal enough to touch people around the globe. In this they resemble other creators who have attracted great fandom, from Roddenberry and Lucas to J. K. Rowling of the *Harry Potter* series. Unlike these examples, however, Miyazaki and Takahata revel in ambiguity and what might be considered a non-Western worldview in which good does not always triumph over evil and the only appropriate response is to continue to look at the world "with eyes unclouded."

The fact that fans worldwide find this viewpoint compelling suggests as much about the contemporary period as it does about Miyazaki. Aden has suggested that fans sometimes appreciate fandom because it allows them to "break the rules" or at least offers an opportunity to see "how the rules limit us."[18] In the case of Miyazaki fans, particularly his Western ones, it is possible to speculate that Miyazaki's subtle and complex worldview allows them to "break the rules" of Western culture, to go beyond the Hollywood happy endings, or the need for a defined good and evil, and embrace the world in all its ambiguity, heartbreak, and hope. By creating and interacting in their own "sacred space" on the Internet, the fans are able to produce a form of community that, in its emotional supportiveness, intellectual atmosphere, and passionate zeal to improve the world, ironically echoes the larger "sacred space" of MiyazakiWorld itself.

..

Notes

1. Roger D. Putnam, *Bowling Alone: The Collapse and Revival of American Community* (New York: Simon and Schuster, 2000), 11.

2. Ibid., 171, 178.

3. Douglas McGray, "Japan's Gross National Cool," *Foreign Policy*, May–June 2002, 48.

4. Margaret Talbot, "The Auteur of Anime," *New Yorker*, January 17, 2005, 66.

5. Henry Jenkins, *Textual Poachers* (New York: Routledge, 1992), 26.

6. Lisa Lewis, "Fan Stories on Film," in *The Adoring Audience: Fan Culture and Popular Media*, ed. Lisa Lewis (London: Routledge, 1992), 158.

7. Roger C. Aden, *Popular Stories and Promised Lands: Fan Cultures and Symbolic Pilgrimages* (Tuscaloosa: University of Alabama Press, 1999), 69. Aden defines *liminoid* in relation to the more well-known *liminal* as a phrase "used to describe the increasingly optional ritual experiences found in industrial and postindustrial societies" (82).

8. Mihaly Csikszentmihalyi, *Flow: The Psychology of Optimal Experience* (New York: Harper and Row, 1990), 214–40.

9. Will Brooker, *Using the Force: Creativity, Community, and Star Wars Fans* (New York: Continuum, 2002), xii; Joli Jenson, "Fandom as Pathology: The Consequences of Characterization," in Lewis, *Adoring Audience*, 9.

10. Andrew Leonard, "Heads Up Mickey," *Wired*, April 1995.

11. Brooker, *Using the Force*, xiv.

12. Credit for the "civilized" quality of the discussion must go, at least in some part, to Michael Johnson, the list owner. As was clear from his conversation with me (January 2005) and in the rules that he set up to govern the list, Michael is extremely conscious of wanting to promote a free-flowing, friendly, and polite environment. As he says, "I don't tolerate irresponsible behavior on the list." Michael's examples of undesirable behavior include everything from poor spelling and grammar to flaming, spamming, spoofing, or trolling. It is clear from the other list members' comments that the framework is much appreciated. Over half the respondents when asked to compare the MML with other anime fan groups mentioned the civilized atmosphere. Or as one member, a Canadian stay-at-home mother, put it, "MML members seem invariably polite and respectful." On the other hand, consistent with what Matt Hills sees as the "performance" aspect of Internet fandom (*Fan Cultures* [London: Routledge, 1992], 179), some members report being occasionally turned off by the more "pretentious" (i.e., literary, philosophical, or psychoanalytic discussions) that certain members of the group enjoy engaging in.

13. On the notion of fans as "specialist consumers" or even "ideal" consumers, see Hills, *Fan Cultures*, 29.

14. Aden, *Popular Stories and Promised Lands*, 6.

15. Space does not permit me to go into this discussion at great length, but some of the reasons behind the ascension of Japanese soft power include (1) globalization and the rise of technology engendering the need for entertainment to fill the newly available electronic media, (2) the fact that Japanese popular culture could be seen by Westerners as an exotic alternative to American popular culture and the perception by Asians that Japanese cultural products were closer in spirit to Asian culture in general, and (3) the relatively high quality of Japanese animation and manga in terms of aesthetics and story content in comparison not only with American cartoons but with Hollywood films in general. For further treatment of this question see Susan J. Napier, *Anime from Akira to Princess Mononoke: Experiencing Contemporary Japanese Animation* (New York: Palgrave, 2001), 239–56.

16. Koichi Iwabuchi, "How 'Japanese' Is *Pokemon*?" in *Pikachu's Global Adventure*, ed. Joseph Tobin (Durham, NC: Duke University Press, 2004), 7.

17. In her 1994 study of West Coast anime fans, Annalee Newitz concluded that about 86 percent of the members of California university clubs were male ("Anime Otaku: Japanese Animation Fans outside Japan," *Bad Subjects*, no. 13, April 1994, 161). In my study of anime fans, I found between 76 and 85 percent (depending on what group I was surveying) were male (Napier, *Anime from Akira to Princess Mononoke*, 247).

18. Aden, *Popular Stories and Promised Lands*, 9.

THERESA WINGE

● ● ●

Costuming the Imagination: Origins of Anime and Manga Cosplay

All over the world, cosplay fans gather at conventions and parties to share their appreciation of and affection for anime and manga (McCarthy 1993; Napier 2001; Poitras 2001). These fans, who also refer to themselves as *otaku*,[1] wear detailed makeup and elaborate costumes modeled after their favorite anime, manga, and related video game characters (Poitras 2001; Richie 2003). Cosplayers spend immeasurable monies and hours constructing or purchasing costumes, learning signature poses and dialogue, and performing at conventions and parties, as they transform themselves from "real world" identities into chosen (fictional) characters. This is the essence of cosplay, or *kosupure* (Aoyama and Cahill 2003; Richie 2003).

The term *cosplay* combines *costume* and *play* (or *role-play*). Cosplay also refers to the activities, such as masquerades, karaoke, and posing for pictures with other otaku, that are associated with dressing and acting like anime, manga, and video game characters (Macias and Machiyama 2004; Poitras 2001). While the term *cosplay* encompasses various types of costumed role-playing, such as science fiction, fantasy, horror, mythology, fetish, and so forth, this chapter focuses only on Japanese and North American cosplay related to anime, manga, and video games.

My objective here is to provide the reader with an understanding of anime and manga cosplay, cosplayers, and their social structures. First, I explore the origin stories of cosplay to establish contributions from both Japan and North America. Next, I discuss the distinguishing characteristics of Japanese and North American cosplay to determine the similarities and differences between the two cultural settings. I contextualize four cosplay elements: (1) anime and manga cosplayers, (2) social settings, (3) character and role-playing, and (4) dress,[2] which includes clothing or costumes, makeup, wigs or hairstyles, jewelry, and accessories. Last, I offer an introduction to the anime and manga cosplay social structures (i.e., interactions, environments, and experiences) in order to provide the reader with an awareness of the complexities and dynamics of the cosplay world.

ORIGIN STORIES OF COSPLAY

The few sources that discuss the origins of cosplay are primarily found on Web sites, online publications, and weblogs. Constructed and maintained by anime and manga fans, these sources communicate information about anime and manga (most with a personal bias). Therefore, it is not surprising that the specific origins of anime and manga cosplay are highly debated topics among anime and manga *otaku* (Hlozek 2004). One side speculates that cosplay began in North America, during the 1960s, when people dressed as and role-played their favorite science fiction and fantasy characters, such as Spock from *Star Trek* and Robin from *Batman* (Bruno 2002a). This type of costumed role-playing (not yet called cosplay) spanned a variety of genres and may have inspired Japanese anime and manga fans to dress as their favorite characters. On the other side of the debate are those who speculate that cosplay was imported from Japan, coming to North America with the formations of anime and manga fan clubs (Bruno 2002a; Ledoux and Ranney 1997).

The origin story that appears to have the most evidence to support it actually blends the Japanese and North American contributions. In 1984 Takahashi Nobuyuki (known in the United States as "Nov Takahashi"), founder of and writer for Studio Hard, an anime publishing company, attended World-Con, a science fiction convention, in Los Angeles (Bruno 2002a; Hlozek 2004). He was impressed with the costumed science fiction and fantasy fans whom he saw, especially those competing in the masquerade (Bruno 2002a). Consequently, when he returned to Japan and wrote about his experiences at the convention, he focused on the costumed fans and the masquerade. Moreover,

Takahashi encouraged his Japanese readers to incorporate costumes into their anime and manga conventions (Bruno 2002a).

Takahashi was unable to use the word *masquerade* because this word translated into Japanese means "an aristocratic costume party," which is drastically different from the costume competitions seen at conventions (Bruno 2002a). Instead, he created the phrase *costume play*, which was eventually shortened to *kosupure*, or cosplay (Bruno 2002a). As a result, Takahashi added two new words to the subculture and pop culture lexicon: *cosplay* and *cosplayer*.

> AN ANIME OR MANGA COSPLAYER CAN BE ALMOST ANYONE WHO EXPRESSES HIS OR HER FANDOM AND PASSION FOR A CHARACTER BY DRESSING AND ACTING SIMILARLY TO THAT CHARACTER.

In 1980, at the San Diego, California, Comic-Con, several fans dressed as anime and manga characters in the masquerade (Ledoux and Ranney 1997). It was not long before anime and manga *otaku* were donning cosplay dress to Japanese conventions (Bruno 2002a). During the 1980s, there was a growing demand for Japanese anime (and manga) imports (Drazen 2003), and an increasing number of *otaku* attended North American science fiction and fantasy conventions (Hlozek 2004; Poitras 2001). As a result, these types of North American conventions began to include anime- and manga-focused activities, such as panels, guest speakers, anime video rooms, and masquerades (i.e., organized costumed performances). In time, *otaku* organized conventions expressly for fans of anime, manga, and related media. Overall, North American and Japanese cosplay have many commonalities, such as a dedicated fan base and the use of costumes. They also have distinguishing characteristics, such as variations within masquerade competitions, appropriate locations for wearing cosplay dress, and cosplay markets.

CONTEXT OF COSPLAY

The context of anime and manga cosplay is a combination of the presence of basic components and related interactions between those components. The four basic components are anime and manga cosplayer, social settings, (fictional) character and role-playing, and dress (e.g., hair, costume, makeup, and accessories, including weapons). Furthermore, these components facilitate complex interactions between people (e.g., cosplayers, spectators, masquerade judges, etc.), environments (e.g., personal, private, public, and virtual), and fantasy (e.g., imagination, fictional characters, etc.). The following four

sections are an overview of the basic components and complex interactions that create the context of cosplay.

Anime and Manga Cosplayer

Anime and manga cosplayers may be any age, gender, and ethnicity. They have varied educational backgrounds, occupations, disposable incomes, and resources. Essentially, an anime or manga cosplayer can be almost anyone who expresses his or her fandom and passion for a character by dressing and acting similarly to that character. Since the exact cosplay demographics are currently unknown, this is an area in need of further research.

A cosplayer researches and studies an already existing anime or manga character with a keen eye for detail, in order to create a cosplay character. The interpretation usually takes shape by reading or watching the chosen character within its given medium (i.e., manga, anime, or video game). The level of research and study is ultimately guided by the cosplayer's objectives (e.g., masquerade participation, socializing, etc.).

Cosplayers exist at various places along a cosplay continuum, which is based on their level of commitment. At one end are cosplayers content with dressing (e.g., wig, makeup, and costume) as their chosen character and attending conventions and events for socializing and having fun. At the other end are those cosplayers obsessed with a given character, re-creating that character with meticulous attention to detail and performing as that character as often as time and money allow. Between these extremes, there are cosplayers who research, study, and practice their characters and participate in cosplay events, such as masquerade and karaoke. Regardless of his or her place on the cosplay continuum, each cosplayer has an extraordinary level of dedication and commitment to the depiction of a chosen character, based on individual objectives that may include, but are not limited to, the following criteria: humor, accurate depiction, and casual participation.

Social Settings

Cosplay is primarily a social activity associated with various activities and conventions, where cosplayers gather to share their passions for anime and manga characters (Aoyama and Cahill 2003). The cosplay social settings may include, but are not limited to, the following: masquerades (i.e., character-based costume or performance competitions), photograph sessions, themed parties, karaoke, club meetings, and conventions. While the social settings for cosplay may vary greatly, conventions are often the primary space where large numbers of cosplayers gather, socialize, and perform.

Conventions are held at all times of the year, around the world, for fans of science fiction, fantasy, horror, anime, manga, and the like to share their interests and passions with like-minded individuals (Poitras 2001). The dedicated cosplayer may attend conventions on the average of one a month. As a result, many science fiction and fantasy conventions include a variety of activities, such as discussion panels, skits, film screenings, and masquerades specifically aimed at anime and manga *otaku*.

The convention activity that attracts the most interest from *otaku*, especially cosplayers, is the masquerade. Cosplayers compete in masquerades by posing or acting in skits relevant to their characters. At science fiction and fantasy conventions, anime and manga cosplayers compete against various genres of cosplayers. Despite slight variations between each masquerade, participants are generally judged on three main criteria: accuracy of the costume's appearance to the actual character; construction and details of the cosplay dress; and entertainment value of the skit and/or accuracy to the character.

Spectators play an important role in the social settings of cosplay. In fact, it could be argued that cosplay events, especially the masquerade, would be pointless if it were not for the spectators, even if they are composed of friends and other cosplayers. Spectators use applause, verbal cues, and laughter to encourage cosplayers to perform and interact.

Furthermore, the cosplay social settings exist beyond the stage of a masquerade. Cosplayers interact with each other, often role-playing their chosen characters while participating in hallway conversations, karaoke parties, and online chat rooms. These social settings take any shape or form desired by cosplayers. Often the settings extend beyond tangible spaces, into virtual spaces, such as Web sites, weblogs, and online journals (Poitras 2001). Cosplayers utilize Web sites to register and plan activities for conventions, as well as to promote and communicate about their fandom for anime and manga cosplay. They also use weblogs and online journals to confide in others, express opinions, and argue about the finer details of cosplay. Additionally, traditional print media, such as the magazines *Animerica* and *Newtype*, feature several pages per issue of cosplay photographs from recent conventions.

Character and Role-playing

An *otaku* chooses an anime, manga, or video game character to cosplay based on personal criteria. A resourceful cosplayer has few limitations in character choice, beyond his or her imagination. The pool of characters to choose from is vast, including characters from anime feature movies and serials, manga single image and series, and related video games. Some cosplay characters are

featured in all three media, such as *Dragon Ball Z* and *Fist of the North Star*. In fact, there are so many characters to choose from that they have been informally classified into subgenres.

Among these subgenres are mecha, cyborg, furry, and Lolita. Mechas (short for "mechanicals") are giant robot characters, often piloted or operated by humans (Napier 2001). Some examples of mecha characters are Gundam Wing Zero (*Gundam Wing* television series, 1995–96) and EVA units (*Neon Genesis Evangelion* television series, 1995–96). Cyborgs are part machine and part human, such as Major Kusanagi Motoko (*Ghost in the Shell*, 1995) and the Knight Sabers (*Bubblegum Crisis*, 1987–91). Furries are characters that have "fur," and the cosplay costumes for them are usually created from faux fur. Some examples are Totoro, a giant, gray catlike creature (*My Neighbor Totoro*, 1988) and Ryo-ohki

> A LOLITA CHARACTER ATTEMPTS TO CONVEY A *KAWAII* IMAGE, WHICH IS YOUNG, CHILDLIKE, AND CUTE. THE CHARACTER MAY DON A BABY-DOLL DRESS TRIMMED WITH LAYERS OF LACE, KNEESOCKS, AND SOMETIMES CARRY A STUFFED ANIMAL OR A PARASOL.

(an alternate romanization of Ryôôki), a cute, furry cabbit (cat-rabbit) (*Tenchi muyô ryôôki* series, 2000, known by the alternate romanization *Tenchi Muyô Ryo-ohki* in the United States). A Lolita character attempts to convey a *kawaii* image, which is young, childlike, and cute (Aoyama and Cahill 2003; Schodt 1996). The character may don a baby-doll dress trimmed with layers of lace, kneesocks, and sometimes carry a stuffed animal or a parasol. A common anime reference for the Lolita character is the Wonder Kids' *Lolita Anime I: Yuki no kurenai keshô* and *Shôjo bara kei* (1984); however, this character has an earlier reference in Vladimir Nabokov's *Lolita* (1955). Both of these references for the Lolita character define and emphasize its sexualized imagery; however, not all Lolita cosplayers intend to communicate that image.

Certain anime and manga characters are more popular than others, which results in trends within cosplay. The popularity of anime and manga characters is most evident by the numerous observations of cosplayers dressed as the same character at a convention. For example, in the September 2003 issue of *Newtype*, there is a photograph of multiple depictions of Inuyasha (i.e., a half dog-demon and half human male, with silver or black hair and dog ears, wearing a red kimono–style garment with a sword) at the Anime Expo convention in Anaheim, California. Another example is the frequent sightings of Lolita characters at anime and manga conventions. The Lolita genre is so popular that there are numerous Web sites, costume shops, and publications dedicated to it.

FIGURE 1. Gothic Lolita, 2005, Cedar Falls, Iowa. Costume designed and constructed by Erin Hamburg. Photograph by the author.
FIGURE 2 (RIGHT). Rainbow Brite Lolita, 2005, Cedar Falls, Iowa. Costume designed and constructed by Erin Hamburg. Photograph by the author.

An additional cosplay character type is known as "crossplay" (Hlozek 2004). Crossplay is where a cosplayer employs gender reversal (i.e., a female who dresses as a male character or vice versa). Depending on the cosplayer's objectives, the crossplay may portray the opposite gender with accuracy or it may have humorous intentions within its display (e.g., dress, role-playing, etc.). For example, at CONvergence 2004 (a science fiction and fantasy convention held in Bloomington, Minnesota) there were several males dressed as each of the Sailor Moon Scouts (teenage heroines who assist Sailor Moon in her endeavors to save the world from evil), and a young woman was dressed as Tuxedo Mask (the young hero who often assists Sailor Moon and the Scouts in their quest). In this example, crossplay was utilized for humorous effect and social levity. These Scouts had deep voices and visible chest and leg hair, along with five o'clock shadows, and this Tuxedo Mask had a high-pitched voice and curvaceous silhouette. Moreover, the group was continuously making gender-related puns and jokes aimed at further identifying and establishing their gender role reversals.

Crossplay among cosplayers is not unusual, considering the many gender reversals, confusions, and ambiguities within anime and manga. For example, Oscar Francois de Jarjayes, from the *Rose of Versailles* (1972–74), was raised as a male; however, she is actually a female. The story centers on Oscar's ambiguity and duality. Another example is the Three Lights from *Sailor Moon*.

In the manga, the Three Lights females pose as human males in a rock band, but in the anime they transform from male pop stars into female sailor *senshi*—Sailor Starlights.

The cosplayer relies on dress and role-playing to display a given character. Cosplay role-playing is the ability to dress, walk, talk, and act similar to the chosen anime or manga character in order to portray a character in a desired fashion. Role-playing is an essential skill for a cosplayer, regardless if he or she is accurate to a character, creating a parody, or just having fun. Role-playing a character is greatly aided by cosplay dress.

Dress

Cosplay dress includes all body modifications and supplements, such as hair, makeup, costume, and accessories, including wands, staffs, and swords. This dress is often referred to as a "costume"; however, cosplay dress goes well beyond a simple costume. Cosplay dress may be the most important tool the cosplayer has to nonverbally communicate his or her chosen character and character traits. This dress functions as character identification and provides a basis for role-playing and interactions with other cosplayers. Cosplay dress also enables cosplayers to move from their actual identities to their chosen cosplay characters, and sometimes back again.

For example, "Sailor Bubba," a bearded male cosplayer (and crossplayer) dressed as Sailor Moon (i.e., manga and anime teenage, female heroine with magical powers), speaks with a deep voice, walks with a gait natural to a 6-foot-tall, 250-pound man, and has dark black chest hair poking out of the top of his schoolgirl uniform. Still, anime and manga cosplayers recognize the dress and accept his change in personality (and gender) when a man in a tuxedo and top hat, the costume for Tuxedo Mask, enters the room. Suddenly it is a cosplay version of Sailor Moon and Tuxedo Mask having a conversation about saving the world (with not-so-subtle references to a room party as the scene for the next battle with a villain called "Mr. Jagermeister").[3]

Each cosplayer determines the accuracy of his or her cosplay dress and character portrayal. For some cosplayers the costume must be an exact replica of that worn by an anime character, which is no easy feat, given the unrealistic aspects of animated costumes. These cosplayers take extreme care to get every physical detail correct, such as adding padding for muscles, dyeing hair to bright, unnatural colors, and wearing platform shoes. They often spend significant amounts of money and time to create the perfect replica of their character's dress (Aoyama and Cahill 2003). Still other cosplayers are content with the bare minimum of dress that communicates their chosen character.

Typically, cosplay dress is either self-created or purchased, or a combination of the two. Wigs, cosmetics, and jewelry are often purchased because these items are difficult to make or may be less expensive than construction from raw materials. The constructed portions of cosplay dress usually include the clothing, but may also include foam swords and (faux) gem-encrusted wands. Some portions of cosplay dress that usually are a combination of purchased and constructed often need to be modified, such as shoes and accessories.

> IN JAPAN, COSPLAYERS ARE NOT WELCOME IN CERTAIN AREAS BEYOND THE CONVENTION, AND SOME CONVENTIONS REQUEST THAT COSPLAYERS NOT WEAR THEIR DRESS OUTSIDE THE CONVENTION.

JAPANESE AND NORTH AMERICAN COSPLAY

A distinguishing characteristic between Japanese and North American cosplay is the way in which cosplayers perform in competition. In North America, during masquerades cosplayers wear their dress onstage and perform skits, often humorous but not necessarily an exact mime of their chosen character. In Japan, cosplayers also wear their dress on stage during competitions; however, they usually give only a static display, such as striking their character's signature pose or reciting the motto of their chosen character (Bruno 2002b).

Another distinguishing characteristic is where cosplay dress is worn. In North America, cosplayers wear their dress in nearly any setting (Bruno 2002b). For example, fully costumed/dressed cosplayers may leave a convention and eat at a nearby restaurant. In Japan, cosplayers are not welcome in certain areas beyond the convention, and some conventions request that cosplayers not wear their dress outside the convention (Bruno 2002b). Both Japanese and North American cosplayers gather with friends for cosplay at conventions and private events.

Since Japanese culture values community above the individual, cosplayers exist as a subculture, outside the acceptable norms of the dominant culture, where acts of discrimination have occurred by the dominant culture (Aoyama and Cahill 2003; Richie 2003). As a result, Japanese cosplayers have a negative reputation as individualists within some areas of Japanese culture (Bruno 2002b; Richie 2003). In Japan, unlike North America, there are areas, such as the Akihabara and Harajuku districts in Tokyo, strictly designated for cosplay costume shops, cafés, and restaurants (Prideaux 2001). Although Japanese

cosplayers may venture into areas not designated for cosplayers, such activity is discouraged because of the negative reputation of cosplayers, and to protect young female cosplayers from unwanted attention (Richie 2003).

A final distinguishing characteristic between Japanese and North American cosplay is the available goods and markets for cosplayers. In Japan, there are districts where anime and manga cosplayers are the target market for consumable goods, such as cosplay costumes, accessories, and publications. North American anime and manga conventions feature dealers who sell a limited selection of cosplay items (e.g., magazines, DVDs, action figures, etc.). Within science fiction and fantasy conventions, anime and manga cosplayers compete with other fandoms, such as *Star Trek* and *Star Wars* fans, for a portion of the market. Outside the convention setting, anime and manga cosplayers must resort to catalogs and online shops for cosplay items, such as wigs, costumes, and makeup.

During the latter portions of the twentieth century, Japan and North America exchanged pop and subcultural ideas (Napier 2001; Poitras 2001). This is evident in Hollywood movies influenced by Japanese anime (e.g., *The Matrix* was influenced by *Ghost in the Shell*). An example of how Japanese anime and manga story lines have been influenced by North American subcultural activities is the *Record of Lodoss War* stories, which were influenced by *Dungeons and Dragons* role-playing games (Poitras 2001). This Japanese and North American exchange has extended to anime and manga and is apparent within the sources of inspiration for anime and manga cosplay.

SOCIAL STRUCTURES OF COSPLAY

Cosplay is a highly social activity that occurs in specific environments, such as anime and manga conventions, karaoke events, and club meetings (Aoyama and Cahill 2003). Therefore it provides significant social benefits for cosplayers, who are often labeled "geeks" (i.e., socially and culturally inferior individuals) by the dominant culture. As a result, the anime and manga cosplay subculture provides cosplayers with "social structures" (Merton 1968). This social structure is composed of social interactions, environments, and experiences.

Most of the social interactions take place via the cosplay character(s). The character provides a (protective) identity for the cosplayer, which may allow for more confident and open interactions. Moreover, cosplay dress and environment(s) permit the cosplayer to role-play the character he or she is dressed as and engage in such social activities within a "safe" and "support-

ive" social structure. In this way the cosplay social structure is established, developed, and maintained.

The environments and spaces created for and by cosplay provide cosplayers with a variety of spaces for social interactions. Some of these environments include, but are not limited to, the following: an intimate space (dress), a private space (solitary rehearsals and research), a public space (interactions with other cosplayers, both in person and virtual), and a performance space (ranging from small parties to masquerades). Cosplay merges fantasy and reality into "carnivalesque" environments and spaces, where individuals have permission to be someone or something other than themselves (Bakhtin 1968; Napier 2001; Richie 2003). It is here that cosplay characters, distinctive from their anime and manga origins, emerge and interact with other cosplay characters. This further suggests the malleable identities of the cosplayers created in these environments where people are "not themselves" but instead are fictional anime and manga characters.

Cosplay social interactions and environments provide cosplayers with unique and significant experiences. These experiences include making new friends to claiming a moment in the limelight. Moreover, cosplay experiences appear to have real benefits for the cosplayers, because of the continued participation and growing interest in cosplay and related activities. The variety of cosplay experiences contributes to the social structure of cosplay.

In summary, cosplay inspired by anime, manga, and related video games expands not only the anime and manga art form but also the interactions of two global cultures—Japan and North America. The interactions begin with origin stories of cosplay and continue as cosplayers share fandom from both Japan and North America (via surfing the Internet and attending conventions). The impact of these interactions is visually evident at conventions where the context of cosplay, which includes social settings, cosplayers, characters and role-playing, and dress, is on display. Moreover, these interactions contribute to, build on, and develop into the social structures of cosplay, providing cosplayers with unique interactions, environments, and experiences.

..

Notes

1. In North America, *otaku* refers to an anime and manga (hardcore) fan or enthusiast. However, in Japan, *otaku* is an honorific and is used to address a good friend or the like (Schodt 1996).

2. In this chapter, I utilize J. B. Eicher's (2002) definition of *dress*—any body modification or supplement, which includes makeup, wigs, shoes, clothing, jewelry, and piercings—when I refer to cosplay dress.

3. Jagermeister is an herbal (anise) liqueur that is popular in North America.

References

Aoyama, T., and J. Cahill. 2003. *Cosplay Girls: Japan's Live Animation Heroines*. Tokyo: DH.

Bakhtin, M. 1968. *Rabelais and His World*. Trans. H. Iswolsky. Cambridge, MA: MIT.

Bruno, M. 2002a. "Cosplay: The Illegitimate Child of SF Masquerades." *Glitz and Glitter Newsletter*, Millennium Costume Guild. October. http://millenniumcg.tripod.com/glitzglitter/1002articles.html (accessed March 20, 2005).

——— 2002b. "Costuming a World Apart: Cosplay in America and Japan." *Glitz and Glitter Newsletter*, Millennium Costume Guild. October. http://millenniumcg.tripod.com/glitzglitter/1002articles.html (accessed March 20, 2005).

Drazen, P. 2003. *Anime Explosion! The What? Why? & Wow! of Japanese Animation*. Berkeley, CA: Stone Bridge.

Eicher, J. B. 2000. "Dress," in *Routledge International Encyclopedia of Women: Global Women's Issues and Knowledge,* ed. C. Kramarae and D. Spender. London: Routledge.

Hlozek, R. 2004. *Cosplay: The New Main Attraction*. May. http://www.jivemagazine.com/article.php?pid=1953 (accessed March 20, 2005).

Ledoux, T., and D. Ranney. 1997. *The Complete Anime Guide*, 2nd ed. Issaquah, WA: Tiger Mountain.

Macias, P., and Machiyama, T. 2004. *Cruising the Anime City: An Otaku Guide to Neo Tokyo*. Berkeley, CA: Stone Bridge.

McCarthy, H. 1993. *Anime! A Beginner's Guide to Japanese Animation*. London: Titan Books.

Merton, R. K. 1968. *Social Theory and Social Structure*. New York: Free Press.

Napier, S. 2001. *Anime from Akira to Princess Mononoke: Experiencing Contemporary Japanese Animation*. New York: Palgrave.

Poitras, G. 2001. *Anime Essentials: Everything a Fan Needs to Know*. Berkeley, CA: Stone Bridge.

Prideaux, E. 2001. "Japanese Trend Sees Teens Dress in Costume." *CNews*. Associated Press (Tokyo), February 7.

Richie, D. 2003. *Image Factory: Fads and Fashions in Japan*. London: Reaktion Books.

Schodt, F. L. 1996. *Dreamland Japan: Writings on Modern Manga*. Berkeley, CA: Stone Bridge.

MARK J. P. WOLF

Assessing Interactivity in Video Game Design

With the increasing amount of scholarship on video games, one might ask how analyses of video games differ (or should differ) from analyses of other media forms. Lacking an organized tradition of game analysis, critics are likely to draw on other disciplines in media studies to make their assessments. Although such methods may be productive to some degree, media-specific biases will likely also be present. Just as early film theory drew on psychology and literary theory, resulting in analyses centered on character and narrative, video game analyses are in danger of becoming dominated by film theory and other theories currently in use (and in vogue) in media studies. It is useful, then, to consider what areas of overlap do exist between analyses of video games and other media as well as what areas of video game analysis are new and unique.

At present, two excellent essays suggest methodologies for analyzing video games. Lars Konzack (2002) divides game analysis into seven different areas: hardware, program code, functionality, gameplay, meaning, referentiality, and socioculture. Espen Aarseth (2003) looks at different game research perspectives and other typologies that broadly address game analysis. In this chapter, I focus much more narrowly on a single area of video game design:

that aspect of user participation commonly referred to as interactivity, in which the player's choices determine the course of the game. As a subject of analysis, this alone could produce enough material for an entire book, so I can begin to sketch out only some of the issues to be considered in this area.

CONTEXT AND CONSTRAINTS

Like most aspects of video games (and media in general), interactivity depends on when and where the game appeared. To place a video game into its historical context, one should take into account the hardware, software, and cultural constraints determining what was possible, or at least typical, at the time when the game was made. Such constraints are often intertwined; for example, a whole generation of home games similar to *PONG* (1972) was produced using the AY-3-8500 chip, which had four video outputs (one for each player, the ball, and the playing field). A different color could have been used for each output, but economic constraints because of competitive pricing kept most systems from using color. As David Winter (2005) explains on his Web site,

> This chip has an interesting feature: the use of several video outputs. . . . This gives the possibility of using a black and white video signal, as well as using one color for each output. Thus, it could be possible for example to draw the playing field in white with a green background, one player in blue and the other player in red. However, the electronic components allowing this were not cheap at this time, and due to the number of manufacturers of PONG systems, the price was a very important feature that could either result in a success, or a failure. This is why most of the systems equipped with the AY-3-8500 used black and white display, sometimes with grayscales (gray background, white playing field and scores, etc.).

Providing historical context can also help one to appreciate the limitations and difficulties faced by programmers, and the programming feats necessary to accomplish what today appear to be simple games. The Atari VCS 2600, for example, which appeared in 1977, had only 128 bytes of RAM (and no disk storage), a graphics clock that ran at roughly 1.2 MHz, and plenty of other programming limitations that had to be overcome with a limited amount of code, since early cartridges had only 2 or 4 kilobytes of ROM. (These and other programming constraints are described in detail on pages

54–56 of Wolf 2003.) For any system, knowing the amounts of memory used (whether RAM, ROM, or disk space), the processor speed, the kinds of input and output devices available, and the software capabilities (including the functions possible within the coding language used) helps show whether a game was making maximum use of the resources available and how it compared with other games of its day, so that its value can be appreciated. The cultural constraints of a particular time period, which are much harder to define and measure, determine what was considered acceptable to players at the time and are also an influence on game design. For example, the controls of the first arcade game, *Computer Space* (1971), were considered confusing at the time, whereas today they would be intuitively understood by today's players who are familiar with a broad range of game conventions established over the last three decades. In this sense, the design of a game's interactivity can rely on player expectations and experience, sometimes influencing (or limiting) the design even more than technological constraints.

INTERACTIVE DESIGN CONSIDERATIONS

Once the game analysis is framed in a historical context, one can begin looking at the structure of the interactivity itself. To compare interactive structures, we can first consider mapping how a player's decisions are related. The smallest unit of interactivity is the choice, which consists of two or more options from which the player chooses. Choices are made in time, which gives us a two-dimensional grid of interactivity that can be drawn for any game. First, in the horizontal direction, we have the number of simultaneous (parallel) options that constitute the choice that a player is confronted with at any given moment. Second, in the vertical direction, we have the number of sequential (serial) choices made by a player over time until the end of the game. Obviously, the player's choices will alter the options and choices available later in the game in both of these dimensions, and in most cases a game's complete grid would be enormous. Even board games like chess and checkers have huge trees of moves that have never been mapped in their entirety. But one does not need to map the entire tree of a game to get an overall sense of how its interactivity is structured.

A game's replayability often depends on its having a good number of options and choices, in at least one of the two dimensions mentioned above. Simple action games, for example, have large grids along the vertical dimension, while the number of options offered simultaneously may be small (at

any given moment in *Space Invaders* [1978], the player has only four options: move left, move right, fire, or wait [do nothing]). Puzzle games, on the other hand, may have a wide variety of options open at any given moment, but need only a few dozen correct choices to be made for the game to be won.

The speed at which options must be considered and choices made is also crucial to examining a game's interactive structure. Action games have a near-continuous stream of choices for the player, who may be in constant motion battling opponents while avoiding danger. Although the serial choices are made one after another so quickly that they appear to be continuous, they are in fact still made in discrete fashion because of the nature of the computer clock that regulates the game (and the number of choices made per second can depend on clock speed). In the genre of interactive movies, a player's choices are often spread out in time with video clips, sometimes as long as several minutes each, coming in between the moments during which a player must make a choice. Some games that involve navigation or the solving of puzzles may accept a fast series of choices to be input (e.g., a player moving through a location quickly) but at the same time not require quick decisions. The time pressure under which a player must play determines whether the player's choices are made as a result of reflex action or reflection (at least during the initial playing; in fast-action games, more reflection can occur on subsequent playing once the player knows what to expect).

Games requiring both reflection and reflex action may also increase their replayability, since players will need more playing experience and a fore-knowledge of what they are facing in order to make the right choices at a fast enough rate. Even in some early arcade games and Atari 2600 games (like Activision's *Stampede* [1981], which features a horizontally scrolling track of cattle to be roped), a player always encountered the same scenarios or patterns of opponents, so that it was possible to memorize where they would appear next and anticipate their presence; indeed, at higher speeds, this would be the only way to keep from getting defeated. Whether the game conditions include a series of events or character positions that differ from one playing to the next should also be considered in the analysis of a game, since that affects how prior knowledge of a game changes gameplay.

> IN SOME EARLY ARCADE GAMES A PLAYER ALWAYS ENCOUNTERED THE SAME SCENARIOS OR PATTERNS OF OPPONENTS, SO THAT IT WAS POSSIBLE TO MEMORIZE WHERE THEY WOULD APPEAR NEXT AND ANTICIPATE THEIR PRESENCE; INDEED, AT HIGHER SPEEDS, THIS WOULD BE THE ONLY WAY TO KEEP FROM GETTING DEFEATED.

Prior knowledge, gained from multiple playings, may also be crucial if some of the choices available to the player at a given time are hidden. The options that are included in a choice can occur anywhere on a spectrum from apparent or obvious ones to options completely unknown to the player. Certain navigational paths, such as roadways, indicate an obvious course of action, while hidden doorways, chambers, or objects may require thorough searches to be found, or even an elaborate sequence of actions that the player is unlikely to perform inadvertently and must learn from the game or some outside source. Such inside knowledge encourages players by rewarding them for their efforts and invites them to search further. The intentionally hidden Easter eggs and unintentional bugs found in games also may add to a gaming experience as a player finds them and learns to exploit them (or becomes frustrated by them). Such hidden features add to a game's replayability, as well as the playing of a game not to win or complete an objective but rather to explore the game's world and how the game functions.

The above discussion of the timing given for the making of choices suggests that several layers of choices can be present at different scales. Some fast-action reflex decisions, like those in a fight or shoot-out, are made instantly and are determined by other, more large-scale choices that the player considers and executes over a longer period of time, such as where to go or what strategy to use. Some choices affecting all aspects of a game may even be made before the gameplay itself begins (e.g., in some adventure games, the choosing of an avatar and that avatar's various attributes). Depending on the speed of the action, a player may need to engage in short-term and long-term decision making almost simultaneously, as the player switches back and forth between different objectives (e.g., fending off attackers, finding certain treasures or supplies, and managing health levels), all while navigating through locations and gaining information that may be needed for larger decisions which determine the game's narrative direction.

> IN MANY FAST-ACTION GAMES, THE MAJORITY OF CHOICES ARE MADE TO KEEP THE PLAYER-CHARACTER FROM GETTING KILLED, INCLUDING THE DODGING OF PROJECTILES AND THE EVADING OR KILLING OF ATTACKERS AND OPPONENTS.

This leads to the next important area in analyzing the player's choices: what are the consequences of the choices made? Some choices may be trivial and have little or no consequences (e.g., wandering in a well-known area where there are no dangers, without any time pressure), while others may determine whether the game ends immediately (e.g., when a player's character

gets killed). Looking at the game's interactive structure, then, each choice can be considered for its importance (what are the consequences of the choice made?), its difficulty (fending off attackers rather than letting them kill you is an easy choice to make, whereas deciding what to do to get into a locked room or which character to trust may be much more difficult to decide), and the amount of time given for the player to decide (reflex action versus reflection, and how much time for reflection). One could also consider how much information the player is given on which to base a choice, and sometimes only in retrospect does the player realize whether all of the available pertinent information was collected or even recognized.

The importance of consequences also depends on the irreversibility of the actions that caused them. After a choice is made, can whatever has been done be undone, and can the game return to the same state as it was before the choice was made? Irreversibility may play a greater role in more narrative-based games or games involving strategy, where a tree of moves leading to win-loss scenarios is navigated, making a return to a previous game state more unlikely or difficult. Many turn-based games, like adaptations of board games, may feature an "undo" command similar to what one might find in utility-based software, and others, like the games of the *Blinx* series, even allow the player to "rewind" action sequences and go back in time, allowing for more exploration and experimentation even into situations harmful to the player-character.

Every arcade game, console-based game, and cartridge-based game can of course be restarted and replayed from its beginning, returning the game to its initial state. This, however, is not true of large-scale networked games (massively multiplayer online role-playing games, or MMORPGs), which contain persistent worlds with thousands of players. The ongoing nature of these games and their continually developing worlds make the consequences of players' actions much more long lasting, and the time and money invested in them raise the stakes of play and the seriousness of player termination. Many MMORPGs have areas that do not allow player-characters to be killed, and the acquisition of experience and game-world objects and abilities, as well as the building of virtual communities within the game's world, are pursued as long-term objectives stretching over months or even years. The irreversibility of players' actions and their consequences weighs heavily in considering the choices faced by the MMORPG player.

Finally, an analysis of a game's interactivity would have to include a look at the motivation and the basis by which choices are made within a game. What are the game's objectives and how are they linked to the choices that

the player is asked to make? And which options within choices are considered to be the correct ones, and why? In many fast-action games, the majority of choices are made to keep the player-character from getting killed, including the dodging of projectiles and the evading or killing of attackers and opponents. The motivation behind the decision making required in a game can be complex and hierarchical, as the player must complete a number of smaller objectives in order to complete other larger ones. Sometimes this can result in actions that appear to run counter to the larger objectives of which they are a part (e.g., killing large numbers of people and destroying property in order to save the world). In almost all cases, the overall motivation behind gameplay is the completion or mastery of the game, either by solving all its puzzles, or by having the highest score or fastest time, or by seeing all the possible endings and outcomes. In short, the player's goal is to exhaust all the challenges the game has to offer.

THE OVERALL INTERACTIVE EXPERIENCE

The structure of a game's interactivity and the nature of the choices that make it up are at the heart of the gaming experience and the subjective assessment as to whether a game is considered fun. Games that are too easy may bore a player, while games that are too difficult may cause the player to give up in frustration. The network of choices within a game should be configured so that each time the player plays there is enough incremental advancement toward an objective to keep the player moving along the learning curve, yet just slow enough to keep the game interesting. While things like cheat codes and walk-throughs are often viewed negatively, since they destroy the puzzle-solving experience or allow players to skip over certain problem areas of a game, they may also be seen as correctives allowing players to stay in a game that would have otherwise frustrated them to the point at which they would have left the game altogether. As players vary greatly in their skill levels, problem-solving abilities, hand-eye coordination, and amount of patience, games must either contain a variable level of difficulty or have carefully designed puzzles and interactivity that balance the advances and obstacles that players encounter in a game. This balance then becomes a part of the construction of a generalized player position, in much the same way that cinematic imagery constructs a generalized viewer position, for example, with a default point of view that matches what a person of average height might experience.

An awareness of the generalized player position being constructed is necessary for game analysis, and it is interesting to consider how this position changes from game to game, or in general over time as video game technology develops and video game conventions develop (a detailed analysis of player positioning, however, is beyond the scope of this chapter). Whatever the genre, time period, or style of game one considers, the structure of a game's interactivity determines much of the game's experience and should be an important part of scholarly video game analysis.

...

References

Aarseth, Espen. 2003. Playing Research: Methodological Approaches to Game Analysis. Melbourne DAC. http://hypertext.rmit.edu.au/dac/papers/Aarseth.pdf (accessed May 27, 2005).

Konzack, Lars. 2002. Computer Game Criticism: A Method for Computer Game Analysis. Tampere. http://www.vrmedialab.dk/~konzack/tampere2002.pdf (accessed May 27, 2005).

Winter, David. 1996–2005. The AY-3-8500 Chip: Closer View. http://www.pong-story.com/gi8500.htm (accessed May 27, 2005).

Wolf, Mark J. P. 2003. "Abstraction in the Video Game." In *The Video Game Theory Reader*, ed. Mark J. P. Wolf and Bernard Perron. New York: Routledge.

TATSUMI TAKAYUKI

Translated by Christopher Bolton

•••

Mori Minoru's Day

of Resurrection

As Japanese science fiction entered the new millennium, its fans might have expected the awakening of elder powers, forces that had long lain dormant. Yet no one foresaw the second coming of Mori Minoru.

A phantom manga artist who published fifty years ago, Mori was the force behind a short-lived but influential series of comics that ceased publication with a puzzling suddenness in the fifties. In the last few years Shôgak-kan has finally published facsimile editions of this artist's complete works, which were acknowledged in their day by the likes of Tezuka Osamu, then an up-and-coming artist himself. Matsumoto Leiji (famous in Japan and the West for manga like *Star Blazers* [*Uchû senkan Yamato*] and *Galaxy Express 999* [*Ginga tetsudô 999*]) listed Mori, Tezuka, and Tagawa Kikuo as the period's three great artists.

But despite this acclaim, one day the man who called himself Mori Minoru stopped publishing and all but disappeared. It was almost ten years before he surfaced again, this time as a writer of fiction. In 1961 he entered a science fiction story contest sponsored by Hayakawa's *SF Magazine* and won an honorable mention for his story "Pacem in Terris" ("Chi ni wa heiwa o"). The next year he debuted in the same magazine under a new name, with "Memoirs of

an Eccentric Time Traveler" ("Ekisentoriki"). And in 1963, "Pacem in Terris" and "The Taste of Green Tea and Rice" ("Ochazuke no aji") were nominated for the fiftieth Naoki Prize, Japan's best-known award for fledgling authors of popular fiction. This was the death of the manga artist Mori and simultaneously the birth of the first generation of Japanese science fiction, in the person of one of its great masters, Komatsu Sakyô. Komatsu would go on to help found the genre of prose science fiction in Japan and then help export it to the West with his novel *Japan Sinks*, which was translated into English, Spanish, Russian, and a half dozen other Western languages.

What summoned Komatsu's early manga from the dead just a few years ago was the discovery (on the shelves of the manga store Mandarake) of a single copy of his work *Subterrocean* (*Daichiteikai*, 1950–52). This prompted Komatsu to search his own archives, where he uncovered the manuscripts for many of the manga he penned in his student days. Hearing of the (re)discovery in the fall of 2001, editors at Shôgakkan rushed to reissue the works, and in early 2002 they were published in four volumes as *The Complete Phantom Manga of Mori Minoru, a.k.a. Komatsu Sakyô* (*Maboroshi no Komatsu Sakyô = Mori Minoru manga zenshû*). Komatsu had just turned seventy, a time for retrospective publications, and one can hardly imagine a more fitting one.[1]

> MINORU FOUND THAT MANGA WERE EASIER TO SELL THAN PROSE MANUSCRIPTS: PUBLISHERS BOUGHT ALL OF HIS WORK, AND HE WAS SOON EARNING MONEY.

Komatsu was born Komatsu Minoru, in Osaka in 1931. He attended Kyoto University, graduating in 1954 with a major in Italian literature and a taste for the avant-garde: his thesis was on Luigi Pirandello, and he was an avid reader of experimental Japanese authors like Hanada Kiyoteru and Abe Kôbô. In the years after the war much of Japan was struggling economically, and as an impoverished student, Komatsu turned to manga as a source of income. Inspired by the work of Tezuka Osamu, in 1949 he started drawing under the pen name Mori Minoru. He found that manga were easier to sell than prose manuscripts: publishers bought all of his work, and he was soon earning money. After graduation he had a series of other jobs—as a factory manager, a radio comedy (*manzai*) writer, and a correspondent for the financial magazine *Atom*—up until his debut as a science fiction author.

In 1964 Komatsu's novel *The Japanese Apache* (*Nihon Apache zoku*) sold over fifty thousand copies. In the same year he published *Day of Resurrec-*

tion (*Fukkatsu no hi*), which *Battle Royal* director Fukasaku Kinji filmed in 1980. In 1966 Komatsu wrote *At the End of an Endless Stream* (*Hateshi naki nagare no hate ni*), a work that still regularly tops the list in Japanese surveys of the best science fiction of all time. Then in 1973 he published *Japan Sinks* (*Nippon chinbotsu*), which described a series of seismic events that submerge the Japanese archipelago. Prefiguring the Tom Clancy simulation

> THE STORY DEVELOPS FROM THE FANTASTIC CONCEIT THAT THE WORLD'S FOUR GREAT DESERTS—THE GOBI, THE SAHARA, THE ARABIAN DESERT, AND IRAN'S GREAT SALT DESERT—ARE CONNECTED BY A VAST UNDERGROUND SEA, HOME TO A MUTANT TRIBE OF FISH MEN CALLED THE DEMONES.

genre, it sold four million copies and spawned a 1973 film and (coming full circle) a popular manga series. An abridged version appeared in English in 1976. And interest in the work continues today: in 2006 the talented young director Higuchi Shinji produced a beautiful and radical remake of the 1973 film version.

After winning several Japanese science fiction fan prizes, Komatsu helped inaugurate the Japanese SF Grand Prize in 1980 while serving as the third president of the Science Fiction and Fantasy Writers of Japan (SFWJ; http://www.sfwj.or.jp). And in 2000 Kadokawa Haruki Publishers established an award in his name. He is still writing: *Galleries of Emptiness* (*Kyomu kairô*), the novel he calls his life's work, is in progress.

Rereading Mori Minoru's manga with Komatsu's history in mind, we see an almost frightening continuity, a half century of genius. Komatsu's student leftism sheds light on why Mori choose to illustrate Leo Tolstoy's masterpiece *Ivan the Fool* (*Iwan no baka*, c. 1950). And today we can see the link between works like the manga *Andromeda, Terror of the Cosmos* (*Dai uchû no kyôfu Andromeda*, 1950s) and Ivan Efremov's novel *The Andromeda Nebula*. It was, after all, Komatsu's admiration for this Russian science fiction writer that spurred him to develop his own theory of science fiction.

But the most striking work is the one that triggered Mori's return, *Subterrocean*. Published in 1950 by Fuji Shobô, in 1951 by Hakuchosha, and in 1952 by Mitama Shobô, it changed designs with each move and enjoyed striking popularity. The story develops from the fantastic conceit that the world's four great deserts—the Gobi, the Sahara, the Arabian Desert, and Iran's Great Salt Desert—are connected by a vast underground sea, home to a mutant tribe of fish men called the Demones. The plot revolves around a "tectonic manipulator" whose Tesla coil technology can shift the earth's crust and potentially eradicate this underground pocket of water. From the manga's point

of departure, it is only a short trip to the world of *Japan Sinks*, where geologic shifts submerge Japan and consign its citizens to a life in diaspora, like the Jewish peoples.

In 1995 the devastating Kobe earthquake hit Komatsu's own Kansai region, and in the same year the Tokyo subway gas attacks were carried out by the Aum Shinrikyô cult (whose supernatural proselytizing manga series was subsequently the focus of its own subcontroversy). In the wake of the attacks, there were rumors that the cult's science division had been conducting research on Tesla coils, stemming from their interest in building an earthquake machine of their own. Published in 1950, *Subterrocean* was set fifty years in the future, but it did not take even that long before it started to come true.

...

Note

1. Komatsu discusses his own and other manga in an interview with Susan Napier, Otobe Junko, and myself, in *Science Fiction Studies* 29 (2002): 323–39.

PLATE 1. An opening page from *Subterrocean* (*Daichiteikai*, 1950–52). The caption for the street scene tells us, "Our story, like so many other science fiction manga, begins fifty years in the future . . ." courtesy komatsu sakyô.

PLATES 2, 3, 4, AND 5. Cover and three interior pages from *Subterrocean* (*Daichiteikai*, 1950–52). At the top of the middle image, Dr. Bourdeaux explains his "Tectonic Manipulator," which can control the movement of the Earth's crust. Originally designed to prevent earthquakes, these machines have been installed in the world's great deserts as part of an elaborate experiment to depress the surface and raise the underlying strata, to eliminate the vast water pocket that exists beneath these deserts. But this subterrocean is inhabited by a tribe called the Demones . . .

In one of the concluding frames, an inky figure introduces himself as "the shadow voice—the author," and tells the reader that the story is at an end. "Can you understand how Kishibe Ichirô could come to do such a horrible thing?" it asks. "Was it his sin? His nature? No. What delivered him into the hands of the devil was the miserable society of the time. He was just one of its poor and oppressed. And what can save people like this? Not the gods, but other people and their love. If we are to live as human beings, we must build a more humane world." COURTESY KOMATSU SAKYÔ.

6

PLATES 6 AND 7. Front and back cover art for *Laboratory No. 5* (*Dai go jikkenshitsu*, 1950s). COURTESY KOMATSU SAKYÔ.

7

PLATES 8, 9, AND 10. Cover art and two interior pages from *Andromeda, Terror of the Cosmos* (*Dai uchû no kyôfu Andoromeda*, 1950s). In this scene, the villain Dr. Ryuryu self-destructs, leading to the death of the heroine Yurii, who is revealed to be the doctor's creation. "I am a robot controlled by his thoughts," she confesses to the hero. "My electric brain was so finely put together that I started to have feelings. In other words I became a living being—just like a human."

In the following frames, it is announced that Dr. Ryuryu's gravity device has been destroyed, and the Earth is out of danger. "We have been saved," says the speaker. "The crisis has passed, and peace has returned to the earth. You see, ladies and gentlemen, in the face of a trial unlike any we have ever before faced, the patience, the hard work, and the courage of humanity have prevailed, aided by a love that stirred even a machine." COURTESY KOMATSU SAKYÔ.

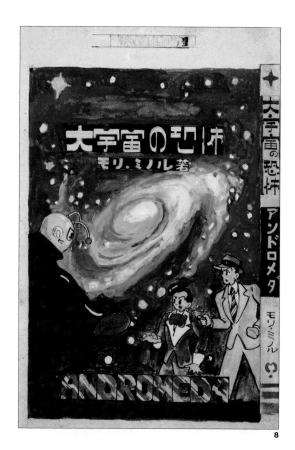

8

9

10

世界名作長編漫画

イワンのばか

もり・みのる 画

1

PLATES 11, 12, AND 13. Title page and opening and concluding pages from *Ivan the Fool* (*Iwan no baka*, c. 1950), based on the short story by Leo Tolstoy. The story opens with the reader standing at the entrance to the Demon's Palace, home of the devils who will tempt Ivan and his brothers. "What lurks behind these doors?" the narration asks. "Let us enter together and find out."

The concluding page of the manga paraphrases the final passage of Tolstoy's story. While the demons have capitalized on the greed and bellicosity of Ivan's brothers, they are unable to corrupt Ivan, whose hard work and generosity earn him a kingdom of his own—a place where no one goes hungry if he or she is willing to work. The final panels read: "In Ivan's kingdom, there is one unwritten law: Those with the lily-white hands of the leisured must eat the leavings of others." COURTESY KOMATSU SAKYÔ.

14

PLATES 14 AND 15. Back and front
cover art for *Our World* (*Bokura
no chikyû*, c. 1950). COURTESY
KOMATSU SAKYÔ.

15

THOMAS LOOSER

Superflat and the Layers of Image and History in 1990s Japan

"Japanese [people]," wrote Murakami Takashi in the year 2000, "are too un-aware of history"—echoing what by then had become a trite sentiment.[1] For Murakami, one remedy lay in art, or at least in what might be thought of as a kind of critical image. And in rethinking art *as* history—not merely art as representing history but art as putting into practice a new relation of and to history—Murakami seems to believe that art potentially has real social and political force. He makes this clear even in his first widely disseminated state-ment on Superflat art, simply by calling it a "manifesto."

Superflat imagery is also eclectic, bringing together, for instance, both the traditional Japanese early modern woodblock prints and postwar Japanese anime;[2] pop and subculture with "high" art; the culture of the early modern Edo period and the 1960s with culture at the end of the twentieth century; and so on. But in the particular way that these artistic, economic, and historical elements of difference are brought together, the implicit claims for Superflat imagery are fairly big: Superflat art, it seems, will open up a new life (or a new "sensibility") in the present, which includes new "seeds" for the future.[3]

I want to take at least a few of these claims seriously. If nothing else, the truly global reach of popularity attained by Murakami may be reason enough.

The central elements of this chapter are the layering and emphasis on sur-face relations (sometimes reductively described as a mere "flatness") and the connections made by Murakami and others between the early modern Edo era and contemporary Superflat culture—as seen, for example, in the "ukiyo" prints of Nara Yoshitomo (see Figure 1). Murakami has always been eclectic, but his early shows (and critics associated with him) gave greater emphasis to this connection with early modern Japan, while more recent shows have an almost exclusive focus on World War II and its aftermath.[4] Although I find the earlier arguments more compelling, this shift in histories of the Superflat is also significant, and I return to it toward the end of this chapter.

Before getting to the details of Superflat image space, I want to lay out a bit of context—starting with apocalypse. As I think is now well known, by the 1990s the image of apocalypse was quite common, at least in Japan—in the so-called new "new" religions, for example, but also as the starting point of a whole range of anime films (as in films associated with the Gainax com-pany lineage in particular, but elsewhere, too). Cultural analysts have tended to cite Japan's atomic bomb experience as the principal factor behind these apocalyptic images, and while those explanations are clearly important,[5] I think there is perhaps still more to it.

The image of an apocalyptic beginning (as well as a completion or ending) can in some ways be thought of as a problem specific to the context of Japan in the 1990s—I come back to this below—but it is also a problem of modern history in general.

Arguably, within modernity, if there is anything that holds things to-gether at all, it is history. History provides the grounds of association between a range of knowledge forms (from biology to economics to linguistics) in the form of analogies organized in a temporal series.[6] In contrast to the layering of differences that Superflat art is based on, the ground of modern history is accordingly more typically thought of as generally homogenous (despite some unevenness). History therefore holds out the promise of a view of a kind of totality—a view of a whole. But at the same time, the argument usu-ally goes, modern history is self-referential: ultimately, we can really fully see and know only ourselves, and this view is immanent, without a transcendent position—and so we end up alienated from any view of a complete whole. More simply put, there is no overarching view of history possible. The world itself, as a horizon, therefore cannot become a theme—we can't thematize the world as a whole.[7] In a way, the same thing can be said of modernity's emphasis on the present, as a time divorced from larger, but differential, nar-ratives of history. The present is, in a sense, our only real origin of experience.

So even if history provides a common ground of modernity, already there is an inherent problem of lack of limits, or horizons, that one might then see beyond.

Apocalypse, on the other hand, does imply an absolute limit of sorts and a complete horizon of experience. So apocalypse could, theoretically, be thought of as a return to the thematization of the world as a whole—providing a view not only of the horizon of our world but also of the limits of the present time. At least theoretically, this might give a kind of productive limit to the present time, raising the possibility of seeing out into something new or different.

Is this positive, productive function what all these apocalyptic openings of anime are about, then? And what are the Superflat apocalyptic references pointing toward? To return briefly to Japan, it is worth noting that the Superflat movement began at almost exactly the same time as the start of the Heisei era in Japan (beginning in 1989, with the death of Hirohito, the Shôwa emperor). The very name *Heisei* contains the idea of a productive ending. Literally the "culmination" or "completion" of peace, the word was meant to indicate an ostensibly successful completion of Japan's postwar policies. So I think it is fair to take the term as naming a real, and at that time positive, ending of sorts. Again, does this mean that all these images of endings and apocalypses in Murakami's shows can be read in any way as part of that moment of productive endings? Endings, that is, that emerge out of an incredibly successful consumer economy and that yet somehow point to something new?[8] Or, even if a more negative ending, one that nonetheless still points hopefully to something else?

> FOR AT LEAST SOME OF THE SUPERFLAT PEOPLE, TOO, THERE IS A KIND OF TRAUMATIC SOLIPSISM, EVEN AN APOCALYPTIC ONE, THAT UNDERLIES THE CONTEMPORARY WORLD AS THEY SEE IT.

That's one possibility, but there is another reading of life in the global economy that also seems to be part of the Superflat shows and that extends back out from Japan to the world in general. An example that I hesitate to return to, but that still seems apt, comes from Ground Zero in New York. Though apocalyptic in a way, this is a very different kind of historical relation to an origin.

Obviously, this is a site of real trauma, and the new World Trade Center buildings will inevitably inscribe this traumatic event into a specific kind of history. As originally planned, the Daniel Libeskind design called for a single unitary tower—the "freedom tower"—to be built on the site, with a spire attached so that it would reach precisely 1776 feet. Less a memorial to the

2001 event, this figure of 1776 would return the World Trade Center to a more mythical kind of origin. Furthermore, it does so in such a way that America's origin (in 1776) becomes the origin of the entire world—emphasized by the early claim that the tower would be the world's tallest. In what can be thought of as one logical outcome of the new global economy and media, America really becomes the world—and the recent traumatic origin at the foundation of the new World Trade Center, and of world trade in general, is supplanted by the stability of a more fixed and prior origin. The result is not so much a fascism as a solipsism: one in which the new global economy ends up as a world of pure interiority—unified and statically fixed, within origins that are themselves ultimately timeless.

> MURAKAMI SAYS HIS STYLE INEVITABLY WILL STINK OF SOY SAUCE, AND THAT'S WHAT HE WANTS TO, AND MUST, WORK WITH.

This less sanguine understanding of an apocalyptic world seems to be present in the Superflat work, too. Murakami's work is certainly part of a global economy, with Louis Vuitton–Murakami branding, for example, extending through both galleries and shops worldwide. Nearly all the Superflat spokespeople fully embrace an all-encompassing consumer capitalism. Murakami constantly refers to his refusal of any distinction between art and commodity, and part of his aim is simply to sell a lot (and he does, with annual sales in the billions of U.S. dollars). At the same time, the Superflat world also entails a perspective of lonely and even radical interiority: the imagery of isolated childhood used throughout Nara's work is supposed to be a sign of this. Or to quote from Sawaragi Noi, just slightly out of context, the new media that help frame this world lead to a "claustrophobic space," "where the outside melts into an inside"—in other words, the fact is that "only an inside exists."[9] Or one could look to the critic Azuma Hiroki's descriptions of Superflat work as starting at a traumatic "ground zero," or the Ground Zero Japan art exhibit curated by Sawaragi in 2000, and so on. So for at least some of the Superflat people, too, there is a kind of traumatic solipsism, even an apocalyptic one, that underlies the contemporary world as they see it.

This construct of apocalyptic time, too, can be brought back to the context of 1990s Japan and the idea of the Heisei period as an ending or culmination of Japan's postwar policies. Those policies, which reached their fulfillment in the late 1980s, were based on a remarkably successful emphasis on consumer capitalism as the basis of social order and were premised on a withdrawal not only from militarism but, in a sense, from the wider world in general (and so they, too, formed a kind of inward turn). The notion of a return to history

under these conditions therefore becomes a loaded idea, with fairly large possible implications as to what a return to history might mean.

Interestingly enough, and in some contrast to the kind of global homogeneity described by the World Trade Center example, it is also out of this global world that a call for a return to national identity springs up in the Superflat work. The vision of returning from a global perspective to a specifically Japanese national origin is a common theme for Murakami. This is phrased literally, as in Murakami's description of his original move to New York as just a step on the way back to Japan, and stylistically—Murakami says his style inevitably will stink of soy sauce, and that's what he wants to, and must, work with.[10] And above all, this emphasis on return is phrased historically, with, again, many early Superflat artists locating the origin of their world in the early modern Edo era, and its culture of capitalist play (with references to kabuki aesthetics, the consumerist knowledge of the flaneurlike connoisseur called the *tsû*, and so on).

So, unlike the global solipsism figured by the World Trade Center plans—which really is a world without difference—here there is a real claim to the possibility of true difference, and even national difference in particular. But then one still has to wonder, what, if anything, is new about this kind of relation to a national origin? What limits could it possibly be opening up? This is not the first time, after all, that people have located the origins of Japan's current identity in the Edo period.

Karatani Kôjin's well-known linkage of contemporary Japan with nineteenth-century Japan is an obvious case. For Karatani, nineteenth-century Japan—which is to also say contemporary Japan—has in some essential way always already deconstructed modernist Western formations of meaning and man.[11] In other words, Japan in a sense has always already stood outside the modern.

The trouble with this model of Japan's incommensurability with the modern is that it risks a kind of transcendent cultural exceptionalism. Japan in general, therefore, and early modern Japan in particular, really cannot speak to the concrete conditions of either the current global capitalism or the global electronic technologies that the Superflat artists take as definitive of the world today. So, is the Superflat movement similarly ending up with a transcendent nationalism, by seeing in early modern Japan the origins of something that is somehow external to the current globalisms? What is this Superflat relation to early modern Japan?

Although the grounds or basic relations of a "Superflat" world are not simply pictorial, or specifically historical, it is in terms of pictorial and historical

relations that I think it may be easiest to get a clearer sense of what is at stake, and so I now turn, finally, to those pictorial and historical conditions.[12]

One of the most basic early claims in this art is that by the 1990s, there are new material modes of inscription that bring into view a truly new relation to the world in general. Digital media, and what are more generally described simply as digital conditions, are taken to have a very large influence—again, bringing about something like a restructuring of the World Picture. A restructuring, in other words, that involves the destruction of received hierarchies of values and a repositioning of the modern subject. Central to this new World Picture is an emphasis on surfaces and a process of layering, highlighted by digital technology. But it is these new, technologically described qualities that the Superflat people see as also *old*, and originating in the early modern. Although I think some of what are thought of as the basic characteristics of digital technology are probably now well known, I here briefly summarize just some of the elements more salient to the Superflat imagery.[13]

> SUPERFLAT PICTORIAL SPACE ALLOWS FOR THE LAYERING OF DIFFERENT SURFACES, AND EACH SURFACE CAN BE THOUGHT OF AS ITS OWN PRODUCTION OF IDENTITY, WITH ITS OWN RELATION TO AN ORIGIN (IN A WAY, EACH LAYER IS AN ORIGIN). THERE IS NO HIERARCHIZATION OF SPACE OR PRIVILEGED GAZE OF THE EYE THAT MIGHT CREATE A STABLE UNIFIED SUBJECT POSITION OR CREATE A SINGULAR DEPTH.

The idea of "super" flatness plays off the material, technological characteristics that are tied to digital as opposed to analog media. This has to do in part with differing relations to an origin, but can more generally be thought of as just differing relations to the world. An analog medium such as filmic photography will necessarily reproduce the optical wavelengths of light to which it is exposed. The photograph, therefore, retains a stability of form and scale; it exists in a mimetic relation to the subject of the photo (the photo's point of origin). This mimetic relation therefore anchors a kind of identity that is stable, unitary, and that privileges the origin as the place of truth, complexity, and authenticity. There is also already a kind of depth model implied, too, similar to the idea of the modernist subject, in which real identity, in all its complexity, lies at the interior, and this interior self determines the more limited outward expressions that one sees on the public surface.

Digital technologies, on the other hand, operate via a fragmentation of an image or sound into a code, which then must be recombined. There is therefore no technological relation of mimesis—there is no morphological constraint of resemblance between the different levels. Furthermore, if one

looks, for example, at the way self-reproducing robots work, a limited code of ones and zeros will in fact produce an open variety of different robots out of that one, limited code. So the only place one can locate the so-called true identity of that originary code is at the level of each actual manifestation of the code. Real complexity, and identity, lies at the level of the surface, not some prior interiorized point of origin. Identity, in other words, is emergent. Reality itself, authenticity, and real complexity thus lie at the surface, and in this sense can be thought of as "flat." This contrasts with the depth model of the modern, interiorized subject.

This idea of emergence has influence on perspective. In classic Western perspectival space, everything is unified and hierarchized by the single vanishing point; space itself is accordingly homogenous, and everything finds its proper place within that space, including the spectator (drawn into the picture plane via the vanishing point), in accordance with fixed mathematical laws of relation. This yields stable positions of near versus far, subject versus object, and, supposedly, the position and identity of the viewing subject. Again, in a depth model, that now seems almost three-dimensional (but qualitatively homogenous).

> IF PERSPECTIVAL SPACE IS AT THE HEART OF MODERN SUBJECT POSITIONING, THEN HERE, TOO, WE SEE THE POSSIBILITY OF A KIND OF LIMITLESSNESS AT THE HEART OF THE MODERN.

In the Superflat (or digital) world, though, precisely because identity is emergent and exists only at the surface, there is no single point of depth by which to locate a unitary subject. Superflat pictorial space instead allows for the layering of different surfaces, and each surface can be thought of as its own production of identity, with its own relation to an origin (in a way, each layer is an origin). There is no hierarchization of space or privileged gaze of the eye that might create a stable unified subject position or create a singular depth.

The space of the Superflat world, or of Superflat subjectivity, would thus seem to be composed of identities that are openly emergent rather than tied to some absolute relation to a prior, fixed origin. And this space, or these surfaces, contains layers of real difference that nonetheless have some relation to each other. In a way, there are real boundaries that allow for a sense of difference, but there is also some contiguity or connection between these layers or worlds of difference. This is fairly different from the homogenous space of Western perspective, which anchors just one whole subject position, and one unified view.

But I want to add one qualifier to the view of the Western perspectival

space, to which Superflat layering is ostensibly opposed. Perspectival space, taken to its most fully and logically developed form, is a purely mathematical space. This mathematics is so regular and so systematic that one could theoretically choose *any* point in a perspectival painting (or any two points, really) and figure out the proper orientation of everything else just in relation to those one or two randomly chosen points. This means that there no longer is any privileged position of an outside, given, observing, and orienting subject. In fact there is no privileged place of perspective at all. The result is a kind of placeless place, a space without any real spaces of difference. It is a subjectless, spaceless space without limit or end. So here, too, there is really no substantial "outside" to any individual position, and the ground of everything is at most an empty classificatory homogeneity. If perspectival space is at the heart of modern subject positioning, then here, too, we see the possibility of a kind of limitlessness at the heart of the modern.

It is by these largely technological terms that Superflatness professes to open up the modern, supposedly hierarchized, and unitary subject—though in ways that do not imply simply a postmodern loss of referents. It is within these material modes of inscription that the return to history in the 1990s operates. This return to history, furthermore, is apparently part of a return to art, or to the relevancy or potency of art. Sawaragi, for example, implies that a return to the Edo era can operate as a return of a new "nowness" (*gendai sei*) to the modernist closures of contemporary art (*gendai bijutsu*).[14]

This brings us back to the actual Superflat artworks, and to the Edo period. What are those "layers" in, for example, Nara's *ukiyo* paintings? What is the surface that holds them together? And what about these claims for the Edo period?

Certainly there is a process of layering openly visible in the example from Nara (Figure 1). Nara has taken an Edo era woodblock print (with the printmaker's name, Utagawa Kunisada, still visible) and reworked it in such a way that one can still see an overlap of authorship (Kunisada and Nara), style, media (woodblock printing, painting, and even sandpapering—the sandpapering is meant to call attention to the surface and thereby to preclude any simple illusion of depth), historical eras (the Edo period and our own time), and consumerism ("Cup Kid" refers, among other things, to "Cup Noodle") versus folktale (Nara has also overwritten "Issun Bôshi"—the title of a well-known Japanese folktale popular in the Edo era). These layers are complicated: in some ways, for example, the Issun Bôshi tale is itself about a kind of consumerist desire that clearly was part of the Edo cultural landscape. Consumerism and commodification thus may act as a kind of surface that

holds the differences together. This already, therefore, is a complex image of history and identity.

But before drawing any conclusions, I would also like to look a little at the Edo period itself. What is the Edo era as a term of relation for all this?

There are, I think, real reasons for turning to this period as a time of Superflat-like formations. The single-point perspectival space that hierar-

FIGURE 1. Yoshimoto Nara (in the floating world, Cup Kid), 1999. Color Xerox on paper, 41.5 x 29.5 cm. Copyright 1999 Yoshimoto Nara. Courtesy Tomio Koyawa Gallery, Tokyo.

chizes a unitary modern subject position did not appear in Japan until far later than in the West, and even then, it was used simply as one among many modes of spatial organization that could be played with, and even layered over other kinds of space.

As an example, one could look to the woodblock prints themselves, in this case to Hiroshige (Murakami often refers to Hokusai, though I think Hiroshige works a little better for the current discussion).[15]

It is obvious, first of all, that Hiroshige was fully capable of employing good perspectival technique, and he often did so.[16] In *The New Naito Station at Yotsuya* (Figure 2), he uses a consistent single-point perspectival space not only to show depth but also to locate (playfully, presumably) the spectator in a fairly uncomfortable position within that space.

But unlike this homogenous and uniform space, Hiroshige elsewhere played with perspective in complicated ways. In the *Landspar in Tango* (Figure 3), a quay of land carries the eye out into a typically receding perspectival space. But next to this quay are boats, which do not diminish in size and so appear to simply float or fly in an airy space that has no connection to the perspectival order of the landspar. The space of the boats, in other words, is that of a flat surface rather than a perspectival depth.[17] In *The Ryôgoku Bridge Riverbank* (Figure 4), Hiroshige again creates a view of perspectival depth, but as part of that depth he uses diagonal connecting lines created by shopping stalls, a bridge, and a shoreline. This creates a pattern of zigzagging lines that carry the eye across and up the picture's surface, rather than into the depth of a three-dimensional space. In this way, too, therefore, perspectival depth space is cooperating with a surface-oriented design space. (At times, Hiroshige uses similar zigzagging lines to create a set of separate perspectival spaces that seem to simply stack up on top of each other, vertically up the print's surface.) Or, in *Ferry at Haneda* (Figure 5), there is, first of all, a depth perspective oriented by a lighthouse, toward the center of the print. But to the left of center, a temple (arguably, the print's "main" subject) is centered, not by depth but rather by a triangle of lines formed by the boatman's legs, a rope, and an oar. We are, in a sense, given two kinds of surface, one of depth and one operating via design, that bump up against each other and that orient two different subjects. It has also been argued that the viewing position in this print at the same time looks up, toward the lighthouse, and down, toward the temple—a seemingly impossible double viewpoint from the same position.[18]

FIGURE 2. *The New Naito Station at Yotsuya.* Used with permission of the Brooklyn Museum.

FIGURE 3. *Landspar in Tango.* Used with permission of the Brooklyn Museum.

FIGURE 4. *The Ryôgoku Bridge Riverbank.* Used with permission of the Brooklyn Museum.

FIGURE 5. *Ferry at Haneda*. Used with permission of the Brooklyn Museum.

The play and layering of different modes of spatial organization were also taken up by the Edo period kabuki theater. There were programs in which no actors appeared onstage at all: the entire performance consisted simply of the rapid switching of background scenes—each of which were painted in varying modes of perspectival and nonperspectival space. These often culminated in a switching of proscenium frames, along with plays of lighting, so that the observer is in effect kept out of any stable relation to any single order of space. Murakami seems to have been aware of this practice and included an example of it in his first Superflat exhibition book.[19]

Lastly, one could look at the poetic layering of worlds within kabuki play narratives. In *Sukeroku*, which even by the nineteenth century was taken to be the era's most representative play, two plots overlap: one invokes an epic (even ritual) return to a classic, samurai hero of the past; the other is a serialized account of a lower-class pleasure-quarters hero. Although most modern readings of the play attempt to resolve it into one or the other of these worlds, the play itself does not.[20]

This does sound like the nonperspectival, layered subject of the Superflat world in many ways. But the Superflat connection is always made directly to the Edo era culture of capitalism.[21]

But if one looks at early modern Japanese history at all, it is fairly clear that that time period did include other value systems—the supposedly natural value of the shogun's rice economy, for instance; differing bases of social power in merchant and samurai groups; or, in the arts, the privileging of something close to an epically fixed canon that served as a fixed point of origin for an increasingly nationalized state—in opposition to the serialism of kabuki. In other words, there *was*, then, to a real extent an *outside* to the values of capitalism. It is not just the merchant culture that was a culture of play. In some ways the real aspect of play, that everyone participated in, was this play of value systems. The Superflat genealogy leads only from a contemporary world of the play of capital, expressed in the digital, back to an earlier moment of the play of capital. The Edo period *was* a real place of difference from contemporary Japan, even while it also can be thought of as correlative to the Superflat vision. But by seeing its origins as lying only in the world of capital, the Superflat group itself remains within that world. It forecloses the differences of the Edo period itself, and of contemporary Japan, as in essence wholly defined by the constraints of capitalism and modernism. The Superflat relation thus gets displaced by a focus on a limitless origin.

In many ways, this becomes a problem of the Superflat aesthetic, or mode of inscription—the way it uses this idea of layeredness—itself. With

its insistence that there is no hierarchy at all between media or between layers of worlds, it would be hard to see how there could *be* an outside, of any sort at all.

> OUR NOTIONS OF HISTORY, AND OF CULTURE, *ARE* FLATTENED OUT, ESPECIALLY AS BEING IN ANY SENSE COMMUNITIES OF DIFFERENCE.

So at least in a pessimistic reading of all this, the Superflat is little more than modernity's dream of an outside. Also, if one were to push this, new media as defined by the Superflat may be little more than 1990s consumer capitalism's dream of an outside. The endless litany of apocalyptic images that Murakami and others now invoke, from the atomic bombing in World War II, to Godzilla, to the Aum Shinrikyô sarin gassings in Tokyo, to Chernobyl, to the weekly world endings of the television show *Time Bokan* (and of course the apocalyptic imagery characteristic of Gainax-type anime films), and so on—all this ends up looking like just a romantic desire for a real limit, a real ending, or a real horizon.

The historical turn to the Edo period might be thought of as roughly equivalent to making 1776 the origin of world trade. It calls up the emphasis on stable origins that would come from a trauma-style relation of history. It is a return to a mythical moment of happy coherence, prior to any moment of actual trauma or irruption of difference, and that mythical moment in turn stabilizes the conditions that make up Heisei modernity. The result is, again, a solipsism.

(Ironically enough, Murakami's more recent shift of focus to the atomic bombings only aggravates this effect. This, too, forms an absolute beginning—no longer overlaid with the Edo or any other time period—of a firm national identity. This national identity may have been humiliated by the West, but it is clearly therefore non-Western, and certain in its place. The war serves as a single origin to a clear, unified narrative of modern national identity. Superflatness is here reduced to the leveling effect of a mere flatness.)[22]

It would seem, then, that there is no movement to this history at all. It is not that Japan has never been modern, but rather that Japan has now finally become fully and completely modern—as it was at its Edo era origins. This is a totality, and a history, only of completion, in which capitalist modernity is abstracted out as the only differential. Our notions of history, and of culture, *are* flattened out, especially as being in any sense communities of difference.

Yet oddly there are ways in which the Superflat turn to both the Edo era and new media also encapsulates something else. To some extent the world, as horizon, does become a theme, as does history as a means of imaging the

world. To some extent the Superflat does, in other words, elicit a retheorization of possibilities in the present. The "Superflat" layering and juxtaposing of different worlds, in ways that retain the unique organization and coherence of each media world or each layer—though still grounded within some kind of common order—are already a new image of history, or a new way of imaging history. It is one that, on the one hand, can bring out the singular set of relations and conditions that make up our own time, without grounding them in a determinative origin. And on the other, it also still insists on some larger picture of history, or a kind of relationality, extending beyond the nonhistorical singularity of any given time.

More simply and concretely, the Superflat image shows us how the Edo era was a truly different world—a kind of limit to our own—even while it can also be very much part of the definition of our time. In a more positive reading, the Superflat may thus bring out new ways of delimiting our present time, and new ways of defining and therefore pointing beyond the seemingly limitless horizons of modern life and modern history.

. .

Notes

1. Murakami Takashi, *Superflat* (Tokyo: Madra, 2000), 161.
2. Even this connection between traditional Japanese art and anime, Murakami says, comes only via the modern European artist Horst Janssen as a kind of intermediary.
3. "Superflat Manifesto," in Murakami, *Superflat*, 5.
4. The change is visible in the differences between the first Superflat exhibition at Parco (Tokyo) in 2000, and the 2005 Little Boy show in New York that completed the three-part "Superflat" series curated by Murakami.
5. One of the more important writers on apocalypse and Japanese popular culture in this sense is Susan Napier. See, for example, her "World War II as Trauma, Memory and Fantasy in Japanese Animation," in *Japan Focus,* http://japanfocus.org/, posted June 2, 2005.
6. I am borrowing this phrase from an unpublished paper by Christophe Thouny (writing on history in a slightly different context).
7. William Rasch, introduction to *Theories of Distinction: Redescribing the Descriptions of Modernity*, by Niklas Luhmann, trans. Joseph O'Neil (Stanford, CA: Stanford University Press, 2002), 2.
8. A simpler and maybe more common understanding of modern apocalypse might say that these images are just part of the inevitable crises of capital—small moments of crisis that capital nonetheless supersedes. That would mean that these are just empty images of an ending, in a world that in fact never really changes, or moves, or has real, clear limits. For the moment, however, I am trying to keep other possibilities open.
9. Comments made in a discussion on the cyberpunk world of the Japanese science fiction writer Fukui Shojin—who, nonetheless, Sawaragi sees as one of the pop cultural

sources of the Superflat (interview by Krystian Woznicki, nettime, http://amsterdam. nettime.org/Lists-Archives/nettime-l-9803/msg00097.html).

10. See, for example, Murakami Takashi, "Life as a Creator," in *Summon Monsters? Open the Door? Heal? Or Die?* (Tokyo: Kaikaikiki, 2001), 130.

11. See Karatani Kôjin, "One Spirit, Two Nineteenth Centuries," in *Postmodernism and Japan*, ed. Masao Miyoshi and H. D. Harootunian (Durham, NC: Duke University Press, 1989).

12. A Superflat identity can also be thought of as an economic relation. There have been a few perfunctory attempts made by critics such as Okada Toshio to define a "Superflat" economic identity. Emphasis is given to subcultural *otaku*-types as having new kinds of power within the culture industries, largely through a kind of connoisseurship; as knowledgeable consumers, they can redefine the things they buy—so that consumption is redefined as production. But these arguments are limited.

13. Among other places, I am borrowing here from my own earlier statements in "From Edogawa to Miyazaki: Cinematic and Anime-ic Architectures of Early and Late Modern Japan," *Japan Forum* 14, no. 2 (2002): 297–327.

14. See Sawaragi Noi, *Nihon, Gendai, Bijutsu (Japan, the Present, Art)* (Tokyo: Shinchôsha, 1998).

15. For a recent work looking at multiple ways of viewing in Hokusai, see Nakamura Hideki, *Shin Hokusai Mangekyô (Gazing at Hokusai's Constellation: Toward Polyphonic Vision)* (Tokyo: Bijutsu Shuppansha, 2004).

16. It has been argued that what might be called irregularities in perspective, even in late–Edo era prints, was due simply to ignorance in perspectival technique. For an article discussing Hokusai along these lines, see Inaga Shigemi, "La réinterpréation de la perspective linéaire au Japon (1740–1830) et son retour en France (1860–1910)," *Actes de la recherche en sciences sociales* 49 (1983): 29–48.

17. Another commentator also argues that the quay is seen from an "impossibly" high angle of vision, while the boats are not. This would imply two basically different spectatorial positions. See Frank Whitford, *Japanese Prints and Western Painters* (London: Studio Vista, 1977), 112.

18. This argument is made in a related discussion of the same print in Whitford, *Japanese Prints and Western Painters*, 110.

19. See Murakami, *Superflat*, 30–31.

20. For a fuller discussion of this, see Thomas Looser, *Visioning Eternity: Aesthetics, Politics, and History in the Early Modern Noh Theater* (Ithaca, NY: Cornell University Center for East Asia Series, 2006).

21. Okada Toshio, for example, has said that the "true aesthetic stream," and the history of Japan in general, leads directly and specifically to merchant culture.

22. This tendency was evident in the 2005 Little Boy show at the Japan Society in New York. For essays by Sawaragi and others in the catalog for that show, see Murakami Takashi, ed., *Little Boy* (New Haven, CT: Yale University Press, 2005).

U E N O T O S H I Y A

Translated by Michael Arnold

• • •

Kurenai no metalsuits, "Anime to wa nani ka/ What is animation"

SEEING THE WORLD AS A STORYBOARD

I once saw Oshii Mamoru's storyboards for the film *Mobile Police Patlabor 2* (*Kidô keisatsu patoreibaa 2 za mûbii*, 1993). I have not seen many storyboards, so I cannot say very much about them, but these were obviously drawn with great detail and subtlety. It looked as if you could make a piece of animation just by moving them. The same storyboards were later included on the second *Patlabor Digital Library* CD-ROM (1995) in a way that makes it possible to actually view the drawings moving in sequence, so now anyone can appreciate the same sensation.

When I saw the drawings, I started to wonder if Oshii looks at the world as if it were like those storyboards—if he views reality as if it were animation from the start. To Oshii, animation is not necessarily just a reflection or copy of reality; it is in itself an independent reality. For him, the world and reality itself are structured and schematized as animation. This is none other than a fundamental principle for watching Oshii's films, and I would like to consider this issue from several angles.

In general, people who do outstanding work in art and expression are

always creating and inventing their own unique worlds within that form of expression. Impressionist painters translate the world as a collection of light and pixels. Hard-boiled novelists invent reality as a set of overlapping actions and objective facts. Filmmakers reformulate the world as if it had been generated as a movie from the start. This much is self-evident.

> THERE IS NOTHING UNUSUAL ABOUT THE ATTEMPT TO COMPOSE THE WHOLE REALITY OF THIS WORLD AS ANIMATION AND CAPTURE IT IN DRAWINGS.

It may be useful to refer to an often-used example from biology. Ticks have a world of their own—a world perceived by ticks—and dolphins have a world perceived by dolphins. Those creatures' worlds are structured according to their own forms of perception. In a similar way, various expressive cultures are formalized according to their own unique views. A superior mode of representation is one that differentiates (makes unique) that form and structure. Naturally, that includes the process of dismantling and distorting that form and structure as well. Thus, is it really so strange for a filmmaker to look at the world as animation from the start?

Actually, there is nothing unusual about the attempt to compose the whole reality of this world as animation and capture it in drawings. It is possible to translate any person or thing into animated drawings; surely this is what all works of animation really try to do. Regardless of whether the images are highly fictionalized by visual distortion or drawn to a relative degree of photographic realism, if the goal is to gaze at reality as animation and recompose the world through that vision, it is a very commonplace activity. This is because the only questions are the delicacy and accuracy of the animated drawings.

It is well known that the original meaning of the word *animation* is to activate or give vitality to something—to give life, to breathe life into an inanimate object or substance. Consequently, the term has carried with it an extremely Western, even Christian, connotation. This is the reason why animation using objects, such as dolls, puppets, or clay, is so common in the West. Perhaps this is also why conventional cel animation is relatively primitive in the West. In contrast, the technology and visual detail of animation in Japan is unusually sophisticated. With the exception of the gold or green color of characters' hair and the exaggerated shapes of their mouths and eyes, animation in Japan simulates reality to an excessive degree. (This is especially striking in reflections of light and water or the depiction of details in vehicles and *mecha*.) It does not aim for the simple reproduction of reality

but the hyperreality of things with no referent, things that are "more realistic than reality." Even if this condition partly grew out of an inability to use the type of massive special effects budgets that Hollywood does, it is something that we cannot ignore.

However, it does not mean the same thing to say that Oshii looks at the world as if it were animation. First of all, Oshii does not recognize reality as a primary object to be photographed or drawn, as something that exists prior to film and representation. Oshii feels, as many filmmakers do, that reality is always already a movie—the movement of images. To understand reality as a moving image per se is also to gaze at film/reality as animation from the start and to organize that reality as animation.

"LIVE ACTION" AND "ANIMATION"

On the one hand, Oshii brings many of the actions of real films into his animation. In other words, a virtual camera operates within Oshii's animation images, executing the functions of real cameras such as the shot/reverse shot and long shot. At times he even employs different "lenses" for different purposes, and, depending on the situation, he sometimes reproduces the visual distortion created by camera lenses. However, the goal of this is not to faithfully reproduce reality; it is simply to point out that animation is nothing more than one possibility of reality.

THE ACTORS' BODIES IN OSHII'S WORK ARE NOTHING BUT AUTOMATONS. OSHII TURNS OUT TO HAVE BEEN A "PUPPET MASTER" HIMSELF.

We cannot reduce this technique to the explanation that Oshii is simply a lover of film. Of course, it would be clear to anyone who watches Oshii's filmography that his movies are filled with countless cinematic references. Jean-Luc Godard, Alfred Hitchcock, Andrei Tarkovsky—we could mention any number of auteurs. However, it would be too easy to satisfy ourselves by finding Oshii's identity as an auteur in such clues. This is because it could only lead to the presumption that Oshii is an auteurist in animation because he is not allowed to make films.

At the same time, the issues addressed in Oshii's live-action films contain definitive elements of his style. It is strange to have to use "live action" to describe Oshii's nonanimated films in the first place. (A prejudice against animation clearly lurks within that term.) Surprisingly, Oshii no longer holds any dichotomy of representation between animation and live action.

Just as he uses the techniques of normal movies throughout his animation, Oshii also considers his so-called live-action work—and film itself—to be animation.

Anyone can see that Oshii's films essentially deal with only one main theme (as eminent philosophers only contemplate a handful of topics). That theme can be expressed through something animation-like or *animate* (*animeteki na mono*), regardless of whether the film is live action or not. It would be easy to pick that theme out from certain markers of the narrative and visual structures of a given film. Surely nobody can overlook the recurring elements in Oshii's films such as dogs, helicopters, birds, dreams and reality, and mirrors. However, the unity or consistency of these themes is not the foundation for Oshii's position that film is equal to animation. That is related to a more materialist, or at least a more physical, dimension.

We could say that the actor Chiba Shigeru (the voice of Megane in the *Urusei Yatsura* TV series and films [1981–91], performer for characters Todome Kôichi in *The Red Spectacles* [*Akai megane*, 1987] and *Stray Dog: Kerberos Panzer Cops* [*Keruberosu jigoku no banken*, 1991], and performer for Maruwa Rei in *Talking Head* [*Tôkingu heddo*, 1992]) has a privileged existence in Oshii's films, yet it is one that originates in Oshii's own unique methodology as a director. In live action, Oshii treats Chiba's physical body and character almost as if they were those of an anime character, although it is not as if he is making Chiba perform cosplay (anime costume play). At the same time that Oshii strongly fictionalizes Chiba's gestures, dress, and manner of speaking, he also endows Chiba with the sense of reality

> WHETHER THE CHARACTERS HAVE BIG ANIME EYES, ARE DRAMATIC COMIC (*GEKIGA*) DESIGNS, OR ARE PERFORMED BY LIVE ACTORS, AS IMAGES THEY ARE ALL OF EQUAL VALUE.

you would get from someone on the street. All of the actors in Oshii's films are required to retain a similar sense of everyday reality within an extremely theatrical acting and direction style. Conversely, the physicality of Yomota Inumaru and the other characters in the anime *Three Cheers for Our Ancestors* (*Gosenzosama banbanzai*, 1989–90) is constituted in two dimensions through acting and gestures that could almost be called Brechtian.

Actors and characters in these cases can have only a thoroughly arbitrary existence. The actors' bodies in Oshii's work are nothing but automatons. Oshii turns out to have been a "puppet master" himself.

BREATHING LIFE INTO ANIMATED DRAWINGS

While Oshii's work *animates* physical bodies, it also attempts to *embody* animation characters. Film scripts written by Oshii himself, as well as those by his regular collaborator, Itô Kazunori, have always been famous for their long lines. The scripts make regular use of monologues, conceptual and allegorical language, and blunt and businesslike terminology full of nuance. While the characters' physicality is made arbitrary and fictionalized, their elocution is directed in a way that clearly gives them a sense of reality. I believe Oshii's style of directing dialogue represents a major distinguishing point between his work and other animated films. By adding subtle *breaths* into the script, he creates a unique rhythm in the dialogue. As a result, the drawings literally have life breathed into them—are embodied—while the actors' voices are fictionalized and animated. (Consider, for example, Chiba's character Megane in *Urusei Yatsura*. Chiba is the only actor who has experienced both layers, living on both sides of this procedure to animate physical bodies and bring a physical sense to the animated.)

Whether the characters have big anime eyes, are dramatic comic (*gekiga*) designs, or are performed by live actors, as images they are all of equal value. We should understand that this crisscrossing of images is exactly what defines the animate. To speak of anime's position as a genre from perspectives other than this would be reactionary. This is because if one pins down the patterns of animated expression and drawings and establishes them as a genre, the perspective that "film itself can always already be animation" will be lost, and it will then become impossible to get a grasp of the animate elements that fill Oshii's so-called live action films. The decision not to invoke so-called anime drawings in such a definition does not indicate any disrespect for anime as a genre.

In that sense, the interpretation endorsed by Azuma Hiroki—that, compared with the tendency toward an irrational animation style in *Three Cheers for Our Ancestors* and *Urusei Yatsura 2: Beautiful Dreamer* (*Urusei yatsura 2: byûtifuru doriimaa*, 1984), the tendency toward more realistic animation in *Patlabor* (*Kidô keisatsu patoreibaa za mûbii*, 1989), *Patlabor 2*, and *Ghost in the Shell* (*Gôsuto in za sheru: kôkaku kidôtai*, 1995) represents a retreat from an animate style—is based on a severe misunderstanding. With such a superficial critique, the author only renounces his own opportunities to encounter the kind of exchange Oshii has organized between animation and film. (This argument also impoverishes channels for discussing post-Oshii animators like Anno Hideaki.)

INVESTIGATING THE ANIMATE

Certainly, in Oshii's most recent films such as *Ghost in the Shell*, the character design has become realistic, and there are few *mecha* that look strikingly anime-like. But those who declare that anime cannot be established as an autonomous genre if the characters don't have the right kinds of eyes are only helping systematize anime's potential as a genre and turn it stale. For Oshii, the issue is, rather, the ambivalence of animated pictures. He takes no steps to pursue realism at all. It is more animate to disregard how the characters' faces look. Oshii uses actors' bodies like animation in his live-action films and brings the blur, distortion, and devices of the camera into his animated films like *Patlabor* and *Ghost in the Shell*. We must not neglect the significance of these transgressions and speak of impressions from superficial personal taste alone. (I should add that Anno Hideaki also highlighted the problem of choice between the arbitrariness and potential reality of animated pictures in the final episode of the TV series *Neon Genesis Evangelion* [*Shin seiki Evangerion*, 1995–96], following and rivaling this trend of Oshii's work.)

In fact, *Talking Head* quotes from the theories of the film scholar Yomota Inuhiko, kneading Yomota's understanding that "film was originally magic" into the latent thesis that "film was always animation." A consistent narrative critique and metafictional style are pursued in Oshii's films not simply because they are part of the chosen theme or plot. The opposition between reality and fiction or dreams is itself layered upon the opposition between reality and images, and images and animation.

> JUST AS A "DOG" WANDERS AROUND AT GROUND LEVEL AND IS COMPLETELY UNABLE TO TRANSCEND THAT WORLD, A FILMMAKER IS EMBEDDED IN THE MEMORY AND INSTITUTION OF THE CINEMA; HE RESIDES WITHIN IT, FULLY UNABLE TO SEE THE TOTALITY OF THAT SYSTEM FROM AFAR.

Thinking about it this way, one can start to see Oshii's reasons for making multiple variations of the same single structure, a structure that is nonetheless repeated in different ways each time. When a time slip occurs, a character is trapped in a dream dimension, or a hallucination repeats over and over, they are all operating within the filmic activity of eternal recurrence. However, outrageously, Oshii believes the secrets of this activity to be in the kinds of animate things we have just looked at. (Actually, this may also be correct from a historical or media-theory perspective. If that is so, the various problems embraced by auteurism as a critical framework would probably be quite serious.)

All of the lead characters in Oshii's films maintain a posture of defiance and resistance while pretending to have already forgotten it. (Examples include Gotô of the Special Vehicles Section 2 in *Patlabor* and Todome Kôichi, the Kerberos member in hiding overseas.) However, one prerequisite for any kind of resistance is the complete submission to a certain structure and order. In that sense, Oshii clearly takes the position of a prowling "dog" in relation to all cinematic memory. Just as a "dog" wanders around at ground level and is completely unable to transcend that world, a filmmaker is embedded in the memory and institution of the cinema; he resides within it, fully unable to see the totality of that system from afar. Films in the so-called tradition of "films about filmmaking" have a long history of aggressively interrogating the systems and principles of filmmaking—the order, institution, and conventions of film, such as photography, script, editing, production, sound, and the like. But Oshii uses animation as an intermediary space between film and reality, a space in which to put all of those prerequisites under doubt.

THE ETERNAL RECURRENCE OF IMAGES

It is all too obvious to ask if this "reality" is a butterfly's dream. Humans have to live on without knowing if life is a human dream or a butterfly dream. The more important questions are, who is proposing the question, and in what way? Who is answering the question and how are they approaching it? The attitude Oshii takes toward this point in his films is rather simple. He does not try to answer the riddle. Instead, he presents the composition of the riddle itself.

The exciting atmosphere of the "day before the festival" (ante-festum) is not necessarily a romantic thing. This is because the time to take care of necessary tasks (pursuing the riddle's answer) passes even while the result and product of the festival (the riddle's answer) is still totally unknown.

At times this task is presented as something heroic, but Oshii's films invoke nonsense and humor instead, as if they are somehow bashful about dealing with the subject. Women and girls have always been placed at the hinges between dreams and reality in Oshii's films—characters such as the Red Girl (*The Red Spectacles*), the customer (*Talking Head*), the "girl within the dream" (Lum in *Beautiful Dreamer*), and Tang Mie (*Stray Dog*). While this pattern brings a structural stability to his films, it also tends to carelessly arouse a sense of romanticism. (At the same time it is not something I personally dislike.)

It seemed that Oshii had taken measures toward resolving this weak point in *Ghost in the Shell* by using what was essentially his first female protagonist and placing her against the "Puppet Master" character, who was gendered as male. However, in the end there was still a girl cyborg waiting in the final scene.

Another theme that can't be discarded in Oshii's films is that of mirrors and alter egos. Either deliberately or unaware, characters in Oshii's films always confront their doppelgängers. Todome Kôichi, shot by an empty set of armor; Ataru (*Urusei Yatsura*), shocked to see himself in a hall of mirrors; the girl with the egg who overlaps with herself in the water in *Angel's Egg* (*Tenshi no tamago*, 1985); the drifting anime director who faces himself as a crazed film director in *Talking Head*—all of these characters unsuspectingly run into their double and struggle against it. It would be easy to label this phenomenon a result of Oshii's paranoia as a film director, but if we did so we would end up overlooking the mirrors and doubles we encounter ourselves. Instead of shattering the mirror, it would be much more challenging and enjoyable to investigate the structure of this phenomenon.

To watch Oshii Mamoru's film/animation is precisely to take part in that investigation.

THOMAS LAMARRE

The Multiplanar Image

When I take the Shinkansen, I love watching the countryside stream past the windows. I can't help but recall Paul Virilio's remark, that the landscape seen from the train window is art, just as much as the works of Pablo Picasso or Paul Klee. Virilio calls the effect of speed on the landscape an "art of the engine."[1] And he associates it with cinema. "What happens in the train window, in the car windshield, in the television screen, is the same kind of cinematism," he writes.[2] For Virilio, this art of the engine, these effects of speed, for all their beauty, are deadly. Cinematism entails an optical logistics that ultimately prepares us for the bomb's-eye view, consigning us to a life at one end or the other of a gun, or missile, or some other ballistic system. Maybe it's just me, but as I look at the landscape from the bullet train, I watch how the countryside seems to separate into the different layers of motion, and how structures transform into silhouettes. These effects make me wonder if there is not also an "animetism" generated through the effects of speed. This animetism does not turn its eyes from the window in order to align them with the speeding locomotive or bullet or robot. It remains intent on looking at the effects of speed laterally, sideways, or crossways. Consequently, animetism emphasizes how speed divides the landscape into different planes or

layers. In addition, it gives the impression that it is not simply the train that moves; the entire world is in motion.

In one of the early sequences in Ôtomo Katsuhiro's *Steamboy* (2004), as the young hero travels by train to London, the English countryside streams past the window, and the landscape—a series of rolling hills, clumps of trees, and small houses—looks like a diorama (Figure 1).[3] But it is not one of those dioramas that use three-dimensional figures and scale models. It recalls the ones that children make in school with a shoebox and cardboard cutouts. Each house and hill and tree is decidedly flat, as if cut out and pasted in place. All sense of depth comes from the play between the cutout layers. As your viewing position moves, you distinctly feel the gap between these different layers or planes. The gap between layers is hard to catch by looking at a static series of screen grabs, so you'll have to imagine the effects of motions (or see the film on a large screen, which really accentuates the play between layers).

FIGURE 1. Sequence from *Steamboy*.

The depth of these open layers is a strange depth—strange, that is, in comparison with the hyper-three-dimensionality that is now familiar to us from digital animation in the style of Pixar; strange, too, in comparison to cinematic norms. The diorama style in *Steamboy* does not construct depth in accordance with the conventions of geometric perspective. This animetism focuses less on realism of depth than on realism of movement. It lingers on the effects of speed, but here the image's different layers seem to move independently of one another. The result is a multiplanar image.

Of course, in this "steampunk" tale, Ôtomo goes to great lengths to evoke and alter technologies of the Victorian era, and his use of diorama-like landscape is part of the historical conceit. The diorama recalls optical technologies of the period, and the sequence emphasizes the diorama effect by slowly

pulling away from the landscape to frame it in the train window—a perfect dioramic moment. The multiplanar image is not limited to *Steamboy* or to old-fashioned optics, however. In *Spriggan* (1998), for instance, in the sequence in which the young hero drives through Istanbul, the landscape appears as a collection of flat, superimposed layers of buildings (Figure 2). Again you feel the openness between the flattened planes of the image, which defies certain conventions of depth yet imparts a distinctive sense of movement. Rather than move into the landscape, you seem to move across it, soaring, speeding, spinning, wheeling.

FIGURE 2. Sequence from *Spriggan*.

Since Ôtomo also worked on *Spriggan* (as general supervisor), you might think that these multiplanar effects are part of his distinctive style, or of Studio 4°C, which is associated with experimental styles, not only on Ôtomo projects such as *Memories* (1995) and *Spriggan* but also on series like *Eternal Family* (*Eien no kazoku*, 1997–98) and films like *Mind Game* (2004). Multiplanar effects, however, appear all the time in animation, not only in Ôtomo films or experimental animation. These travel sequences from *Steamboy* and *Spriggan* touch on something fundamental to animation—at least to those forms of animation that grow out of cel animation.

THE MULTIPLANE CAMERA

A basic feature of cel animation is the layering of celluloid sheets, or cels, which produces odd effects of depth—odd, again, from the standpoint of certain conventions of rendering depth. Take a very simple scenario, for instance, in which you draw the lines of a character in dark ink on a transparent sheet of celluloid and carefully apply colors. You then place the character cel on top of a background (painted on celluloid, glass, or some other support). Two layers alone can produce effects of depth. If you draw and color the background somewhat lighter than the character, the more boldly drawn character will appear closer to the viewer—which is usually the desired effect. Now you draw various positions of movement for the character and take exposures. When projected, the character will appear to move in the foreground; if you slide the cel a bit, the character seems to move over or across the background. Still, as depth goes, this is not all that deep.

The difficulties begin when you want to create illusions of movement in depth, as Walt Disney did in the early 1930s.[4] As you stack more and more cels, you can create some sense of depth, but you also begin to get silhouette effects, and a host of other problems arise. For instance, the colors of the lower cels tend to change, and lighting becomes difficult. Things truly take a turn for the worse, however, if you want to create the sensation of moving into or out of a background—for instance, if you adopt the viewing position of a character moving toward something in the background. Say that you want to create the sensation of walking toward a barn under a full moon. You can change the camera focus (zooming in or out) or move the camera closer or farther away from the picture. The problem is that, as the barn gets bigger, so does everything around it in the picture. The moon, for instance, also grows larger—rather than remain the same size, as it ought. Piling on

additional layers doesn't help with this problem. To ensure that everything in the image remains in scale while moving into the image, you would have to draw a series of backgrounds at different scales, each depicting the landscape a bit closer, with the sizes of barn and moon changing appropriately.

Actually, this is not merely a problem of creating an illusion of depth, as is commonly supposed. Nor is it a problem of depicting movement toward or away from the camera. It is easy enough to depict movement away from the camera: draw the character smaller and smaller (or bigger and bigger); successive exposures make the character appear to move and vanish into the landscape. Miyazaki Hayao's *Castle in the Sky* (*Tenkû no shiro Rapyuta*, 1986) provides a good example: as Sheeta falls from the airship toward the ground, she gets smaller and smaller (Figure 3). Thus she appears to move away from us. Moreover, the images of Sheeta "falling" (that is, shrinking) alternate with images of the pirates looking at her fall, who also become smaller and smaller. Thus you know that Sheeta and the pirates are moving rapidly apart. Nonetheless, such a scenario does not give you the sensation of falling, of dropping into the image, of plummeting through the night sky toward the city lights below. You don't have the sensation of movement into the depths of an image—the ballistic angle, as it were.

> APPARENTLY, CONVEYING A SENSE OF MOVEMENT INTO THE IMAGE BECAME AN OBSESSION FOR WALT DISNEY.

Apparently, conveying a sense of movement into the image became an obsession for Walt Disney. As the story goes, he felt that he could not make his feature-length animated film (*Snow White*) without the ability to produce the sensation of movement in depth—the sensation of a changing point of view and of accelerated camera movement. Prior work on animated shorts had introduced techniques of drawing, overlapping layers of cels, lighting, and camera movement to produce various kinds of movements as well as sensations of weight and dimensionality. But Disney aimed for something analogous to cinema's "motionless voyage" into the world on the screen.[5] His solution was to introduce gaps between the layers of cels. Inspired by the creation of depth on the stage with its layers of scenery, Disney designed an apparatus, the multiplane camera, which allowed him to regulate the distances between layers, which he then calibrated in accordance with a shift in camera focus and position. In 1940 he received a patent on the multiplane camera, which he had already put to use in a *Silly Symphonies* segment called "The Old Mill" (1937). But it was in *Snow White and the Seven Dwarfs* (1937) that the multiplane camera came into its own, remaining the dominant means of

conveying a sensation of motion in depth well into the 1990s. Even today, digital animation software packages emphasize their abilities to produce multiplane camera effects.

While Disney surely deserves credit for the multiplane camera, it is also true that animators had been experimenting with this problem of layers since John Bray first introduced the use of transparent cels in 1914. In a 1933 photo, you see the Japanese animator Kimura Hakusan working with a rather sophisticated animation stand.[6] While it is not clear from the photo whether he could use this stand to introduce significant gaps between layers, such a development is clearly not far off, given the arrangement of lights, camera, and glass panes. Because Japanese animators were already playing with the use of multiple layers of cels, the multiplane system did not present any technical obstacle. Already, by the late 1930s, animation stands were beginning to introduce separations between different layers of the image. A recent exhibit on Japanese film heritage, for instance,

FIGURE 3. Sequence from *Castle in the Sky.*

displayed the animation stand and camera used by Ôfuji Noburô, whose cut-paper animation met with international acclaim from the 1930s through the 1950s (Figure 4). The real obstacle was budget. It was only during the war when the Japanese government began to provide substantial budgets for animated films imbued with patriotic flavor that some studios could afford to put multiplane techniques to use.

The expense of the multiplane camera comes of the fact that you have to fuss with every shot, which makes it exceedingly time-consuming—and animation costs are above all labor costs. It demands so much attention because each time you wish to move a bit farther into the image, you have to readjust the vertical distances between layers. And if the camera moves inward at an angle, the various layers have to be adjusted horizontally as well. To ensure

大藤信郎アニメーション撮影台
千代紙や影絵によるアニメーションで世界的
にも有名な大藤信郎自作の撮影台。

FIGURE 4. Stand for animation photography constructed by Ôfuji Noburô.

that things shift in accordance with scale, you must finesse the relations among layers shot by shot, vertically and horizontally. Otherwise, the viewer will feel the gaps between layers.

This problem persists in digital animation. In the supplementary disk with commentaries on *The Phantom Menace*, for example, techies talk about problems of movement within the digital image. After they had introduced layer upon layer of architectures into the image, they had to pay close attention when moving the (simulated) camera around because things did not remain in scale. You could see the slippage, or, if you could not exactly see it, you could feel it. Now you would think that computers could correct for the possible "deformation" of scalar relations automatically. But you would have to introduce calculations for every one of the many layers and for their relations, which is not such an easy matter. And if you then decide to add another layer or alter one (as often happens during production or postproduction), everything changes. As a result, the camera doesn't move around very much in many of these digitally composited sequences. Some sequences feel more like tableaux than worlds that you can move around in.

When everything works, however, the results are astonishing, precisely because the multiplane system gives the viewer the impression of being able to move around inside the image, as if the image had become a world. Moreover, the viewer can move around more rapidly and freely than in daily life. You can zip around. Cinema also aims for such effects, from its earliest attempts to produce a voyage into the world on the screen. As Nam June Paik says, "Cinema isn't to see, it's to fly."[7] I would add: cinema is to fly when it strives to produce a sense of movement in depth, giving you the sensation of speeding inside the image. Initially, the multiplane camera may seem nothing more than an attempt to imitate in animation the high-speed movement in depth that is characteristic of cinematism. But animation is not a simple repetition of cinematism. Multiplane techniques in animation can actually push beyond the limits of live-action camerawork. Animation has the potential to fly faster and farther. In this respect at least, animation does not merely replicate or simulate the ballistic-style optics of cinematism. It is a multiplication and even a "powering" of it—cinematism to the tenth power. Or at least, the

multiplane system has the potential to raise cinematism to another power. Needless to say, this is one of the prime uses of digital animation right now. Think of the chase scenes in *The Incredibles* (2004) in which Dash zips around. Of course, it costs a bundle, this digitally animated cinematism-to-the-tenth-power, this supercinematism.

But what happened to animetism, to those sliding layers that I opened with?

THE MANGA FILM

Multiplane camera techniques allow the transformation of animation into a supercinematism by pushing the limits of movement in depth. Animetism, however, begins to happen when you do not have the time, money, or, more important, the interest or inclination to fuss so much with the layers. Or, more precisely, animetism is what happens when you begin to prefer the sensation of openness between layers, or when you favor a flattening of layers. Animetism puts less emphasis on compositing the image tightly, on hiding the gaps between the different layers of the image as the camera (or viewing position) moves. Still, animetism is not the opposite of compositing. One kind of animetism favors an "open compositing" in which the image's layers are allowed to move more independently of one another. While open compositing tends to work against sensations of movement in depth, it makes possible other sensations of movement. Open compositing does not have you look from the tip of a bullet speeding directly, in a straight line at its target—or the train rushing straight down the rails, or the camera moving into a world. It not only looks at speed sideways, it also gives a very different sensation of motion, and of relation to the world.

Open compositing is not the opposite of speed, then: it is one kind of animetism that uses the multiplane concept to produce different effects of speed.

> ANIMETISM BEGINS TO HAPPEN WHEN YOU DO NOT HAVE THE TIME, MONEY, OR THE INTEREST OR INCLINATION TO FUSS SO MUCH WITH THE LAYERS.

For animetic effects, you introduce separations between various layers of the image in a stand, as with the multiplane system. But you don't adjust the distances between layers to keep things perfectly in scale when you move the camera. Thus, as the camera moves (or the focus changes), the elements in different layers will appear to pull apart or to draw closer together as they become smaller or larger. The effect is like

FIGURE 5. Sequence from *Castle in the Sky*.

that of curtains opening and closing. Because the camera has moved (or its focus has changed), however, you have the sensation of sliding across the image more than moving into it.

Moreover, rather than hold the layers in place and move the camera, you can hold the camera in place and move the layers. In other words, you can move the drawings rather than draw the movement. In this respect, rather than strive to produce a sense of the camera moving into and around inside a world, animetism plays with the relative movement of different layers. This is one way to play with the multiplanar image. And the viewing position of the camera loses its privilege; it becomes another layer.

In Miyazaki Hayao's *Castle in the Sky*, after Sheeta and Pazu crash-land on the castle, they begin to explore their surroundings. As they walk to the edge of a cliff, a foreground layer and a background layer slide apart to reveal the depths below (Figure 5). Again, this is difficult to render with a series of screen grabs, but a close look at the images should demonstrate that, rather than a movement into depth, this sequence involves a sliding of the image's planes. You don't have the sense of moving into the image. Likewise with the views of the castle: layers of clouds are slowly pulled across and between layers of architectures. Although there is no movement in depth, the effect is panoramic, and you definitely have the sensation of movement, even a slightly giddy sensation.

Miyazaki generally avoids the sort of compositing associated with the multiplane camera. Although he certainly has access to large budgets and computer technologies that would allow him to lessen the sensation of movement between layers, he prefers not to. For the most part, he restricts the use of digital technologies to coloring or painting. This resistance stems from reluctance to composite the image, which would enable certain ballistic effects of speed. Indeed, when he does resort to computer animation, the sequences

tend to stand out, as with the scenes in *Princess Mononoke* (*Mononoke-hime*, 1997) in which a wild boar charges after the hero (Figure 6). It stands out because, even though digital compositing would make it possible to produce effects of motion in depth, Miyazaki emphasizes lateral movement in ways that undercut the sensations of depth.

In a general way, Miyazaki dislikes the sort of cinematism that Virilio describes and denounces in so many of his books. Miyazaki appears as resolutely opposed to cinematism as Virilio. Yet Virilio does not think it will be easy—and it may no longer even be possible—to strip away the effects of modern technologies, to get back to a slow, nonballistic world fashioned on the scale of the human body and its senses. In his animated films, however, Miyazaki seems more optimistic than Virilio. He goes to great lengths to create a slow, human-scaled, nonballistic world. He labors to avoid cinematism rather than to denounce it.

Miyazaki thus prefers the lateral view of motion over motion in depth. He favors the sliding sensation of speed. Only rarely in his works do you see

from the perspective of a speeding vehicle, and even then the vehicle is likely to be a bicycle or a glider or a flying broomstick. Usually, you glide alongside the glider, as if gliding yourself, rather than zeroing in on a destination or target. Compositionally as well, he often turns to the slippery

FIGURE 6. Sequence from *Princess Mononoke.*

staircase, the canted deck, the tilting plane, and then gives you a sideways impression of falling, slipping, careening. In his resistance to cinematism, he strives to invent "nice" effects of speed, ones that are closer to the human body or, rather, to the child's body and imagination. The child looms large in Miyazaki's animetism precisely because the child's body is not yet completely habituated to ballistic effects of speed. In this respect, Miyazaki's children or tweens are not so much about purity or innocence as about a sensory-motor openness, elasticity, and malleability. The child does not simply return you to the old pretechnological world but opens the possibility of a posttechnological world. At the level of narrative, too, Miyazaki avoids reaching a destination or conclusion or coming full circle. He avoids both linear progressive movement and cyclical regressive movement. Even his stories tend to move laterally, sideways, diagonally.

> MIYAZAKI WORRIES THAT, EVEN THOUGH HIS GOAL IS TO GET KIDS AWAY FROM THE TELEVISION AND ITS BALLISTIC OPTICS THAT DESTROY THEIR IMAGINATIONS AND RELATIONS TO NATURE, HIS MANGA FILMS MIGHT PROVE JUST AS HARMFUL AS ANIME.

Miyazaki openly expresses his dislike of what he sees as the violence and ballistic optics of anime (that is, *terebi anime*, or television animation), insisting that his works are "manga films."[8] It often seems that he sees television anime as an extension of cinematism. Indeed, he suggests that anime is not unlike Hollywood films and American TV in how it uses character and genre, and how it stresses violence. Put another way, for Miyazaki, anime appears to be a variation on the cinematism of the action film. And his resistance to cinematism entails a resistance to action films in general. But what of Miyazaki's movies? Aren't many of them like action genres?

Rather than rejecting action altogether, Miyazaki uses animetism to rethink and rework action. This is especially true of his earlier films. But even his more recent films rework action genres—what is *Princess Mononoke* but a reworking of the action and narrative patterns of the samurai film? This is also where difficult questions arise. Is it possible to make an action film without all the "bad" effects of action films? This is what open compositing is supposed to do in Miyazaki's manga films. But Miyazaki himself has doubts. He worries that, even though his goal is to get kids away from the television and its ballistic optics that destroy their imaginations and relations to nature, his manga films might prove just as harmful as anime.[9] What's to prevent kids from watching *My Neighbor Totoro* (*Tonari no Totoro*, 1988) over and over, rather than getting out in the garden (if they have one)? In other

words, even though the animetism of the manga film may produce different effects of speed than cinematism, those effects are nonetheless effects. As Miyazaki is well aware, the emphasis on sliding layers and gliding movements in his films could never be unquestionably, unambiguously, safe or natural or noninstrumental. Ultimately, his films are about radically limiting the optical logistics and ballistic instrumentality that come with cinematism. This is why so many of his films entail a quest for worlds based on clean, nonimpact sources of energy—usually the wind and human muscle. His is a quest for another, better kind of action, another, better kind of energy, another, better kind of animation.

This is why Miyazaki and his associates at Studio Ghibli tend to disparage anime (television animation), seeing it as not so different from the ballistic optics of cinematism (and its genre worlds). But is the action of so-called anime really just a capitulation to cinematism? Other commentators resolutely disagree. They see Japanese television animation as deliberately flat and two-dimensional. If flatness defines anime, then how could anime achieve the motion in depth characteristic of cinematism? How could it produce the same techno-political violence?

An insistence on the flatness, or two-dimensionality, of anime comes to the fore in the notion of the "superflat" lineage of Japanese art conceptualized and promulgated by the artist Murakami Takashi.

SUPERFLAT

The problem of cinematism—of motion in depth—can also be seen as a problem of geometric perspective. Geometric perspective (sometimes called linear perspective) makes the objects in a drawing look as if they recede into the distance, appearing smaller the farther they are away from you. To produce geometric perspective, you have to use perspective lines. That is, you need to draw straight lines at an angle that converge at a point, the vanishing point, on the horizon line (an imaginary line at eye level in the drawing). Such lines allow you to draw three-dimensional objects in scale in three-dimensional space. Clearly, cinematism depends on a sense of geometric perspective. The multiplane camera, for instance, is supposed to allow you to produce the sensation of cruising around in a 3-D world, by ensuring that the different layers of the image remain consistent with geometric perspective even as the camera angle shifts. Simply put, the multiplane system keeps the world of cels in scale even as the camera moves.

Television animation in Japan has rarely had the time, money, or inclination to produce multiplane camera effects. It may come as no great surprise, then, that Murakami sees, in Japanese television animation, a compositional timing that directs the "movement of the observer's gaze along planes." Like the art of early modern Japan (especially ukiyo-e woodblock prints), anime makes the viewer aware of the image's "super-planarity."[10] In other words, Murakami sees in the anime image an extreme flattening of depth that makes everything seem to lie on the same plane. Murakami doesn't seem interested in the gaps that can arise between layers of the image as your viewing position moves. Murakami pays no attention to multiplane effects at all. Everything conspires against any sense of depth whatsoever. You might think of this sort of image as "uniplanar" with a vengeance.

Murakami traces the flatness of the anime image back to the era of "limited animation" in the early 1960s—to the emergence of animated television series such as Tezuka Osamu's *Astro Boy* (*Tetsuwan Atomu*, 1963–66). At that time, animators had neither the time nor the money to produce "full animation," that is, animation that aspired to produce movement as fluid and detailed as cinematic movement. Consequently, they quickly developed techniques designed to present movement in other more economical and schematic ways. What is important in this context is that animators tended to limit the number of image layers—usually to two or three—to a foreground layer with a moving character and the background, sometimes with another layer sandwiched between them, with other characters or an additional layer of background. Significantly, even when there is a gap between these layers, you don't feel it as much as in Miyazaki's manga films. Sometimes there is no sense of gap at all, since it is easier to layer one image closely on another. In addition, animators avoided motion in depth with the camera, moving the camera across the image rather than into it; or they finessed motion in depth by having figures run directly toward or away from the camera, in which case it is enough to enlarge or reduce the character rather than use zooms or close-ups. A character on a background of speed lines also provided a sense of movement without any need to fuss with depth effects. Or you could produce movement by pulling the character cel across the background, without moving the camera at all. In sum, it is a combination of such effects that Murakami refers to when he calls attention to the extreme planarity of the anime image.

Murakami's examples of anime are highly selective. His lineage is rather narrow, because he draws heavily on the ideas of Okada Toshio, one of the founders of Gainax Studios and celebrated king of *otaku*, or "otakingu." Like

Okada, Murakami tends to see Gainax series as the heirs of a tradition that begins with the limited animation of the 1960s and extends through the epic series popular with boys in the late 1970s and early 1980s, such as *Space Cruiser Yamato* (*Uchû senkan Yamato*, 1974–75), *Mobile Suit Gundam* (*Kidô senshi Gandamu*, 1979–80), and *Super Dimensional*

> YOU WOULDN'T EXPECT FLATNESS TO BE PARTICULARLY WELL SUITED TO CONVEYING ACTION. AT LEAST, YOU WOULDN'T EXPECT TO SEE BALLISTIC EFFECTS OF SPEED THAT DEPEND ON CREATING A SENSE OF MOTION IN DEPTH.

Fortress Macross (*Chôjikû yôsai Makurosu*, 1982–83). For Okada and thus for Murakami, it is Gainax Studios above all that builds on this legacy, bringing it to new heights. Still, partial as his lineage of anime is, Murakami's emphasis on Gainax makes sense. After all, Anno Hideaki's *Neon Genesis Evangelion* (*Shin seiki Evangelion*, 1995–96) truly defined a new sense of what anime was and could be. *Evangelion* was (and remains) one of the most successful anime series, and, like many other Gainax series, it consciously references other animated television series. Moreover, the Gainax director Anno deliberately sticks to an extremely limited style of animation. All in all, it is really not surprising that Murakami would adopt Okada's Gainax-centered slant on the history of anime.

In any event, if you're looking for how limited animation turns flatness into superflatness or into "superplanarity," Murakami's examples are good ones, despite *and* because of the Gainax bias. Surprising, however, are the recurring images of explosions, space battles, planetary destruction. Famously, in his superflat exhibit, Murakami highlighted the work of the animator Kanada Yoshinori, including images from the climactic battle scenes in *Galaxy Express 999* (*Ginga tetsudô 999*, 1978–81) (Figure 7). He writes admiringly of "the beauty of that climactic battle scene and the disintegration of the Planet Meteru scene!"[11] In other words, superflat anime is not in opposition to action, or to genres of space war and futuristic military action. This is surprising because, after reading about the multiplane camera, you wouldn't expect flatness to be particularly well suited to conveying action. At least, you wouldn't expect to see ballistic effects of speed that depend on creating a sense of motion in depth.

Rather than dwell on the images in Murakami's exhibit, I would like to present a sequence from a more recent Galaxy Express 999 movie—*Ginga tetsudô 999: Eternal Fantasy*, 1998)—to give a sense of the ubiquity of these superflat explosions (Figure 8). In this sequence you see the train spiraling outward as bits of flaming wreckage from an explosion. This sequence has

FIGURE 7. Sequence from *Galaxy Express 999*.

neither the ballistic movement in depth characteristic of cinematism nor the open compositing favored in Miyazaki. As Murakami notes, everything calls attention to the image's planarity. But what is the relation between the superplanar image and genres of future war action and mass destruction?

Murakami finesses the relation of superplanarity to action by stressing the beauty of Kanada's sequences, as if their beauty allowed them somehow to transcend the story's depiction of violence, chaos, and death. But what kind of action is this superplanarity? Should we see superflatness only in those moments when the composition and timing of limited animation calls our attention to the planes of the images, to their flatness, thus taking us to an experience beyond that of war (yet in the midst of war)? Does the super-flatness of limited animation take us into an aesthetic realm beyond action? Or is it a new or different kind of action from cinematism?

Murakami isn't really interested in such questions. But, when pressed to deal with them, he tends to associate the superplanar effects of anime with inaction and impotence. This is already apparent in his superflat exhibit in his treatment of the art of Nakahashi Katsushige, who takes photographs of small models of Japanese Zero fighter planes and tapes them together to make a full-scale paper model, which is then burned. Nakahashi links the production of these paper planes to sites of Japanese violence during World War II, pulling members of the local community into the project, encouraging them to help carry the model to the site and burn it. Where Nakahashi stresses the politics of remembering the war and Japanese imperialism and aggression, Murakami sees a demonstration and reminder of "the impotence of the Japanese themselves."[12] Indeed, impotence runs like a refrain through Murakami's conceptualization of superflatness. More recently, Murakami has made a third entry in his superflat trilogy, a 2005 exhibit at the Japan Society Gallery in New York titled Little Boy: The Arts of Japan's Exploding Subculture, which stresses the feeling of impotence experienced by a generation of Japanese boys in response to Japan's defeat, as manifested in their responses to the atomic bombs dropped on Hiroshima and Nagasaki—code-named "Little Boy" and "Fat Man." For Murakami, images of nuclear destruction that abound in anime (or in a lineage of anime), together with monsters born of atomic

FIGURE 8. Sequence from *Galaxy Express 999: Eternal Fantasy.*

radiation (Godzilla), express the experience of a generation of Japanese men of being little boys in relation to American power, of being unable to become men, while eternally full of nostalgia for their boyhoods.

This insistence on the impotence of the Japanese (male) in relation to the potency of the United States has a long and complicated history.[13] But it is clearly part of a cultural nationalism that would erase the history of Japanese militarism, reconstructing national values by lingering on Japan's subordination to the United States. Not surprisingly, Murakami turns out to be rather

ambivalent about Japan's support for the American invasion and occupation of Iraq. After all, in his world, little boys just want to become men, and becoming a man means driving military vehicles.

If it is possible to set aside, at least temporarily, Murakami's transformation of superflat into Japanese nationalism and militarism, there may be another way to think about the superplanarity of the anime image in relation to action. This other way of looking at superflatness calls attention to an information-rich Japan. It does not find a Japan obsessively trying to catch up with America but a Japan that is struggling to situate itself in transnational networks—and succeeding, for the most part.

First, we need to ask how something apparently uniplanar (flat) becomes superplanar (superflat). Superflat implies that something is not simply flat but very, very flat—complexly flat. To make something look superflat, you have to begin with layers that introduce the possibility of depth and then crush it. As I've already discussed, such layers can be tightly composited as in the multiplane camera system, allowing motion in depth. Or they can be openly compositing, allowing more animetic possibilities—sliding and gliding and wheeling effects—a sort of motion over or across depth. You achieve superflatness, however, only by having complex layers and making them all appear equally on the surface, and equally important visually. In other words, backgrounds or intermediate layers don't fade away, allowing themselves to be overlooked. On the contrary, they push to the fore. Oddly enough, very flat backgrounds—say, a background of a single color or one composed of speed lines—often appear as important as the figure that they highlight. Depth comes right to the surface even as it serves to direct attention to the character. Foreground and background become equally striking.

This is the basic idea of superflat: no element within the image is more important than any other element. The result is a visual field without any hierarchy among elements. You could also call this a distributive visual field, since elements are distributed rather than hierarchized. Of course, you might argue that this is bound to fail because viewers automatically select certain elements of an image as more important than others. But this is precisely the effect that superflat strives for. When everything comes equally to the surface, you still make connections, you will still orientate yourself, but those connections and orientations will not be guided by depth cues. There is greater potential for disorientation, since elements are not only distributed but also densely packed. (Murakami's art, for instance, is nothing if not busy, as are his anime examples.) But now you are orientating yourself in a very different kind of space (different from spaces designed for motion in depth,

that is). Now you are orientating yourself in a densely packed distributive field—a sort of information field. Rather than simple flatness, you have complex superflatness. Here you might think of "super" literally as "over" and "above." For, as you connect elements, there emerges a pattern that is not given directly in the image, which hovers above it, as it were—a set of shifting connections.

A couple examples may explain better how this works in different registers. First, with respect to anime characters, Murakami reminds us of how Kanada allowed animators to assert their individual styles. Usually, animators are supposed to follow the designs of chief animators closely, to ensure that a character always looks the same. Murakami credits Kanada with changing this system, permitting animators to make their own styles visible as they "copied" a character. In some ways, such freedom had already arisen on an ad hoc basis in television animation, for schedules and budgets were tight, and animators often didn't have the time to produce seamlessly identical drawings. In any case, Okada Toshio gives a good example in his book on *otaku*, *Introduction to Otakuology* (*Otakugaku nyûmon*, 1996): he shows renditions of the character Ryô from *Getter Robot* (*Gettaa Robo*, 1974–75) drawn by three different animators, Komatsubara Kazuo, Nakamura Kazuo, and Noda Takuo.[14] Each design is slightly different. Okada remarks that, with the advent of the VCR, anime fans of such series began to pay greater attention to the work of different animators and designers. In effect, fans began to flatten hierarchies between anime producers, watching for patterns of distributed information rather than attributing the series entirely to the director, or writer, or chief animator.

A second example comes from *Evangelion*, with its multiple story lines or, rather, referential and iconic networks. Viewers who watched the series closely (and really, there wasn't much choice but to watch it closely) found that there were patterns of iconic references that led in different directions. Ultimately, Anno would foil all efforts to gather these various information patterns into a single narrative. *Evangelion* leaves viewers with the protagonist Ikari Shinji grappling with his sense of insecurity and his inability to commit to life. In other words, viewers select and follow diverse patterns of information throughout the series, but there is no attempt to hierarchize these different patterns, to draw them all together into an overarching pattern or to select one pattern among the many. In the final episode of the television series, Shinji turns into a modulating set of lines (Figure 9), as if unable to hold himself together, and yet modulation itself steps in to ensure the emergence of something coherent. The series ends (if it can be said to

FIGURE 9. Sequence from *Neon Genesis Evangelion*.

end) with all the characters applauding Shinji (Figure 10). And, while Anno has not pulled anything like his end of *Evangelion* in subsequent works, his series *His and Her Circumstances* (*Kareshi kanojo no jijô*) or *He She* ("*Kare Kano*," 1998–99) and his movie version of *Cutie Honey* (2004) certainly crowd the images with flattened layers of nonhierarchized information, which asks viewers to make superplanar connections and patterns.

In a sequence from the end of the first episode of *Kare Kano* (Figure 11), "she" (Miyazawa Yukino) rushes to the door with an umbrella, thinking that it is her sister, who has forgotten her umbrella and has rung at the door for it. "She" leaps out the door, only to plant her foot squarely in the belly of "him" (Arima Sôichirô). Rather than motion in depth, the sequence is composed of a series of manga-like stills, and at moments of heightened emotion or affect, the image transforms into another color scheme or graphic style. You have affective layers of the "same" scene. Moreover, as the sequences career through radically different image types to create an effect of emotions running wild, Anno introduces layers of words, icons, and symbols that operate at another level. The overall effect is one of flatness, both within and between images, yet this flatness generates new effects (superflatness) with its affective stacks. It is not surprising that another anime theorist, Azuma Hiroki, sees in anime a "database structure."[15]

If Murakami tends to associate superflatness with inaction and impotence, maybe it is because he sees anime fans as submitting passively, masochistically, to the superplanar image. This is speculation on my part, since he never addresses this problem. Clearly, however, the superplanar image (at least as I have extrapolated it from Murakami with an example from *Kare Kano*) would imply a certain kind of viewer, one more comfortable with scanning for information and stacked windows of data. This viewer would be extremely attentive to fluctuations and modulations of the image. Such a viewer would not necessarily be an impotent adolescent but one attuned to

focusing attention at various levels amid a buzz of informatic connections. This is a very different world of viewing from that of Miyazaki's posttechnological children who wheel across panoramic landscapes. Still, the superplanar image is not the opposite of the multiplanar image. In fact, you might think of superplanarity as a special case of multiplanarity, one that goes to extremes.

FIGURE 10. From *Neon Genesis Evangelion*.

Where Miyazaki leaves gaps open between layers, the superplanar image flattens them. Flattening the openly composited depths of the multiplanar image does not get rid of layers, however. Rather, the image's different layers all demand equal attention. And the depths of the image come right to the surface. You see multiple planes at the image's surface. In contrast to the open compositing characteristic of Miyazaki, you have a "flat compositing." As a result, you tend not to have panoramic effects so much as architectures, schemas, and flow charts. The image still has multiple planes, but, because they are not hierarchized, you scan over them rapidly, with details of layers swarming and flashing in new patterns. In brief, the image's multiple planes push toward strobing effects that produce patterns. In this respect, superflat is closer to the spirit of manga reading than the so-called manga film. Or maybe these are very different interpretations of what manga is.

In any event, the superplanar image accelerates the effects of limited animation, pushing multiplanarity to an extreme—toward pure animetism. It flattens the image's multiple planes in order to force multiplicity to emerge at another level, that of information. At the other extreme, you have the pure cinematism that Virilio describes in such lavish detail. Some examples of cinematism in animation come to mind, especially in films that hover between live action and digital action. As more interesting recent examples, I would tentatively suggest *The Matrix* or *The Incredibles* or *Kung Fu Hustle*, but only tentatively. I remain cautious here because neither animetism nor cinematism occurs in pure form. Moreover, a film like *Kung Fu Hustle* pushes cinematism to the point where its speed folds characters back into flatness. Similarly, while there are hypercinematic moments in *The Incredibles*, Pixar has learned that such films work better with rather flattened characters, that is, characters that retain much of the iconic qualities of flat cel animation characters (rather than the hyperreal characters of *Final Fantasy: The Spirits Within* [2001]). Similarly, while Anno pushes toward a hyperanimetism akin

私は今まで絶対に
しなかったミスを

FIGURE 11. Sequence from *His and Her Circumstances*.

to the superplanarity touted by Murakami, superplanarity never arrives in pure form. Many sequences in Anno's *Nadia, Secret of Blue Water* (*Fushigi no umi no Nadia*, 1990–91) come close, though. For instance, in episode 13, in which the little girl Marie wanders off on the island alone and discovers railroad tracks: as she walks down the tracks with the lion named King, their walking is a repeated loop without forward movement (Figure 12). The clouds stay in place, and so do the lion and girl; but, as their limbs move in circles, the grass slides by, and it is the sliding grass that gives the impression of forward movement.

CODA

In sum, rather than the ballistic effects associated with cinematism and its motion in depth, the superplanar image tends to produce motion on the surface, as the different layers of the image vie for attention, transforming the image into an informatic space, a distributive visual field. You might see this superplanarity as just another example of the information bomb, a notion that Virilio borrows from Einstein to refer to a complete collapse of distances resulting from the global spread of telecommunication technologies.[16] Through this look at the multiplanar image in Japanese animation, however, we begin to see some things that do not occur to Virilio, with his emphasis on almost mythic oppositions—the old, slow, human-scaled world versus the new, accelerated, posthuman world.

First, as Miyazaki's push toward a slower, greener world of human proportions indicates, that world is not really prior to or outside the allegedly posthuman world. Rather, his more livable world comes from opening gaps *within* the ballistic operations of the posthuman world. You need only introduce spaces of play into cinematism, which allow you to limit its effects and its purchase on the imagination, radically. Miyazaki's open compositing transforms cinematism by imposing extreme limits on its tendency toward motion in depth.

Second, as Murakami's notion of superflat and Anno's extremely limited animation suggest, the tendency toward a superplanar field, a distributive visual field, has a direct relation to information. And, although I began this exploration of the multiplanar image with Virilio's ideas in order to highlight some of the techno-politics of manga films

FIGURE 12. Sequence from *Nadia: The Secret of Blue Water.*

and television anime, I would still insist that these animations are more interesting than the ballistic cinematism that comes to the fore in most of today's big-budget 3-D digital animation—precisely because their animetic relations to the information bomb are more complex and decidedly less nostalgic. Nevertheless, the complexity of Japanese animations is not attributable to a Japanese sense of impotence or inferiority vis-à-vis American global hegemony and military power (as Murakami would have it). Nor is it merely a bid for an alternative (Japanese) vision of the globalized world. Rather, we come face to face with complicity between different realms of media production in the contemporary world. We glimpse the tendency toward a unilateral world in which nations operate on the surface only to extend the reach of total war via information. Yet that experience, too, is full of complex dislocations and confabulations, full of worlds. This is an experience that the animetism of Japanese animation offers, in very diverse ways. One variation on that experience would be rather like riding the Galaxy Express from *Galaxy Express 999*, which Murakami cited as an example of extreme planarity.

Rather than looking out the window of the bullet train, we're now in an old-fashioned train somehow retooled for flight into outer space (Figure 13). Clearly, the animetic effects of this Galaxy Express are not only due to acceleration, to looking out from an ever-faster train approaching rocket speed. Animetism is not only an experience of speed that gives you the sensation of transcending older bodies, technologies, and limitations. Animetism is also an effect of reworking and rethinking what was expressed in those older modalities. In its awkward and mawkish way, this is what *Steamboy* attempts to do: to think animetically about the history of technology. While *Steamboy* may not be considered a great success, it does serve as a reminder that animetism entails more than putting the same old multiplane camera effects in new software packages. Animetism is an experimentation that challenges the multiplane system and opens it in new directions, whose techno-politics have yet to be explored. I would hazard to say, however, that the future worlds of animation lie in those animetic directions.

FIGURE 13. From *Galaxy Express 999: Eternal Fantasy.*

Notes

1. Paul Virilio, "Cyberwar, God, and Television: Interview with Louise Wilson," in *Digital Delirium*, ed. Arthur Kroker and Marilouise Kroker (Montreal: New World Perspectives, 1997).

2. Paul Virilio, *Pure War*, 2nd ed. (New York: Semiotext(e), 1997), 85.

3. Special thanks to Heather Mills for her assistance in locating images.

4. This account derives in part from the discussion titled "The Multiplane Camera" at the Golden Gate Disneyana Club's 100 Years of Magic, http://www.ggdc.org/mp-100multiplane.htm.

5. Noël Burch, *Life to Those Shadows*, trans. Ben Brewster (Berkeley: University of California Press, 1990), 59. On the problem of motion in cinema in relation to panoramas and trains, see also Jacques Aumont, "The Variable Eye, or the Mobilization of the Gaze," in *The Image in Dispute: Art and Cinema in the Age of Photography*, ed. Dudley Andrew (Austin: University of Texas Press, 1997).

6. Yamaguchi Katsunori and Watanabe Yasushi, *Nihon animeeshon eiga shi* (*A History of Japanese Animation Films*) (Osaka: Yubunsha, 1977), 33.

7. Cited in Paul Virilio, *War and Cinema: The Logistics of Perception* (London: Verso, 1989).

8. See Miyazaki Hayao, "Animation to manga eiga" (1982) in *Shuppatsuten 1979–1996* (Tokyo: Studio Ghibli, 1996), 151–52. In 1984 Miyazaki specifically refers to *Castle in the Sky* as a manga film in "'Tenkû no shiro Rapyuta' kikaku gen'an" ("Original Plans for 'Castle in the Sky Raputa'"), also in *Shuppatsuten*, 395.

9. See Margaret Talbot, "The Auteur of Anime," *New Yorker*, January 17, 2005, 70.

10. Murakami Takashi, "*Sûpaafuratto Nihon bijutsu ron*—a Theory of Super Flat Japanese Art," in *Superflat* (Tokyo: Madra, 2000), 12–13. Translation modified.

11. Murakami, "Visual of Superflat Manual," 114–15.

12. Ibid., 120–21.

13. Among the many discussions of this problem, see Michael S. Molasky, *The American Occupation of Japan and Okinawa* (London: Routledge, 1999); and John W. Dower, *Embracing Defeat: Japan in the Wake of World War II* (New York: Norton, 1999) for cogent overviews of the sexual and racial politics arising in the wake of the American Occupation of Japan.

14. Okada Toshio, *Otakugaku nyûmon* Shinchô OH! Bunko 019 (Tokyo: Shinchôsha, 1996), 16–17.

15. Azuma Hiroki, *Dôbutsuka suru posutomodan: Otaku kara mita Nihon shakai* Kôdansha gendai shinsho 1575 (Tokyo: Kôdansha, 2001).

16. Paul Virilio and Sylvère Lotringer, *Crepuscular Dawn*, trans. Mike Taormina (New York: Semiotext(e), 2002), 135–36.

ANTONIA LEVI

•••

The Werewolf in the Crested Kimono: The Wolf-Human Dynamic in Anime and Manga

Two years ago, when I taught a class in horror anime at Portland State University, a student asked me why the werewolf in *Vampire Hunter D* was so "lame." I replied that because the Japanese have no werewolf tradition, this werewolf and the few other examples we might see were simply included as a nod to Western vampire legends and movies. I commented briefly on the difference between Japan's animistic and Buddhist traditions and Judeo-Christian ideas regarding the human soul, sin, and sexuality that underlie the werewolf concept. And then, I dropped the topic. I owe that student an apology.

Since that class, I have reconsidered the matter and have concluded that my definition of *werewolf* was too narrow and too Eurocentric. If we define *werewolf* more generally as any fictional wolf-human (and/or sometimes dog-human) dynamic that is used to frame discussions about the nature of humanity, humanity and nature, humanity and the social order, human sexuality, and gender roles (all themes traditionally addressed in Western werewolf stories), then it becomes apparent that anime and manga feature a wide variety of such creatures that are used to address similar concerns, although how those concerns are addressed is strikingly different and, in some cases, diametrically opposite. In anime and manga, werewolves and other animal-human shape-

shifters are seldom depicted as the stuff of horror, and their wolf or dog form is often more benevolent and admirable than the human form.

These Japanese "werewolves" actually provide far richer and more complex metaphors for exploring such contemporary issues as humanity's connection to nature and other animals, conformity and pariahs, and gender roles. Japanese mangaka (manga author-artists) routinely use shape-shifters of all sorts to explore these issues, while American authors, cartoonists, screenwriters, and game programmers struggle to create a more flexible view of the human-animal relationship, often drawing on Native American traditions and occasionally on Japanese examples.

> HUMANS WHO TURN INTO ANIMALS ARE RARE IN JAPANESE TRADITIONS, BUT THE OPPOSITE IS NOT.

In this chapter, I consider the representation of werewolves, or at least wolf-human hybrids, in Tezuka Osamu's 1986 *Hinotori: Taiyôhen* (*Phoenix: The Sun*),[1] Miyazaki Hayao's 2000 *Mononoke-hime* (*Princess Mononoke*), Nobumoto Keiko's 2005 *Wolf's Rain*, and Takahashi Rumiko's 2004 *InuYasha*. It should be noted that these are very different types of works. *Hinotori* and *Mononoke-hime* are considered classics and works of art; *InuYasha* and *Wolf's Rain* fall more into the category of light entertainment. *Mononoke-hime* is a feature film. *Hinotori* is a single story within a thirteen-volume manga series, which contains many stories embodying the same themes of karma and reincarnation.[2] *Wolf's Rain* is a short television series (30 episodes) and a tragedy; *InuYasha* is a long television series (167 episodes) and a romantic adventure. Nonetheless, all deal with wolf-human hybrids, werewolves, as metaphors to discuss the individual and society, sexuality and gender roles, and humanity's relationship with nature.

It should also be noted that these representations do not always use the word *wolf*. Rather, they describe the creatures involved as mountain dogs (*yama no inu*), dog gods (*inugami*), or dog demons (*inuyasha*), only rarely employing the more specific designation of wolves (*ôkami*). Nonetheless, the illustrations leave no doubt that they are, in fact, wolves.

SOURCES OF ANIME AND MANGA WEREWOLF TRADITIONS

The wolves in the anime and manga described above are mostly uninfluenced by Hollywood or other Western traditions. *Wolf's Rain* and *InuYasha* do incor-

porate one aspect of Western werewolf mythology, in that both assign great importance to the moon. The boy-wolves of *Wolf's Rain* are energized by the full moon and drawn to the scent of the lunar flower maiden. The half-human title character, Inuyasha, is deeply ashamed of the fact that when the moon is full, he transforms into a fully human boy. Clearly, Japanese *mangaka* are aware of, and see the connection of their work to, the West's werewolf traditions. This limited use of Western werewolf traditions suggests that these traditions simply are not as suitable for the kinds of stories these *mangaka* wish to tell using human-wolf characters.

Japanese traditions provide more influential sources for anime and manga werewolves, especially the folklore associated with animal shape-shifters. Humans who turn into animals are rare in Japanese traditions, but the opposite is not. *Tanuki* (raccoons)[3] and *kitsune* (foxes) are the main shape-shifters. Both species are tricksters, but in general, the raccoons are more inclined toward innocent mischief, while foxes are sometimes truly malevolent. Foxes, for example, often appear as beautiful women and lure human men to their doom, or possess the wives of those who cheat them. Raccoons, however, simply do things like turn themselves into tea kettles to reward kindly humans, and then run off when the trick is discovered. Cats and other animals also sometimes display shape-shifting abilities.

The shape-shifting traditions of both *tanuki* and *kitsune* appear in the classic anime *Heisei tanuki gassen pom poko* (*Heisei Era Raccoon War Pom Poko*), a contemporary environmental fable about a band of *tanuki* who use their shape-shifting talents in a futile attempt to frighten away developers who are destroying their habitat. Initially, the *tanuki* reject the solution of the *kitsune* who live happily and successfully among the humans in human form, often as gangsters, prostitutes, and public relations executives. When the *tanuki* fail to save their habitat, however, they are left with no choice. They are not as happy in this role as the *kitsune*. At the end we find the *tanuki* hero, cheerful, courageous Shôkichi, in his human form on a crowded train, another hollow-eyed *salariman*. Although he breaks his journey to answer the call of the wild and rejoin his fellow *tanuki* in a final dance on a small patch of untouched wilderness, we are grimly aware of the joyless life that awaits him when the dancing ends. Animal life is more pleasant and decent in *Heisei tanuki gassen pom poko*.

Heisei tanuki gassen pom poko is very much a trickster tale, as funny as it is tragic, with many unexpected twists and turns, and the shape-shifting played primarily for laughs ("pom poko" is the sound of a hand slapping a full tummy). That is a very different mood from what we see in anime and manga

(or Western) werewolves. Wolves are not shape-shifters in Japanese traditions, and when they take on that role as they increasingly do in anime and manga, they must draw on traditions set by the foxes and raccoons, although the wolves are seldom tricksters. Many anime and manga werewolves do not shape-shift at all, and those that do are mostly shape-shifting animals, wolves who turn into or appear as humans rather than humans who turn into wolves or part wolves. The change is usually, although not always, voluntary.

Much of the Japanese folklore about wolves is regional and based on oral traditions, but the Japanese also have a written source in the *Nihongi* and *Kojiki*, two compendiums of oral traditions written down in the early eighth century. Miyazaki clearly mined this source to produce the imagery and part of the story for *Mononoke-hime*. In particular, he has focused on the story of Yamato Takeru, a legendary trickster hero who almost died in the mountains of Japan when, after offending the god of the mountain by accidentally killing a deer, he was attacked by a boar or a snake (accounts differ) and poisoned. A white dog that led him to a healing spring saved him (Levi 2001).

Another source is the story of Aeonia-kamui, the sacred ancestor of the Ainu, who was first warned away from danger by the younger sister of the wolf god; he was about to go into battle, but she transformed into a large dog and chased him away. He fell during the chase and was injured. She healed him, then transformed again into a beautiful woman. She asked him to marry her, but he ignored her. Undeterred, she followed Aeonia-kamui home. Some legends say that the Ainu people were born of that union of human and wolf (Philippi 1979; Walker 2001). The influence of this tradition is strong in *Hinotori* and also evident in *InuYasha*.

The similarities between these two stories suggest some common origin, or perhaps just later influence, since the Ainu version was not set down in writing until 1932 when Japanese cultural influence was already deeply entrenched. Moreover, the work of collecting and transcribing Aeonia-kamui's story was done by a Japanese scholar, Kubodera Itsuhiko (Philippi 1982). It is also true that both Japanese and Ainu culture have traditions in which wolves are worshipped. To the Ainu, they were ancestors. To the Japanese, they were messengers of the gods and protectors of crops (mostly from deer). Those traditions are presumed to have died, along with Japan's wolves, which are now extinct, in the nineteenth- and twentieth-century rush to modernize and industrialize.

Elements of all these traditions about wolves and shape-shifters appear in varying combinations in all four works mentioned above. *Hinotori* features both a human who has been cursed with a wolf's head and a clan of

wolf gods who can appear as humans (with dog ears) when they so choose. *Mononoke-hime* also offers two takes, but without any shapeshifting; it features sentient, talking wolves who are actually wolf spirits, or *kami*, and a girl who is

entirely human but thinks of herself as a wolf. *InuYasha* offers a hero who is half-dog, half-human; a dog demon who nonetheless appears as a young man; a wolf demon in human form who doesn't care for the dog variety; and two dog demons who nonetheless appear in human forms. And *Wolf's Rain* offers a pack of wolves who can appear as human boys, and also a half-wolf, half-dog character who faces her own internal conflicts.

In *Hinotori*, first published in manga form in 1986, a Korean soldier named Harima has a wolf's head grafted onto his own flayed face when he is captured after a lost battle. Together with an old woman herbalist who saves his life, he escapes across the ocean to Wakoku (Japan) where he finds a culture that worships wolf deities (the *kuzoku*) in the traditional fashion. He and the old woman are welcomed after they save the life of Marimo, the daughter of the wolf clan's leader, using the old woman's herbal skills. They settle down to live in the village quite happily; but when the authorities, influenced by Buddhism, ban the old ways, banish the wolf deities to the mountains, and thereby bring disaster on the village, Harima rises to the occasion as their hero and champion. When he is injured in the battle between the new religion and the old ways, Harima's wolf's head falls off, revealing the human face beneath. With the loss of the wolf's head, however, Harima loses his mystical link with the wolf deities and apparently much of his memory of it, much to the dismay of Marimo, who has not only fallen in love with him but fought beside him and saved his life on several occasions. His final comment dismisses her and her kind as common wolves.

Harima's inadvertently cruel dismissal of Marimo echoes the odd response of Aeonia-kamui who, after having been saved by the wolf god's younger sister, ignores her and walks away with the sad wolf maiden trailing after him. Marimo does not trail after Harima in any literal sense. She recognizes that he is lost to her, but she does merge with her own future incarnation in the twenty-first century in an effort to make things work with Bandô Suguru, Harima's twenty-first-century incarnation. (Bandô's story is interwoven with Harima's in a way that at first seems like a dream but eventually turns out to be the two channeling one another.)

> ONLY RARELY DOES A HUMAN TRANSFORM INTO A WOLF IN ANIME AND MANGA, AND WHEN ONE DOES, IT IS OFTEN AN IMPROVEMENT.

The Ainu element is also implicit in the artwork and the more general story of Marimo's people. Although they represent the old gods of Japan retreating before the onset of Buddhism, the fact that they retreat to the north is probably a reference to one theory about the Ainu: that they were driven north by the incoming Japanese. The names also reference Hokkaido and the Ainu: Marimo is a rare type of algae that is highly prized by the Ainu, while Rubetsu (her father's name) is the name of a village and a bay in Hokkaido. Their attire also connects them to the Ainu. In particular, Rubetsu wears a coatlike garment that looks distinctly like a traditional Ainu garment called an *attus*, while the lightly sketched circle around his brow suggests the male headdress known as a *sapanpe*.

In *Mononoke-hime*, Miyazaki draws his imagery, but not his story, from the story of Yamato Takeru as set down in *Kojiki* and *Nihongi*. Since these two sources represent an oral tradition later set down in writing, each contains more than one version of each story, and neither tells quite the same story. Nonetheless, the imagery remains fairly consistent, and that is what Miyazaki has used, sometimes combining elements to make them even more consistent. He has not used much of the original story, except perhaps at the beginning of *Mononoke-hime*.

According to the old tales, Yamato was attacked by a boar or snake god; Miyazaki combines both elements by having his protagonist, Ashitaka, attacked by a cursed boar god whose body is crawling with snakelike tendrils. And, as with Yamato, the encounter leaves him poisoned and dying. But that is where Ashitaka's story parts company with Yamato. When the elderly shaman explains the situation, the village elders kick in with some exposition: Ashitaka is not Yamato or any part of him. He is Emishi,[4] a people who lived in northeastern Japan and who fought the Yamato (Japanese). He is sent west to Japan to seek a cure. Thereafter, his story is quite different from Yamato's, but the imagery remains (Levi 2001).

Like Yamato, Ashitaka finds his way into a forest where gods reign. And like Yamato, he is led to a healing spring by a white dog, or rather by San, the wolf-girl raised from infancy by the wolf *kami*, who considers herself a white dog like her brothers. In the original story, the white dog that leads Yamato out of the forest or (versions vary) to the healing spring is a minor character. In Miyazaki's version, that dog becomes both the talking wolves (Moro and her two pups), and the wolf-girl San, who was raised by Moro and considers herself part of this wolf family.

The sources for *InuYasha* are less explicit. There are no direct Ainu references, although the story of Inuyasha's parents certainly represents a joining of dog demon and human. In this case, however, the wolf was male, and the human female, and also decidedly Japanese. The story of their union is, however, in the past and relevant mostly as background for their son, Inuyasha, and his rivalry with his half brother, the dog demon Sesshômaru.

InuYasha also features another major wolf character, Kôga, who becomes a rival to Inuyasha for Kagome's affections. Kôga is described as a wolf demon and is part of a pack that combines wolves in human or part human forms, as well as actual wolves. He is the pack leader and a morally ambiguous character, a roughneck with a heart of gold.

Wolf's Rain creates its own mythology in which wolves were the original rulers of the planet while humans served as their messengers, a direct reversal of the Shinto folklore that assigns wolves the roles of messengers. This changed when some wolves overused their abilities to appear as humans and found themselves unable to change back. By the time the story of *Wolf's Rain* begins, humans assume that all wolves are extinct, and they almost are. The story's mythology may derive in part from the current plan being debated in Japan about whether to reintroduce wolves in an attempt to control the exploding deer population.

NATURE AND THE HUMAN ANIMAL

One reason the werewolf occupies a place in the Western horror genre is that it represents the animal: the beast that lies beneath the civilized exterior. The most common interpretation of the original 1941 *Wolf Man* movie is that the protagonist's uncontrolled change from a rather gentle man to a ravening animal represents how war turns "civilized" men into animals. This was a marked contrast to earlier depictions of the werewolf, which tended to see it as an existing, spiritual division, a Jekyll and Hyde transformation (Skal 1993).

The few Japanese werewolves who reflect either of these metaphors usually appear as supporting characters in vampire films drawn from Western sources. In many cases, these are comedies, and the transformation is played for laughs. Although Japanese werewolves are used to discuss humanity's relationship to animals and nature, the result seldom belongs in the horror genre. Only rarely does a human transform into a wolf in anime and manga, and when one does, it is often an improvement. More frequently, wolves transform into humans, into the appearance of humans, or simply display human characteristics (like

speech) without transforming at all. As a result, they reflect a very different attitude toward human relationships with animals and nature.

This is most apparent in *Mononoke-hime,* which is an unabashed fable about humans destroying the environment. Even so, the human side is not depicted as entirely evil or the forces of nature as entirely benign. It is not easy to differentiate, since the humans' urge to survive at any cost is itself entirely natural.

Some of the humans, like the scheming imperial forces and the samurai, are fairly evil, and their destruction of the environment and one another seems almost insane. But the central character representing humanity is a humanitarian, Eboshi-sama, who has led her band of outcastes, oppressed peasants, and ex-prostitutes into the forest to build a self-sustaining commune through iron smelting and the manufacture and selling of firearms (early muskets). In the same way, some of the forces of nature, like the boars and the apes, seem already to be losing sentience, and their actions are not only destructive but counterproductive. The main forest deity, the deerlike *shishigami*, is neither good nor evil, neither life nor death; it is simply what it is at any given moment, and Moro, the mother wolf, shows her wisdom by accepting that.

Her human daughter, San, however, does not accept. She is not a werewolf in any literal sense, but she is a lycanthrope in the psychological sense. She believes herself to be a wolf in her heart, although in her case, the cause is not mental illness but her own life experience. She does not transform, however, and so she is torn between her humanity, represented largely by her growing love for a human man, Ashitaka, and her wolf nature, which loves the forest and will destroy anything that threatens it. Yet she also resists nature. When she finds out that Moro is dying, she cries out against the unfairness of the *shishigami* and its ways, and is only partly convinced by Moro's own acceptance of the natural order. San is too human to accept that entirely. Her conflict is not shown to have any easy resolution. San's hatred for her own species (humanity) is somewhat muted both by her love for Ashitaka and by the revelation of how much worse things can be when the *shishigami* is not allowed to follow its course. However, she never fully accepts her own humanity and refuses to live with Ashitaka, although she does agree to his proposal that he visit her in her forest home.

> THE WOLVES OF *WOLF'S RAIN* ARE NOT MINDLESS OR SOULLESS IN THEIR ANIMAL NATURES THE WAY WESTERN WEREWOLVES SO OFTEN ARE, BUT THEY ARE NOT HUMAN EITHER, AND THEIR INTERACTIONS WITH HUMANITY ARE OFTEN TRAGIC.

Wolf's Rain presents an even less optimistic view of the relationship between humanity and nature, and this is revealed in the depiction of the main characters as walking, talking deceptions. The boys of the wolf pack are not truly the boys they appear to be. They are wolves, and this often leads to tragedy, especially when they interact with humans who do not recognize the boys' true natures. One boy, for example, kills a human child while trying to rescue it, while another is revealed to have accidentally killed the old woman who took him in. In both cases, the wolves simply did not know their own strength; nor did the humans until it was too late. The wolves of *Wolf's Rain* are not mindless or soulless in their animal natures the way Western werewolves so often are, but they are not human either, and their interactions with humanity are often tragic.

Their understanding of nature is also problematic. At first, it seems as if they have an insight into the natural order that humans lack. Wolves, we are told, are the only creatures that can find the way to paradise, a legendary haven that suggests wolves retain a purity that humans have lost. As the story develops over thirty episodes, however, we come to see that their instinct for paradise has a darker side and that the paradise they seek is quite possibly an illusion.

On its surface, *Wolf's Rain* seems to present a stark contrast between postapocalyptic urban scenes and the green, flower-strewn glimpses of a rural paradise. But there are also grimmer scenes of nature as the wolf pack battles cold and hunger, kills to eat, and encounters death in a variety of forms. They also encounter Darcia, a noble who seems more than human, possibly alien, but who turns out to be another wolf, a twisted wolf who has forgotten his own wolf nature and who seeks a false paradise that ultimately rejects and destroys him.

Moreover, the whole concept of paradise as a return to rural purity is subverted in the finale. With the pack and pretty much the entire cast dead, the last wolf, Kiba, does manage to open the gates to paradise, only to find what looks very much like the original urban setting. Paradise, the finale suggests, might be the pack, the comradeship of others, and not a place at all. Or paradise may simply be an illusion. This is actually suggested to Kiba earlier when he falls under the thrall of a plant that causes him to imagine himself in a delightful but manifestly false paradise. He is rescued from this potentially fatal illusion by a tribe of what seem to be Native Americans who offer the wolves a chance to join them in a fairly idyllic reality. Kiba refuses that offer, however, and persuades the other wolves to do the same. He prefers to continue chasing the illusion, a preference that leads to tragedy.

The idea of rural recidivism as a paradise is also a theme in *Hinotori*. Here, too, the werewolf is a metaphor for the ways in which humans are part of nature and yet separate from it, although here the focus is more on the spiritual aspects of that unity and separation, with the werewolf playing the role of boundary spanner. When Harima is given a wolf's face, he becomes more than human, not less. The same thing happens when the head is transferred to Harima's twenty-first-century incarnation. With the wolf's head, both men are able to see and communicate with the forces of nature represented by the animistic Shinto deities, including the *kuzoku*, the wolf clan. When Harima loses the wolf's head, he reverts to a mere human—pleasant enough, but unexceptional. And, of course, when he loses the wolf's head, he also loses his connection to Marimo, the *kuzoku* woman who loves him.

That, in turn, spurs Marimo to attempt a more radical transformation into a fully human woman. She does this not by shape-shifting but by projecting her spirit into her own future, wherein she will be reincarnated as a human. Unfortunately, the human woman she becomes is too weak to survive the horrors of the twenty-first century and is first torn apart by machine gun bullets and then incinerated. With her human form totally destroyed, Marimo manages to rejoin her love in his twenty-first-century incarnation, but he is now a wolf-headed man, while she is entirely canine. Her attempt to reconcile human and wolf has failed. Nonetheless, she and her lover (now in his Suguru form) make one last attempt to find happiness. They walk together into the heart of the Phoenix, into eternity and probably death, hoping to rejoin the *kuzoku* in a paradise of the spirit if not in physical reality.

No such serious concerns affect the characters in the long-running comedy *InuYasha*. Although the same themes do emerge, they are interpreted more in terms of sexuality, romance, and the desire to belong than as a metaphor for humanity and nature. Takahashi does resist the urge to overromanticize the less-technological sixteenth century, however. It is presented as scenically beautiful, but the twenty-first-century heroine desperately longs for a hot bath and a soft bed, while even her companions who belong in this era are quick to discover the joys of junk food.

PARIAHS AND THE PACK

In Western traditions, the werewolf is often a symbol for becoming a pariah, for losing or failing to find an acceptable role in the social order. This theme is often linked to puberty, sexuality and race, class, or gender roles (Hutch-

ings 1993; Jancovich 1991). And this is also true in anime and manga where there are often implied analogies to "*haafu*" or "*daburu*" issues,[5] but even when that is the case, the pariah status of the werewolf is more often balanced by the existence of a wolf pack, an alternate social order in which the werewolf does belong.

This is most clearly shown in *Wolf's Rain* where the wolf pack is composed entirely of misfits. Their leader, Kiba, is an obsessed "lone wolf" who acquires his companions more or less by accident. Tsume is an outcast, expelled from his original pack for failing to come to the aid of a comrade. Hige and Toboe both grew up among humans, as did Blue, who is half-dog. Their theme song is "Stray," which begins, "In the cold wind, I walk alone." But the wolves of *Wolf's Rain* do not walk alone. However fractious and divided they become, ultimately they walk, fight, and die together. They may be pariahs to the humans, but they have their own place in which they belong.

That theme also emerges in *InuYasha*. Inuyasha himself is a "lone wolf," or rather, a lone half–dog demon, half-human misfit, unable to fit fully into either group. His goal at the beginning of the series is to obtain the gem that will allow him to become a full demon. His determination dims as the series progresses and he falls in love with Kagome, but his status as neither demon nor human remains a factor. Later we learn that in his earlier, ill-fated romance with Kikyô (Kagome's earlier incarnation), he considered using the jewel to become fully human. Despite these (*haafu*?) issues, Inuyasha has a pack, a group of friends, all of them odd, all of them misfits, with whom he travels in search of jewel shards. It may help that he is the most clearly defined as a dog, a domestic animal. He is certainly not the best-behaved pet, but he does respond to the word *sit*, which Kagome uses to control him.

> THE WOLVES OF *WOLF'S RAIN* DO NOT WALK ALONE. HOWEVER FRACTIOUS AND DIVIDED THEY BECOME, ULTIMATELY THEY WALK, FIGHT, AND DIE TOGETHER.

The importance of the pack, of belonging, comes to the fore when a wolf demon named Kôga enters the story as a rival for Kagome's love. Kôga is not only more of a roughneck than Inuyasha, but actively dangerous. When he first arrives on the scene, he tells his wolf pack to slaughter a village, something they do most efficiently. He then kidnaps Kagome and takes her to his lair, where only his protection prevents the pack from eating her. Yet the pack is not portrayed as an entirely negative entity; Kagome herself rapidly changes her attitude toward Kôga and his wolves on seeing how the pack members care for one another. Later, as he comes to love Kagome, Kôga softens a bit, enough

that some members of his pack desert him to join more aggressive groups. Kôga seems unconcerned about this, secure in his new status as a less-conventional alpha male and still surrounded by a sizable pack of loyal wolves.

Inuyasha's relationship with his half brother, Sesshômaru, also suggests that there are worse things than being a misfit. Sesshômaru is a full dog demon and secure in his place in his universe. Yet he is the one who is mostly alone. He is also the possessor of a healing sword, bequeathed to him by his father as an incentive to become more gentle, more human, more likely to reach out to others. Sesshômaru's progress in this regard is slow in the extreme, but he does become kinder and less alone when he heals and adopts a young girl, Rin, who has been orphaned and injured by Kôga's wolf pack. Sesshômaru's story suggests that challenging preconceived roles and ideas, even becoming a misfit, may offer as many rewards as disadvantages.

That same theme is explored in greater depth and with greater complexity in *Hinotori*, both through Harima's transformation into a wolf-headed man and through Marimo's decision to leave her pack to become human. Like Western werewolves, Harima's transformation is not voluntary, and the initial results are disastrous. He becomes a complete pariah, feared and hunted by terrified villagers to the point where he flees the country, accompanied only by an old woman who dares to accept him as he is. He finds a happier life in Japan where he becomes a spiritual and secular leader to a village, and ultimately a hero, but he still does not belong anywhere. To the villagers he is not quite human (as well as being foreign), and he is wolf enough to communicate freely with Marimo's people, the *kuzoku*. When he becomes fully human again, a process that is not entirely voluntary either, he accepts it gladly. This seems natural enough, a very human thing to do, yet it leaves him less than he was, simply another human in a world filled with humans. As a pariah, he was more than that.

Marimo's experiment with nonconformity is less happy. She gives up everything, her people and her family, to find love by becoming human, only to find herself neither human nor able to be with the half human she loves. At least he does not entirely reject her; his original self does, but his futuristic self joins her in entering the heart of the Phoenix, in the hope that this will take them back (or perhaps forward; time is cyclical in *Hinotori*) to her people and a place where they can be together, but we never learn if they succeed.

The conflict between individual and group needs also combines with the quest for love in *Mononoke-hime*, but is resolved differently, as the two lovers, San and Ashitaka, elect to live separately, each with their own pack, and visit when possible.

ROMANCE, SEXUALITY, AND GENDER ROLES

The connection between challenging social roles to find love and challenging gender roles for the same reason is evident in all four works. And, as with challenges to social roles, the results are mixed. Some succeed and some fail, but all pay a price of some sort.

San, the hero of *Mononoke-hime*, gets the most positive results. She pays a high price for many of her actions, but not such a high one for challenging and subverting gender roles. This is due, in part, to the fact that she challenges them so utterly, judging her life on its own merits and by her own standards. She does not give up everything, or even much of anything, for love. This is also true of her rival, Eboshi-sama. As Susan Napier (2001, 190) notes, both San and Eboshi "exist in their own right, independent of any male interlocutor. . . . these independent women are not domesticated by marriage or a happy ending, but are instead interested in living separate but presumably fulfilling lives." As a reward for her independence, San gets a man who accepts what relationship he can have with her on her terms. He tells her he will visit her, and she nods her permission.

This is a stark contrast to Blue of *Wolf's Rain*, who pays the highest price, although not in terms of romantic love. Blue initially appears in the series as a large dog who hunts wolves for her obsessed master, Quent; Quent believes his family was killed by wolves and is bent on revenge. Blue is useful to him because she can see wolves for what they are, even through their human camouflage, and it is also clear that he loves her; she is his only real companion. Indeed, it becomes apparent as the show progresses that he is a father figure to her. However, the reason Blue can sense the wolves so well is because she is part wolf herself, and when she smells the scent of the lunar flower, her inner wolf

> THE AMERICAN GENRES OF SCIENCE FICTION AND FANTASY ARE ONLY SLOWLY BEGINNING TO EXPLORE HOW THE WOLF-HUMAN DYNAMIC CAN BE USED TO DISCUSS ISSUES OF HUMAN NATURE AND NATURE, OTHERNESS, SEXUALITY, AND GENDER ROLES.

awakens. Eventually, this change will allow her to appear as a human and to speak, but before that happens, Blue kills some humans while defending herself and her master. Without giving her the benefit of the doubt, Quent turns on her, and she is forced to flee. Later, she confides to a human friend how much she regrets that she cannot use her newfound skills to talk to Quent and explain what happened, but she knows that he will never accept

her if he finds out she is part wolf. Her ability to stand on her own two feet, to defend herself against attack, and to speak with her own voice has cost her her father.

On the other hand, Blue does much better in terms of romance. She finds love with the most easygoing member of the wolf pack, gentle Hige, who admires her spirit and independence, and cheerfully agrees to let her set the rules and pace of their relationship. The two die in the final battle simply because everyone dies, but they die together.

Marimo risks losing both lover and father in a sense, when she decides to transcend time and species in the name of love, and the quest for the happy ending San and Eboshi ignore. Whether she loses both or neither is hard to say. She is not able to become human for her man who, by the end of the story, is neither entirely human nor entirely himself. Even so, they are still the wrong species to be together when they leap into the Phoenix in the hope that this will restore them to the land of Marimo's people and to a place where they can be together. This ambiguous ending is typical of most of the stories in *Hinotori*, and, in fact, Marimo fares quite well in comparison with the unjust fates that befall many other characters. This may be because Marimo does not really subvert traditional female roles. Although she is a powerful *kami* (animistic goddess) and does more than her share of active fighting, she remains a filial daughter and a loyal lover to the end. She seeks fulfillment through these roles. The fact that she does not necessarily find that fulfillment, however, subverts those roles to some degree. It is doubtful that this subversion is intended as a message or moral either way, however. As with all the stories in *Hinotori*, Marimo's tale is more a comment on the random cruelties of life, death, and karma than a challenge to gender roles.

None of the werewolves in *InuYasha* really challenge gender roles. All the human-wolf characters are male and remain male, something that cannot always be guaranteed in Takahashi's works.[6] However, while falling in love with Inuyasha and learning to live in his world, the schoolgirl Kagome finds herself learning new-old gender roles. In particular, she begins to master certain skills (especially archery) that are associated with her own sixteenth-century incarnation, Kikyô, who was a Shinto shaman (*miko*). In so doing, she finds that the gender roles of the sixteenth century make her more powerful than she is as a schoolgirl in the twenty-first century. And, although she makes this adaptation in part for love, she also makes it because she believes in what she is doing for its own sake.

JAPANESE WEREWOLVES IN AMERICA

The American genres of science fiction and fantasy are only slowly beginning to explore how the wolf-human dynamic can be used to discuss issues of human nature and nature, otherness, sexuality, and gender roles in ways that are more positive than the traditional werewolf paradigm, which stresses mindless, soulless animal instincts. Most of the efforts that do go further are literary, draw heavily on Native American or other animist traditions, and are more prone to use coyote traditions than actual wolves. There have been some efforts to portray werewolves as sentient beings, but only a few to present them as sympathetic in both forms. However, the human form of the werewolf is often portrayed sympathetically and, occasionally, even as heroic. This trend is apparent in novels like Michael Cadnum's *St. Peter's Wolf* and Laurell Hamilton's Anita Blake series, but movies and television lag far behind in this regard. *Wolfen* (1981) and the short-lived series *Wolf Lake* (2002) attempted to tell the werewolves' side of the story and to make them at least somewhat sympathetic when in wolf form, but neither fully transcends the more negative tradition nor carries the werewolf metaphor particularly far in terms of complexity.

Literature, film, and television have not kept up with youth culture where the werewolf is concerned. Werewolf-related role-playing games online and off suggest that a more sophisticated use of the werewolf metaphor is appealing. In the arena of literature, film, and television representations, however, the Japanese products seem likely to fill the gap for some time.

...

Notes

I would like to acknowledge the input of Ellen Klowden, who not only proofread this chapter on very short notice but also added extremely valuable commentary and suggestions.

1. *Hinotori* is a thirteen-volume anthology of stories about humanity's quest for immortality. The stories are linked by the enigmatic appearances of the *hinotori* (phoenix) throughout and also by the fact that many of the characters reappear in different incarnations to play out different aspects of their karma.

2. There is also a shorter, animated version of *Hinotori*, but it greatly simplifies the plot, totally eliminating the twenty-first-century saga of Bandô Suguru, and this, in my opinion, changes the meaning of many aspects of the original, especially the role of the wolf-human dynamic.

3. *Tanuki* are a species unique to Japan: *canis viverrinus*. They look very much like raccoons, and the word is usually translated that way.

4. There is much scholarly debate about whether the Emishi were, in fact, Ainu, part Ainu, or a totally different people who may have fought the Ainu. Miyazaki, however, has stated that his depiction of the Emishi was based on the assumption that they were the descendants of the Jômon people, not the Ainu.

5. Both terms refer to people of mixed race where one part is Japanese. The question of whether to call them *haafu* (half), *daburu* (double), or a number of other options is currently a matter of heated debate.

6. Takahashi is perhaps best known for her *Ranma ½* series, about a martial artist who changes into a girl whenever he is splashed with cold water.

References

Ainu Museum. 2005. http://www.ainu-museum.or.jp/english/english.html (accessed March 3).

Ashton, W. G., trans. 1972. *Nihongi: Chronicles of Japan from the Earliest Times to A.D. 697.* Tokyo: Tuttle.

Hutchings, P. 1993. *Horror and Beyond: The British Horror Film.* Manchester, UK: Manchester University Press.

Jancovich, M. 1991. *Rational Fears: American Horror in the 1950s.* Manchester, UK: Manchester University Press.

Kyoto National Museum. 2005. http://www2.kyohaku.go.jp/mus_dict/hd33e.htm (accessed March 3).

Levi, A. 2001. "New Myths for the Millennium: Japanese Animation." In *Animation in Asia and the Pacific*, ed. J. A. Lent. London: Libbey.

Miyazaki, H. 1999. *Princess Mononoke.* Miramax, DVD.

Napier, S. 2001. *Anime from Akira to Princess Mononoke: Experiencing Japanese Animation.* New York: Palgrave.

Nobumoto, K. 2005. *Wolf's Rain.* Bandai Entertainment, DVD.

Philippi, D. 1979. *Songs of Gods, Songs of Humans: The Epic Tradition of the Ainu.* Tokyo: University of Tokyo Press.

———. 1982. *Kojiki.* Tokyo: University of Tokyo Press.

Skal, D. 1993. *The Monster Show: A Cultural History of Horror.* New York: Norton.

Takahashi, R. 2004. *Inuyasha.* VIZ, DVD.

Tezuka, O. 1986. *Hinotori: Taiyouhen*, vols. 10–12. Tokyo: Kadokawa Bunko.

Walker, B. 2001. *The Conquest of the Ainu Lands: Ecology and Culture in Japanese Expansion, 1590–1800.* Berkeley: University of California Press.

Metamorphosis of the Japanese Girl: The Girl, the Hyper-Girl, and the Battling Beauty

In the 1980s Miyasako Chizuru coined the term *chô-shôjo*, or "Hyper-Girl," to conceptualize the emergence of a new kind of girl in manga and anime, one with powers and attributes beyond those of prior *shôjo* figures. Since then, Girls and Hyper-Girls have continued to transform, and I would like to trace some of those changes, especially in the context of the anime series *Revolutionary Girl Utena (Shôjo kakumei utena)*, which presents not only a revolutionary girl but also revolutionizes the Japanese Girl.

REVOLUTIONARY GIRL UTENA

Tokyo's Channel 12 broadcast *Revolutionary Girl Utena* for thirty-nine weeks, from April 2 through December 24, 1997. The series followed the popular manga series written by a woman artist, Saitô Chiho, who collaborated with the artists at the studio collective Be-Papas and with the director Ikuhara Kunihiko, known for his previous work on the anime series *Sailor Moon*.

In the television version, the heroine is a fourteen-year-old girl, Tenjô Utena. Utena continues to cherish the memory of her encounter with a

prince, who offered her consolation when she lost both her parents (Figure 1). When she enters a private middle school, Ohtori Gakuen (an alternate romanization of "Ôtori Gakuen"), she hopes that she might once again meet the prince there. Naturally, given such a setup, viewers might well expect a variation on the Cinderella story. Yet, as the story advances, Utena adopts a male school uniform, complete with short pants. While instructors at the school try to dissuade her, their protests are in vain (Figure 2). Utena insists on male attire, and viewers who expected Utena's story to conform to that of a helpless girl seeking her prince charming may well feel betrayed.

FIGURE 1. Tenjô Utena Utena in *Revolutionary Girl Utena*.

Whence Utena's insistence on male attire?

The answer is simple. Utena wishes to become a prince, which (interestingly enough) is not exactly the same as being a boy (in case anyone might think she desires to be a boy). In fact, when Utena duels with Saionji Kyôichi, he (Saionji) notices her breasts and expresses his surprise that Utena is a girl. Utena retorts that she never said she wasn't a girl. Her adoption of male garb could be called cross-dressing, for she

FIGURE 2. *Revolutionary Girl Utena*.

is seen as a boy, yet she does not take herself as one. She is a girl prince.

Now, on the surface, Utena's middle school, Ohtori Gakuen, is just another prep school for rich kids. Yet it turns out that members of the student council control the school. Only members of this elite group are eligible to become duelists. An unseen person known only as "End of the World" chooses students to serve as council members and duelists, and this status allows them to challenge and battle one another. Students enter duels to compete for Himemiya Anthy, the Rose Bride, who holds the secret of the power to revolutionize the world. It is this power that duelists seek.

When Utena enters this rigidly hierarchical school society, she is clearly an outsider. Moreover, her goals are entirely different from the other duelists.

Her aim is not to fight and gain the Rose Bride. Yet, to achieve her goals, she must enter into the world of duels, which amounts to a transgression of the school's hierarchies. In the end, Utena proves victorious, insofar as she defeats all the other student duelists. She never defeats Ohtori Akio, however, the school headmaster who becomes Utena's most dangerous opponent in the series' final episodes.

What is important is her status as an outsider, or an other. It is this status that allows her to unravel the school's mysterious hierarchies.

TRANSGRESSION

Fights in this series appear highly ritualized. As a world apart, the battleground becomes an object of intense curiosity and interest. Only duelists may enter the battleground, which truly stands apart from the school's daily life. This separation allows for highly dramatic actions and theatrical behaviors. The battleground resembles an outdoor arena, with a castle hanging from the sky, like a chandelier (Figure 3). It is here that Utena prepares to fight.

Some members of the elite corps of students challenge her to a duel, not because they feel any particular animosity toward her but rather because they wish to obtain the Rose Bride and the power to control the world. Significantly, their various romantic entanglements mesh with the mysterious world of duels, as if dueling were an expression of their sexual interests. It is as if these battles held the key to sexuality.

FIGURE 3. A battleground in *Revolutionary Girl Utena.*

What happens to Utena, who continually wins? What of her sexuality?

Let's take a closer look at her first duel.

Saionji Kyôichi, an active member of the student council, receives a love letter from one of Utena's friends, Shinohara Wakaba. Saionji makes the letter public, thus insulting Shinohara. Angry, Utena, as the prince, stands up to defend her girlfriend's honor. She challenges Saionji to a

duel and defeats him. By the rules, to Saionji's great dismay, Utena wins the Rose Bride, Himemiya Anthy (Figure 4).

FIGURE 4. Utena wins the Rose Bride, Himemiya Anthy, in *Revolutionary Girl Utena*.

Utena's victory thus results in an interesting couple, with Utena as the prince and Anthy as the princess, lovely as a flower. Indeed, Anthy is already named as a flower princess (with the Japanese *hime*, or princess, and the Greek *anthos*, or flower, in her name). These roles are, in a sense, stereotypical—prince and princess, and the princess appears quite passive, surrendering herself to the victor. Yet the prince is, of course, a girl in boy's attire—and pink at that. And princess is just a bit too obedient. *Revolutionary Girl Utena* thus makes a mockery of conventional gender roles and narratives. It makes fun of the heroic heterosexuality and monogamy of traditional fairy tales such as *Sleeping Beauty*, *Snow White*, or *Cinderella*. Ultimately, from episode to episode, it is this queer couple that survives the series of duels—the mock prince and slave princess.

In the end, the series discloses an incestuous relationship between Himemiya Anthy and her brother, Ohtori Akio, chairman of the school's board of directors. The "cross-dressed" prince Utena thus becomes party to a transgressive relationship between brother and sister. While Utena finds Akio thoroughly charming, she never surrenders her role as prince and strives to save Anthy. Ironically, it is Anthy herself who undermines Utena's attempts to save her: still in love with her brother, jealous of Utena, Anthy stabs the transvestite prince in the back.

THE HYPER-GIRL AND THE BATTLING BEAUTY

Reading the works of the manga artist Hagio Moto, Miyasako Chizuru noted how Hagio rejects social ideals and conventions for what a girl should be. Rather, Hagio's works begin with the idea that the boy is a "Non-Girl," albeit an ambitious one, which Hagio uses to rethink and reorganize radically the subjectivity of the Girl. Miyasako called attention to the conceptual work involved in Hagio's transfiguration of the Girl, designating this new figure as

the Hyper-Girl. This Hyper-Girl bears some resemblance to Anglo-American feminist heroines such as Ripley in the *Alien* series.

Oddly, after the publication of *Star Red* in 1980, Hagio never again worked with the figure of the Hyper-Girl. Moreover, despite its genuine interest, Miyasako's conceptualization of the Hyper-Girl never came to be widely accepted. By the late 1990s it seemed that audiences had become more interested in the figure of the boy as a Non-Girl, a figure prior to Hyper-Girl. Whence this preference for the Non-Girl over the Hyper-Girl?

The answer lies partly in the popularity of another figure, the Battling Beauty (*sentô bishôjo*). While the Battling Beauty may at first appear analogous to the Hyper-Girl, these figures are substantially different. The Battling Beauty is another variation on the boyish girl. She initially appears pliant and extremely effeminate, but this is only on the surface; she is in fact a dynamo.

A gifted psychiatrist and critic, Saitô Tamaki, provides a clear definition of the Battling Beauty in his book, *The Illness of Context* (*Bunmyakubyô*). He begins with depictions of the Battling Beauty in manga and anime for boys from the 1960s, presenting five points well worth careful consideration.

1. Anglo-American pop culture has warrior women who tend to be Amazons, that is, Phallic Mothers, but Battling Beauties tend to be Phallic Girls.

2. Because they lack any original trauma, the Battling Beauty or Phallic Girl seems to lack motivation, to be somehow empty inside, to lack interiority.

3. The Battling Beauty frequently adopts the position of shaman.

4. The subversive power of the Battling Beauty does not derive from her subjectivity but from a structure of repulsion between different worlds.

5. Where the Phallic Mother is a woman who possesses the phallus, the Phallic Girl identifies herself with the phallus, hysterically.

The Battling Beauty is a child full of perversity. While ordinary girls are frequently seen as incapable of fighting and thus as nothing more than "inanimate things," the Battling Beauty proves as aggressive as any boy. Yet she does not seem to hold out any hope or desire for liberation. The Battling Beauty is a beauty, which configures her in relation to boys' desires. Thus she may function as a mirror of boys' desires, for their liberation.

SHÔJO POWER

Utena is, of course, a Battling Beauty. As a beauty, she satisfies the lustful eyes of the male voyeur who reads manga for eroticized images of girls. In this respect, Utena could be considered a figure for liberating men, or at least reconfirming the active role of men. This reading finds support in Utena's adoption of male attire. In male garb, she is not unlike a boy dressed as girl. It is as a boy that she becomes active. But then there is some confusion here, for Utena is clearly a girl. In effect, it is as prince that she becomes active, which raises a question: "Can only boys become princes?"

Generally, *shônen* manga (manga for boys) tend to linger on war, while *shôjo* manga (manga for girls) cope with love and romance. Part of the success of *Revolutionary Girl Utena* lies in its blurring of the boundaries between these two worlds—via its girl prince. This may explain why *Utena* so deftly exposes the structure of sexuality implicit in manga for girls.

Takarazuka revues, in which women play all the roles, both male and female, have often served as a point of comparison for *shôjo* manga. As the psychologist Watanabe Tsuneo has suggested, it is the sharpness of the boundary between *shônen* manga and *shôjo* manga that created sophisticated generic patterns as well as the possibility for transgressing genre/gender. This is something of a paradox: the more socially conservative and rigid the worlds of *shôjo* and *shônen* become, the more transgression becomes possible.

Shôjo manga, as a category, was origi- nally constructed *for* female writers and readers but controlled *by* decidedly con- servative male editors. On the one hand, female desire has enabled women manga artists to create a range of different nar- ratives and representations of sexuality, some of which take great risks and gen- erate scandals. On the other hand, male authorities do not exactly frown on these forms, surely because they remain under the rubric of *shôjo* manga. Thus, even as *shôjo* manga construct hyperfemi- nized images of girls in a hyperfeminized society, *shôjo* manga are also able to evade the imposition of patriarchal categories.

> GENERALLY, *SHÔNEN* MANGA (MANGA FOR BOYS) TEND TO LINGER ON WAR, WHILE *SHÔJO* MANGA (MANGA FOR GIRLS) COPE WITH LOVE AND ROMANCE. PART OF THE SUCCESS OF *REVOLUTIONARY GIRL UTENA* LIES IN ITS BLURRING OF THE BOUNDARIES BETWEEN THESE TWO WORLDS.

When she rises to the challenge of dueling, Utena recalls narrative and sexual strategies cultivated in Takarazuka and *shôjo* manga. It is not surpris-

ing, then, that Utena stumbles into a sort of hard-core situation, the incestuous romance between Akio and Anthy. *Utena* brings to light the transgressive impulses that run through *shôjo* manga.

AWAKENING THE HYPER-GIRL

Enokido Yôji, one of the producers of the anime versions, offers an explanation of Anthy, whom I previously described as the slave princess. He feels that Anthy enables us to perceive the same realities from the feminine perspective. Recall that, in the television series, Utena strives (yet fails) to liberate Anthy from the power politics of the school and from an incestuous relationship—embodied in her brother, Akio. To Akio's dismay, Anthy finally leaves Ohtori school on her own. Anthy is, in this sense, another name for revolution. Utena, however, who drives the revolution, finds herself expelled from school by Akio.

The relationship between Anthy and her brother is exceedingly complex. Akio exploits her and abuses her sexually. Yet he is dependent on her power in order to exert control over the school and the duelists. In this respect, Anthy symbolizes a world under the control of girls. Utena, the Battling Beauty, merely awakens Anthy to the potential of the Hyper-Girl. Anthy does not take Utena's place as Battling Beauty. Rather, the Battling Beauty brings to light the Girl structure, thus releasing the Hyper-Girl.

As was true of *Sailor Moon*, both male and female spectators fell in love with the Hyper-Girl. The transgender popularity of the Hyper-Girl surely derives in part from how the Battling Beauty at once fulfills the criteria for the boy's desires and fuses with the Hyper-Girl, a figure that promises to liberate femininity and female desire.

Nevertheless, the Battling Beauty and the Hyper-Girl remain distinct throughout most of *Revolutionary Girl Utena*. The Battling Beauty (Utena) transforms into Hyper-Girl only once she has experienced defeat at the hands of the Hyper-Girl (Anthy). It is this traumatic experience that awakens in her an awareness of the structure of obedience and resistance.

Significantly, Anthy cannot remain in the world of *shôjo* manga. She awakens to the potentiality of the Hyper-Girl through her encounter with the Battling Beauty, which makes her aware of sexual diversity even as overtones of a heterosexual regime remain in force (i.e., prince and flower). This is why the Hyper-Girl must do battle with the Battling Beauty. *Revolutionary Girl Utena* describes a negotiation between "transgender" (the Battling

Beauty) and gender (the Girl), which raises gender to a new power or potential (Hyper-Girl). At the same time, *Utena* makes clear how difficult it is for the Girl and Hyper-Girl to coexist in the same discursive space. It is the Battling Beauty who serves as a mediator, allowing for unstable, volatile points of coexistence that result in transformation. *Utena* thus revolutionizes the Girl, reinventing the very nature of *shôjo*.

..

Revolutionary Girl Utena: Manga and Anime Citations
Compiled by Timothy Perper and Martha Cornog

Ikuhara, Kunihiko (director), and Saito Chiho (original manga). 1999. *Revolutionary Girl Utena: The Rose Collection, Part 1*. DVD: Episodes 1–13. New York: Central Park Media. ASIN: B00000IBUK.

———. 2001. *Revolutionary Girl Utena: The Movie*. DVD. New York: Software Sculptors. ISBN 1-57800-532-9.

———. 2002. *Revolutionary Girl Utena: The Black Rose Blooms*. DVD: Episodes 14–17. New York: Central Park Media. ISBN 1-57800-554-X.

———. 2002. *Revolutionary Girl Utena: Impatience and Longing*. DVD: Episodes 18–20. New York: Central Park Media. ISBN 1-57800-555-8.

———. 2002. *Revolutionary Girl Utena: Darkness Beckoning*. DVD: Episodes 21–23. New York: Central Park Media. ISBN 1-57800-556-6.

———. 2002. *Revolutionary Girl Utena: The Beginning of the End*. DVD: Episodes 24–26. New York: Central Park Media. ISBN 1-57800-557-4.

———. 2003. *Revolutionary Girl Utena: Temptation*. DVD: Episodes 27–30. New York: Central Park Media. ISBN 1-57800-560-4.

———. 2003. *Revolutionary Girl Utena: Unveiling*. DVD: Episodes 31–33. New York: Central Park Media. ISBN 1-57800-561-2.

———. 2003. *Revolutionary Girl Utena: Revelation*. DVD: Episodes 34–36. New York: Central Park Media. ISBN 1-57800-562-0.

———. 2003. *Revolutionary Girl Utena: Finale*. DVD: Episodes 37–39. New York: Central Park Media. ISBN 1-57800-563-9.

Saito, Chiho. 2004. *Revolutionary Girl Utena: The Adolescence of Utena*. San Francisco: VIZ Media, 1 volume. ISBN 1-59116-500-8.

Saito, Chiho, and Be-Papas. 2001–2004. *Revolutionary Girl Utena*. San Francisco: VIZ Media, volumes 1–5. English translation. Volume 1, ISBN 1-56931-713-5; Volume 2, ISBN 1-59116-030-8; Volume 3, ISBN 1-56931-812-3; Volume 4, ISBN 1-59116-068-5; Volume 5, ISBN 1-59116-145-2.

Saito, Chiho, and Be-Papas. 2003. *La Fillette Révolutionnaire (Revolutionary Girl Utena)*. Boulogne: Pika Édition, volumes 1–5. French translation. Volume 1, ISBN 2-84599-218-1; Volume 2, ISBN 2-84599-234-3; Volume 3, ISBN 2-84599-248-3; Volume 4, ISBN 2-84599-262-9; Volume 5, ISBN 2-84599-286-6.

[Saito, Chiho, and Bi-Papasu.] 1998. *Shôjo Kakumei Utena: La Fillette Révolutionnaire (Revolutionary Girl Utena)*. Tokyo: Flower Comics Anime Edition/Shôgakkan, volumes 1–5.

Volume 1, ISBN 4-09-135831-4; Volume 2, ISBN 4-09-135832-2; Volume 3, ISBN
4-09-135833-0; Volume 4, ISBN 4-09-135834-9; Volume 5, ISBN 4-09-135835-7.

Saito, Chiho, and Bi-Papasu. 1996–98. *Shôjo Kakumei Utena* (*Revolutionary Girl Utena*).
Tokyo: FC Flower Comics/Shôgakkan, volumes 1–5. Volume 1, ISBN 4-09-136084-X;
Volume 2, ISBN 4-09-136085-8; Volume 3, ISBN 4-09-136086-6; Volume 4, ISBN
4-09-136087-4; Volume 5, ISBN 4-09-136088-2.

[Saito, Chiho, and Bi-Papasu.] 1997, 1998. *Bara no Kokuhaku: Shôjo Kakumei Utena* (*The
Rose Confession: Revolutionary Girl Utena*). Tokyo: Flower Comics/Shôgakkan. One
volume. ISBN 4-09-101543-3.

Saito, Chiho, and Bi-Papasu. 1999. *Shojo Kakumei Utena: Aduresensu Mokushiroku* (*Revolu-
tionary Girl Utena: Adolescence Apocalypse*). Tokyo: Flower Comics/Shôgakkan.
One volume. ISBN 4-09-136089-0.

The Song at the End of the World: Personal Apocalypse in Rintarô's *Metropolis*

WILLIAM L. BENZON

Rintarô (director). 2001. *Metropolis*. Culver City, CA: TriStar Pictures. ISBN 0-7678-8180-X.

The penultimate sequence of Rintarô's *Metropolis* (2001) is astonishing. We see a finger press down on a key, followed by flashing light, and then hear Ray Charles singing "I Can't Stop Loving You," a bittersweet ballad about lost love. As the music unfolds, we see the horrendous destruction of a huge building complex. The juxtaposition of music and image is exquisitely jarring. What is going on here?

Sound-track music is rarely so inconsequential that one may dismiss it as mere ornament. In this scene, the music bears as much of the dramatic burden as the action, imagery, and dialogue. Several narrative, thematic, and expressive features can be isolated that are associated with this complex.

Metropolis is set in a large, sprawling city that seems generally Western. As the film opens, we are celebrating the completion of the Ziggurat, an elaborate skyscraper. While ultimately biblical, the reference links Rintarô's film to Fritz Lang's silent film *Metropolis* (various art deco images make the same link). It is this Ziggurat that comes tumbling down at the film's end. Simultaneously, we see Ken'ichi's last attempts to save Tima, a young gynoid (female robot) who is at the story's center. Ken'ichi fails, and yet the overall effect is not so much of loss as of relief. Although the final scene depicts rubble and ruin, and despite Ken'ichi's grief for Tima, the ending is optimistic and is rendered in bright, saturated colors.

Charles's ballad laments the end of a romantic relationship between a man and a woman. No such relationship exists in the film, whose major characters are male except for the visibly female Tima. Tima and Ken'ichi quickly develop a close relationship, but it is hard to say just what kind of relationship exists between a young human boy and a newly animated gynoid. It surely is not erotic. Yet, within the apocalyptic scene itself, that relationship is the most obvious focus for the song's grief. So we have personal grief amid large-scale destruction.

That destruction is itself given a very personal context. Duke Red, an ambitious industrialist, commissioned Tima to replace his deceased daughter, and he simultaneously created the Ziggurat as his instrument for world domination. Actually, the Ziggurat was built to be Tima's throne, which she could use as her instrument. Thus Red's *wille zur macht* seems to be the twisted expression of a father's undying grief for his dead daughter, and that grief brings him, also, within the affective penumbra of Charles's song.

The song was triggered when Rock—an orphan taken in by Duke Red—was attempting to reach him just after Red finally called out to Rock in need. Rock thought of Red as his father, although Red repeatedly and explicitly denies it. Rock jealously attempts to destroy Tima, which is central to the causal nexus that brings down the Ziggurat. Coupling Red's motivation for creating Tima and the Ziggurat with Rock's motivation for destroying Tima, we seem to be facing a film that asks us to believe that a large-scale historical event—revolution and destruction in a major city—is but a family affair writ large.

Thus the determining dynamics of large-scale historical events have been rendered, in part, by assimilating them to the personal

motives of a small group of people. The external social realities of class warfare and robot rebellions are made personal in the actions and feelings of Ken'ichi, Tima, Rock, and Duke Red. And that makes *Metropolis* art, not political science and not sociology.

We find a similar assimilation in Stanley Kubrick's *Dr. Strangelove* (1964). Early in the film, a renegade U.S. Air Force general defies orders and commands his bomber group to proceed to targets in the (then) Soviet Union and release their nuclear payloads. When Washington learns of this, officials begin a desperate dance that succeeds in recalling all but one bomber. The pilot of that bomber—Maj. T. J. "King" Kong—rides a bomb to the ground, waving his cowboy hat and yelling as though he were riding a rodeo bull. That one bomb is sufficient to trigger a doomsday device the Soviets created to destroy the world should an atomic blast ever occur on Soviet soil. The final sequence consists of images of nuclear explosions while the soundtrack plays a nostalgic ballad, "We'll Meet Again." Alas, no one is likely to meet anyone else, ever again.

This use of music is a signal similarity between *Dr. Strangelove* and *Metropolis*. These rather different films share other characteristics that, taken together, suggest an overall logic behind this striking juxtaposition of song and action.

Like *Metropolis*, *Dr. Strangelove* assimilates large-scale historical events to the personal motivations of a small core group. The film is set in the Cold War nuclear arms race between the United States and the Soviet Union. But this apocalypse is not depicted as the result of rationally war-gamed geopolitical considerations. Rather, it is the result of freakish circumstances. The renegade general, Jack D. Ripper, is obsessed with the purity of his vital fluids and worries about fluorine in the water supply, not to mention ice cream and whatever else he can think of. These obsessions started when he interpreted postcoital *tristesse* as an instance of Soviet subversion. When Dr. Strangelove—formerly a Nazi—suggests that the country's elite hole up in underground bunkers, another general, Buck Turgidson, is intrigued at the possibility of having ten women for every man, a sex ratio deemed optimum for breeding purposes. The world is going up in mushroom clouds because of the testosterone-driven incompetence of these powerful men.

So, we have three things lined up: (1) an apocalyptic scope, (2) presented in personal terms, (3) where the apocalypse itself is set to poignant music. To this we must add a fourth element: the obvious unreality of both films. *Dr. Strangelove* is a vicious satire and revels in exaggeration and caricature. Though grounded in real motives and attitudes, the film's main characters are all presented as types, not as real people.

The unreality of *Metropolis* is subtler, residing in its mélange of styles. The characters are rendered in a "cartoony" style closely based on that of Tezuka Osamu, whose manga inspired the film. In contrast, the buildings and city are depicted realistically. Within this primary juxtaposition is the additional contrast of the art deco style of much of the architecture and furnishings with the futuristic technological infrastructure of this world, most obviously its robotic technology. Finally, the sound track combines various musical styles, including relatively pure traditional jazz and segments conceived along the classical lines of much soundtrack music. While the overall effect is quite coherent, it is not a coherence one can easily place either in the world of historical reality or in some future extrapolation from historical reality. Yet the obvious references to historical reality make it difficult to place the film in some "completely other" world.

A final aspect of this unreality is that both films seem "disengaged"—not a particularly good word, but I do not know a better one—from the death that accompanies their respective cataclysms. The only death we see during the *Metropolis* climax is Tima's; otherwise, we see only massive property destruction. *Dr. Strangelove*

ends with elegiac images of mushroom clouds and bomb blasts. We can readily infer the human implications of these events, but we do not see them directly. If you compare these films with explicitly realistic films such as *Saving Private Ryan* or *Grave of the Fireflies*, it is clear that conveying a sense of violence and death *to the audience* is not their focal concern. These films "converse" with the audience in terms of out-of-control personal-social dynamics.

And it is in relation to this "conversation" that we must think about how music functions at the climax of *Metropolis*. The music neither participates in nor advances the action. The characters and events are what they are independent of that music. But the music plays a significant role in how *we* participate in those events. Thus to understand how music works, we have to move away from thinking about the meaning of the events represented in the film and, instead, begin to think about how the film works on and through us.

We do not need to hear "I Can't Stop Loving You" in order to know that the action in *Metropolis* is driven by love and loss. That is easily inferred from the events themselves. But it is one thing to know something, and quite something else to feel it. The song allows us to *experience* love and loss, not only that of the characters in the film, but our own. It thus connects us with the deepest wellsprings of our psychic life.

What more could one ask of art?

The Influence of Manga on Japan

VERN BULLOUGH

Kinsella, Sharon. 2000. *Adult Manga: Culture and Power in Contemporary Japanese Society*. Honolulu: University of Hawai'i Press. ISBN 0-8248-2318-4.

Sharon Kinsella, who researches emergent Japanese culture and social trends at Cambridge University, has basically written a history of adult manga. She traces its sources to the 1920s when classic American children's comics such as *Felix the Cat* and adult political cartoons were translated into Japanese. Soon after, a number of Japanese independent associations of cartoon and comic strip artists began to produce works on their own. The writers and illustrators of some of the more political ones quickly ran afoul of the police, but a more cautious form of manga continued to grow despite censorship and media control during World War II that led to a decline in production. Many artists were thrown out of work but managed to survive by producing wartime propaganda for the military.

In postwar Japan, a reinvigorated manga appeared at very low cost, first as picture cards and then in book form. Since most Japanese could not afford the books, distributors rented them for small fees. During the 1950s, a teenage artist, Tatsumi Yoshihiro, invented the term *gekiga* (dramatic picture) to describe the new genera of adult manga that explored new topics. As Japan's economy grew, manga rapidly expanded between 1956 and 1961 in the form of weekly magazines. Animated manga stories on television became a new form of public entertainment. Many manga publications were antiestablishment and leftist, a stance that appealed to the working classes who were its largest audience but also led to considerable criticism from the establishment.

For the early manga, a single artist both drew and made up the story. As the number of new magazines increased, the creative and publication processes also changed. Editors developed a theme or story line and gave it to the artist to illustrate. This arrangement soon led to a sort of oligarchic control of manga, with five companies producing most of the material appearing in a variety of magazines. By 1994 the circulation of their twelve magazines was more than a million. However, the actual readership has been estimated at three times the official circulation because the magazines were

inexpensive enough to be discarded when the reader was finished, only to be purchased by additional readers for next to nothing.

The variety of magazines led to increasingly diversified forms of manga designed to appeal to different audiences. The standard was a weekly magazine with one episode of each running story. Somewhat more expensive was the manga book, which usually had fifteen or more episodes of one story. Since the books were compiled from cartoons that had already been published, republishing expenses were minimal and profits high. Readership expanded as manga books and magazines came out aimed at specific markets, with titles aimed at boys, others for girls, and still others for adults, from businessmen to literary aficionados. Some were designed to appeal to women in general; others to specialized audiences of women. The same was true for those aimed at men.

Kinsella is very much interested in manga production and how the industry could adjust and thrive in a changing market. Each change demanded a rethinking of methods and topics. For example, the forty-eight-volume manga history of Japan (*Manga nihon no rekishi*) was published over a four-year period. Although Ishinomori Shôtarô was the artist illustrating it, he relied upon a team of fifty academic specialists for information. The result was a series that came to be recognized as suitable for use in the state schools.

Manga, however, remained diverse, and as it became more and more acceptable, other authors and illustrators took to developing new forms that challenged the establishment. What Kinsella terms "Lolita Complex" manga featured a little girl heroine and was developed in the 1980s by and for men. She maintains that the girl reflects the increasing power and centrality of young women in society as well as a contrary reactive desire to see these young women infantilized, undressed, and subordinated to the male. The result of the growing erotic and even pornographic manga was a call for regulation and cen-

sorship, especially following the so-called Miyazaki Incident, where a serial killer was found to have many pornographic manga. Confronted by considerable public concern and efforts to censor the art form, the manga establishment responded by developing rules of self-regulation and withdrawing some of the low-circulation adult manga. There was also the attempt to set out a new agenda for manga with the cooperation of the government. Interestingly, Kinsella more or less ignores the development of other kinds of erotic and pornographic manga.

According to Kinsella, manga has been a major force in bringing about a new national identity for Japan. She argues that the government's willingness to cooperate with the industry arose from a recognition that a more inclusive society could integrate formerly alienated political and social groups such as those that created manga.

With this new integration, manga for a time settled into a kind of rut, but it soon found new frontiers to conquer. Publishers sought outsiders, non-Japanese, to furnish themes and illustrations for new types of manga. Writers came from Italy, Germany, United States, Belgium, France, the United Kingdom, Yugoslavia, and Spain, and others soon followed. The inevitable next step was exporting manga, which is now taking place. This marks a new global role for Japan.

The book is heavily documented and has many illustrations, although some have been reduced in size and are not as striking as the originals. If Kinsella is right, manga are a major resource for researching the changes that have taken place in Japan.

The Shock of the Newtype: The *Mobile Suit Gundam* Novels of Tomino Yoshiyuki

PATRICK DRAZEN

Tomino Yoshiyuki. 1979; translated 1991. *Mobile Suit Gundam*. Berkeley, CA: Stone Bridge Press. ISBN 1-880656-86-8.

In the West, print and animated cartoons are usually consigned to a "children only" ghetto, peopled by little beyond superheroes and Scooby-Doo. "Serious" writing is reserved for novels. However, manga and anime range far beyond the children's playground, which is part of their attraction for Westerners.

Modern manga date from Tezuka Osamu's *Shin Takarajima* (*New Treasure Island*, 1947), which ran 250 pages in draft, and countless manga since then have reached for the scope of story and complex characterization found in novels. Anime based on novels range from *Hotaru no haka* (*Grave of the Fireflies*) to *A Dog of Flanders*. But novels can also be based on anime. In this postmodern environment, novels aren't necessarily excluded from a discussion of Japanese popular culture.

The trilogy of novels by Tomino Yoshiyuki (*Awakening*, *Escalation*, and *Confrontation*) is based on the TV series *Mobile Suit Gundam* and represents a unique kind of crossover. Tomino had already directed Tezuka's televised anime series *Tetsuwan Atomu* (*Astro Boy*) and *Ribon no kishi* (*Knight of the Ribbon*) and the giant robot series *Brave Raideen* and *Zambot 3* when *Mobile Suit Gundam* premiered in 1979. The series departed from the giant robot formula with its ambiguous and conflicted heroes and villains who were not caricatures.

Initially the TV series had relatively low ratings, and the producers decided that it would end two months earlier than originally planned, requiring much rewriting. However, when rebroadcast later that year, the series proved much more successful, begetting several successful sequels (and model kits) as well as this trilogy of novels. Its director and creator, Tomino, radically rethought and expanded the series for the novels, the first appearing in 1979 just as the television series was ending. All three novels were republished in 1987 in Japan.

In 1988 a Del Rey Ballantine editor approached Frederik Schodt, on the strength of his *Inside the Robot Kingdom*, and asked if he would translate the *Gundam* trilogy. Schodt's translation appeared in 1991 and, like the original broadcast of the series in Japan, confused fans whose expectations were based on more conventional anime. After spending a dozen years out of print, the trilogy has now been reissued by Stone Bridge Press.

Schodt's translation works both as a novel and as a genre piece of science fiction writing, more Heinlein-style hard core than cyberpunk. Combining the three books into one makes organic sense and allows the reader to follow the story of Amuro Ray, Char Aznable, and both sides of the war that brings them together while forcing them to confront their Newtype abilities.

The novels also provided a Western standard for the character, place, and device names in *Mobile Suit Gundam*, which had varied widely in Japanese transliterations. For example, Lalah Sune also appeared as Laura Soon, and the character Tomino had named Shah Azunaburu was variously renamed Char Aznable, Shaw Aznable, and even Charles Aznavour (a real French pop singer!).

An interesting facet of the novels—and possibly a reason why Tomino wrote them—is the expanded view of just what constitutes a "Newtype," a key concept of the tale. The original story was driven in part by a prophetic statement from Zeon Zum Deikun, monarch of the space colonists and founder of the Republic of Zeon. His successor, Degwin Sodo Zabi, says, "Zeon Zum Deikun once prophetized [*sic*] that someday mankind would undergo a transformation. Should that come to pass, mankind may give birth to a new race of men who by themselves will rule the universe. . . . What he called a 'new type' of human" (93).

Like many prophecies, this one was short on details and allowed for many interpretations, most of them managing to turn up in the novels. Humankind's worst impulses had first try at defining a Newtype; as Tomino put it, perhaps reflecting on earthly civilization, "because the military authorities . . . were so embroiled

in war, they were the first to interpret it their own way, . . . as humans with paranormal powers, as pilots with prescience, as weapons of war" (237). One soldier of the Earth Federation, Hayato, can't quite accept the proposition: "Something about all this smacked of nonsense. If the Zeon government was really planning to form a special Newtype Corps, its members could hardly represent a total transformation of humanity. Surely they would simply be a group of murderous supermen, even super-butchers. Weren't Newtypes just some freak-mutants? . . . Newtypes, Hayato concluded, were really just deviant personalities" (140).

The Zeon Federation also sought Newtypes through testing at the Flanagan Institute, which determined that Newtypes had "enhanced powers of intuition." But this raised "the question of how to define, or for that matter how to even find, Newtypes. There was no guarantee of identifying them in any great number among the truly gifted members of society—the geniuses in the arts and sciences. Nor were average persons with superior intuition always Newtypes. Newtypes sometimes even existed among extremely ordinary, conventional people with a rigid sense of self and relatively little heightened awareness" (162–63).

One of the story's principal Newtypes, Char Aznable of the Zeon forces, dismisses Zeon Zum Deikun as "an idealist"—at least, in conversation with another potential Newtype connected with Zeon military leader Gihren Zabi. Char's denial, therefore, can be seen as a strategic maneuver, especially since he had known the mysterious woman Lalah Sune and had experienced both her Newtype abilities and his own. Ultimately, we learn that Char endorsed Zeon Zum Deikun's perspective on Newtypes: "Ordinary people with an uncommonly developed sense of intuition and a unique sense of humanity. People who, in adapting to a new concept of time and space in an extraterrestrial environment, would be transformed. . . . if this experience could ever be shared by all of humanity, then, as

his father had predicted, mankind itself could truly undergo a transformation" (384).

Amuro Ray is a Newtype for the Earth Federation and pilot of their lone Gundam. Yet his Newtype radar tends to get scrambled in the presence of women, creating another layer of self-doubt and misperception, especially for those to whom he feels attracted, particularly Char's sister, Sayla Mass. At first she discounts her own belief in Newtypes and tries to describe her own talents strictly physiologically: "Sometimes I have something like a seizure . . . like something suddenly goes off in my mind sometimes" in the presence of another Newtype.

She especially distrusts the possibility that she might be one: "The Newtypes Zeon Zum Deikun spoke of were supposed to symbolize something much more universal, something that applies to all mankind. They're not supposed to be people who dash off on a whim, like me" (233). Yet "dashing off on a whim" is precisely the way Amuro's Newtype abilities might appear to an outsider. His ability to make instantaneous, seemingly intuitive or prescient, decisions in battle is clearly a Newtype trait.

Toward the end of the first novel, Amuro experiences a transcendental communion in the midst of battle with another Newtype, Lalah Sune:

> There were no words spoken. Amuro simply knew. His thoughts were hers. Hers were his. They had fused together; a direct line of pure thought flared and soared straight into the heavens. It was perfect; two separate individuals had experienced a perfect empathetic communion.
>
> Amuro and Lalah's fused consciousness ignited, expanded, and journeyed far into space. Before returning to lodge in human form, it presided over a world where chaos and confusion continued to reign. (170)

But even after all this, Amuro internally voices self-doubts:

I may have better than average intuition, but I hardly think I'm a real Newtype—I'm hardly some sort of new species that's going to transform humanity. Frankly, I don't believe that stuff for a minute. Lalah, the whole thing's crazy. . . . It makes me exhausted just to think about all this. (177)

Despite the prophecy, or perhaps because of it, the Newtype appeared in a vacuum of information as complete as the vacuum of space. This is hardly the first time humans have had to make decisions with a complete lack of knowledge. Shibutani Tamotsu's *Improvised News* is a study of rumor, which grew in part out of his experience in a Japanese American detention camp during World War II. In such a strictly controlled environment, real and reliable news was hard to find, and as a result,

> rumors emerge in ambiguous situations. . . . Examination of the various contexts in which rumors develop reveals that they have one element in common: they are all problematic situations. . . . men are unable to carry out their activities for want of accurate, up-to-the-minute information. (56–57)

Shibutani concluded: "*If the demand for news in a public exceeds the supply made available through institutional channels, rumor construction is likely to occur*" (57).[1]

So, given the control of Newtype information by military establishments on both sides of the conflict, it's no surprise that rumor and doubt, false assumptions and prejudiced denial were integral to speculations about this supposed quantum leap for the human species. The greater irony is that, once the Newtypes come into full transcendent bloom, they realize that the potential greatness of humankind consists of *not* going to war. Yet these very Newtypes are placed on the front lines of battle precisely because of their Newtype abilities, which may

never have been fully awakened away from the battlefield.

Tomino seems to be saying that there may even be ironic benefits to the horrors of war, as long as one is open to that possibility. In that case, *Mobile Suit Gundam* serves as the predecessor of the other *Gundam* tales in more ways than one.

The notion of humans moving to higher (or at least different) stages of evolution is found in Darwin, in Nietzsche, in most world religions (metaphorically, at least), and in the Transhumanist movement. In science fiction, change is often a by-product of apocalypse; for example, in John Wyndham's novel *The Chrysalids*, postatomic "Newtypes" must conceal their abilities to avoid being mistaken for radioactive mutants. Tomino's trilogy is not postapocalyptic, since it takes place during the war that gives birth to the Newtypes. Nor are these Gundam novels—indeed, nor are any of the Gundam stories—about giant robots. Instead, Tomino focused on the people who waged war in the robots. In doing so, he changed science fiction anime, influencing the Macross series that premiered three years later. Not bad for an anime that also managed to sell cool plastic robots.

Good work, Tomino, and good work, Schodt and Stone Bridge Press, for bringing these novels back into print in English.

Note

1. Shibutani, Tamotsu. 1966. *Improvised News: A Sociological Study of Rumor*. New York: Irvington.

The Yin and Yang of Schoolgirl Experiences: *Maria-sama ga miteru* and *Azumanga Daioh*

MARC HAIRSTON

Matsushita, Yukihiro (director). 2004. *Maria-sama ga miteru*. Tokyo: Geneon. Volumes 1–7: GNBA-7021 through GNBA-7027.

Nishikiori, Hiroshi (director). 2004. *Azumanga Daioh*. Houston: ADV Films. Volumes 1–6: ASIN B000II5682, ASIN B000228T0E, ASIN B00029NMM2, ASIN B0002IQFMC, ASIN B0002VKZGQ, ASIN B00062J0BC.

Maria-sama ga miteru (*The Virgin Mary Is Watching over Us*), or *Marimite* as it is more commonly known in the anime community, is unusual as much for what it is not as for what it is. While the young female characters in many anime are energetic, hypercute, and generally endowed with magical powers or involved in loud adventures piloting robots or spaceships, in *Marimite* the characters are ordinary students (echoed by the animation's subdued color palette). The story focuses on the interpersonal relationships of eight high school girls. For thirteen episodes, nothing much happens, and that is the beauty of the show. Instead of following a high-powered story line, we observe the interior lives of these girls as the school year unfolds.

The story is set at the Lillian Girls' School, an elite all-girl Catholic school in Tokyo. The opening monologue in each episode describes the students there as maidens with angelic smiles who wear a "dark-colored school uniform [that] covers their pure minds and bodies." With further comments about how "they make sure the pleats on their skirts are not disturbed . . . [and] their white sailor collar is always kept orderly," we realize this is a very proper place for the education of young women.

The story centers on a school tradition: an older student picks a younger student as her *petite soeur* (little sister) and then acts as a mentor to the younger student. At the top of the school's social structure are three third-year students who head up the *Yamayurikai*, the equivalent of a student council. These top officers are elected, which means they are the school's three most popular third-year students. They are always referred to by their positions on the council, which are named after roses, so they are known as Rosa Chinensis, Rosa Gigantea, and Rosa

Foetida. In fact, it is only after the halfway mark in the series that we discover the proper name of Rosa Gigantea. The rest of the *Yamayurikai* is composed of the second-year students who are the *petite soeurs* of the third years, and the first-year students picked as the *petite soeurs* by the second years.

The central character is Fukuzawa Yumi, a mousy first year who is unexpectedly picked by Ogasawara Sachiko, the most elegant and admired of the second-year members of the *Yamayurikai*. Through Yumi's point of view, we see the events and interactions of all the other girls. As this is a *shôjo* anime (based on a series of novels by Konno Oyuki rather than a manga serial), the emphasis is on romance and emotion—but it is a romantic world without males. In a desire to promote the ideal of pure female friendship, the school's social structure centers on the *soeur* system. The system is further romanticized by the rituals surrounding it; for instance, the *grande soeur* gives the *petite soeur* her rosary as a formal symbol of their bond. (For Yumi and Sachiko, the romance is further emphasized by doing this in front of the statue of Mary in the school's garden.) Thus friendships, crushes, jealousies, and quarrels all play roles in the story. In one plotline the school newspaper runs a Valentine's Day contest for which the prize is a half-day date with one of the three *Rosas en bouton* (the *petite soeurs* of the three top Rosas). This is a moment of great anxiety for the first-year members of the *Yamayurikai*, who are upset over the thought of other girls having a date with their *grande soeurs*.

In such an environment of all-girl romantic friendships, homoeroticism is never far from the surface, and toward the end of the series it becomes part of the main story line. Lesbian themes are hardly new in anime and manga (so much so that the satirical series *Excel Saga* did an entire episode lampooning the lesbian clichés common in anime), but *Marimite* is rare in treating the subject respectfully and emphasizing romantic feelings over sexuality. In a flash-

back story line, we see the second-year Rosa Gigantea falling hopelessly in love with a first year. Although their love is mutual, it is doomed because the younger girl has decided to leave the school and enter a convent. The episode's final scene, as the devastated Rosa Gigantea is brought back home by her friends, is both powerful and heartbreaking.

What Western viewers may find most surprising about the series is the strong use of Catholic and Christian imagery. The rosary is used as the symbol of the *soeur* relationship, and throughout the series we see the students stopping to pray to the statue of Mary. However, most students are not Christian, and they pray to the statue as they would pray to any other icon or statue at a Japanese shrine. Even the name *Yamayurikai*, meaning "mountain lily council," is a reference to the lily as the symbol of Mary. Ironically, this combination of Catholic imagery and lesbian content may be the reason *Marimite* has not yet been licensed in North America as of this writing (early 2005). None of the distributors may feel the show to be worth the potential controversy, and that is a shame, since it is one of the most interesting and touching anime series of the past two years.

In contrast, *Azumanga Daioh* (an alternative romanization of the Japanese title *Azumanga daiô*), another series focusing exclusively on ordinary Japanese high school girls, was a commercially successful release in North America. Based on a manga by Azuma Kiyohiko (the title is a play on his name), this series takes a lighter and more wry view of the Japanese schoolgirl's world. Rather than the usual narrative graphic novel form, the manga follows the four-panel gag comic-strip format more familiar to Western readers. Thus the twenty-six-episode anime series covers the entire three-year career of seven girls, from their first day of high school to graduation, as a sequence of short and slightly disjointed comic vignettes. Its humor can be something of an acquired taste, as it is frequently oblique and so culturally based that

the English-language releases come with guides to explain many of the references. But through these short snippets of the girls' lives, we slowly build a picture of their personalities and watch them develop over time.

The characters themselves are not fantasy heroines with unusual powers but individuals with slightly offbeat personalities. There is Sakaki, a tall and athletic girl who is shy and distant. A running joke is that she loves animals but is continually attacked by all the cats she attempts to pet. There is Tomo, the boisterous tomboy who is always causing trouble along with her cohort, and Kagura, another athletic girl who is always challenging Sakaki. Then there is Ayumu (nicknamed "Osaka"), the class "space case" with an incredible ability for puns, most of which do not translate well. Koyomi is the class brain and the only one who seems concerned about getting into a good college. Kaorin is the sweet girl who hero-worships Sakaki. And last is Chiyo-chan, a child prodigy allowed to skip several grades and go straight into high school. Because she is five years younger than the rest of the group, she is alternately treated as the cute "little sister" and teased for her innocence and gullibility. In addition, there are two young teachers at the school, Miss Yukari, a barely competent English teacher, and Miss Nyamo, a very competent physical education teacher. They have been friends and rivals since they were together in high school and have continued their rivalry into the present, thus showing that even teachers still carry their high school selves on into adulthood.

Ultimately, *Marimite* is about self-discovery and self-acceptance. Coming from an unremarkable middle-class background, Yumi is both in awe of and frightened by Sachiko's upper-class elegance and cannot overcome her sense that Sachiko's choice of her was a mistake or fluke. Yumi desperately wants Sachiko's approval and affection and is terrified of doing something to upset or disappoint her. Yumi's confidence grows as she begins to realize that much of

Sachiko's aloofness is just a cover for her own lack of self-confidence. We see a true friendship develop once Yumi gets past her hero-worship and Sachiko gets past her own insecurities. While *Marimite* emphasizes the inner life of its characters, *Azumanga Daioh* focuses mostly on the external social interactions and antics of the characters, thus holding us at a distance but still allowing us to laugh at and sympathize with them. Considered together, the two shows present the yin and yang of the modern Japanese schoolgirl experience, with *Marimite* embodying the romantic ideal, while *Azumanga Daioh* demonstrates the playfully ironic reality.

Note

The author thanks Nobutoshi Ito, Sara Cooper, and Pamela Gossin for their helpful discussions.

Historicizing Anime and Manga: From Japan to the World

BRIAN RUH

Gravett, Paul. 2004. *Manga: Sixty Years of Japanese Comics.* New York: Harper Design International. ISBN 1-85669-391-0.

Patten, Fred. 2004. *Watching Anime, Reading Manga: Twenty-five Years of Essays and Reviews.* Berkeley, CA: Stone Bridge Press. ISBN 1-880656-92-2.

With the popularity of Japanese comics and animation, it is surprising that nobody has yet written a comprehensive history in English about anime or manga. This is not to say that we lack an understanding of how these forms developed—indeed, ·several books provide a general outline of this history. For anime, the most comprehensive historical book is Jonathan Clements and Helen McCarthy's *Anime Encyclopedia* (2001). For manga, the oldest book is still the best: Frederik L. Schodt's *Manga! Manga!* (1983), an engaging account that high-lights the manga universe. Both books do have drawbacks. Although *The Anime Encyclopedia* is an eminently useful (and occasionally delightfully snarky) reference book, it is more a compendium of titles than a history per se. Schodt's book sets the stage for an in-depth analysis of manga but does not emphasize how the medium developed historically.

Chapter 1 in Sharon Kinsella's *Adult Manga: Culture and Power in Contemporary Japanese Society* (2000) is close to a sociocultural history of manga, but, at only thirty pages, it is just a thumbnail sketch. The two books under review both initially seem to remedy this lack, given that each refers to significant time spans. Although neither fulfills my wish for a comprehensive history of manga or anime, they each have strengths that make them useful research tools.

At first, Gravett's book seems like a slicker, more up-to-date version of Schodt's *Manga! Manga!* The layout is similar—each page bears one or more manga illustrations, and the chapters are arranged by theme rather than chronologically. But the seeming similarities between Schodt's and Gravett's books arise more from the seminal position of Schodt's book in English-language manga studies than any intentional structural similarities. In *Manga! Manga!* and his later *Dreamland Japan*, Schodt sketches the workings of the manga industry in such detail that it has become difficult to write a general look about manga without rehashing Schodt. Certainly, a new book is needed to keep up with recent trends in manga and manga scholarship. Nonetheless, Gravett faces considerable challenges in writing *Manga* in the wake of Schodt's books.

Gravett distinguishes himself from Schodt and other manga scholars on several points. Most obvious is Gravett's position on the development of manga. Anyone familiar with Schodt's work would be surprised that Gravett limits manga to a span of sixty years, essentially marking manga as a postwar phenomenon. (Indeed, Schodt's second chapter in *Manga!*

Manga! is titled "A Thousand Years of Manga.") In Gravett's formulation, modern manga owes much to the influx of comics and American popular culture after World War II. Writes Gravett, "American comic books swept into Japan from 1945 via the occupying forces. Imagine the impact of these strange new artifacts, all in pictures and in striking colors, on children who for years had suffered the deprivations of war. Comic books proved irresistible. Like chewing gum, they came and they stuck" (12–13). Gravett disputes the continuity other scholars find between manga and earlier narrative work like Bishop Toba's twelfth-century parodic "Animal Scrolls." In fact, Gravett writes that what we now think of as manga "might never have come into being without Japan's long cultural heritage being soundly disrupted by the influx of Western cartoons, caricatures, newspaper strips and comics" (18).

Gravett's take on manga's modern origins is supported by Kinsella's position. Kinsella writes, "The opposition to the manga and animation industries by conservative elements in post-war society has encouraged the defenders of manga, namely professional manga critics, to emphasize or even invent stylistic origins for manga in ancient Japanese history. . . . This defensive argument has drawn attention away from the fact that manga is a strikingly *contemporary* cultural phenomenon" (19–20). Kinsella seems to suggest that Western writers on manga like Schodt have adopted a false idea from Japanese scholars that manga has long cultural roots in Japanese culture. This argument seems to hinge on how "manga" is defined. If manga is a form of "sequential art" (to borrow Will Eisner's term), then, as the cultural anthropologist and comics scholar Matt Thorn argues, earlier forms of Japanese comic art could be considered manga. Writes Thorn (2004), "The first clear examples of such sequential art are the picture scrolls of medieval Japan, which combine pictures and text to tell stories or describe events. These scrolls look and work like modern manga or comics

in many ways, but there is a crucial difference: whereas modern-day manga are produced for mass consumption, picture scrolls were singular works of art produced for an elite audience." In the end, Gravett does not completely ignore Japan's pre–World War II comic art, and he devotes a chapter to these "ancestors of manga." But it is one of the shortest in the book, thereby suggesting that Gravett does believe we should de-emphasize these ancient art forms in an analysis of contemporary manga.

Gravett's next chapter is about the "god of manga," Tezuka Osamu. It provides a good overview of the life and works of the man who revolutionized manga in Japan and (some might say) created what we now think of as modern Japanese comics. However, as Thorn points out in his article on manga history, Tezuka was not the first to apply ideas derived from films to comics. In subsequent chapters, Gravett delves into boys' comics, girls' and women's comics, young and adult men's comics, general audience comics, underground comics, and the spread of manga worldwide. Each chapter is thoroughly illustrated with examples from the original Japanese versions as well as the English translations.

One of the most interesting aspects of Gravett's book is his final chapter on the internationalization of manga. It shows how artists around the world have been influenced by and have incorporated manga into their comics. Gravett concludes the last chapter with the line, "As artists combine the genres from manga, Eurocomics, American comics and other sources, rather than forging a single 'universal' style, they seem to be ushering in a post-imperialist, transnational culture of 'World Comics'" (157). Perhaps this assessment is overly optimistic, but it indicates that manga is no mere passing fad and will remain on the world's popular culture landscape, in one form or another, for many years.

My main problem with Gravett's book is that it is often short on text. I constantly found myself wishing for more text and fewer visuals.

But this is probably an intentional editorial decision. Many other books on comics published by Harper Design International—like Rika Sugiyama's *Comic Artists-Asia: Manga Manhwa Manhua* and Comickers Magazine's *Japanese Comickers*—are similarly long on images but short on words. Gravett's approach to his sources is similarly frustrating, footnoting none of his quotes and citing none of his information. He does provide a list of resources at the end, but these are listed only as possibilities for further reading. This is obviously a mass-market rather than an academic book, so some of the criticisms can be forgiven. However, with just a little more work Gravett's book could have had much greater potential as a research source.

Fred Patten's *Watching Anime, Reading Manga* takes a different approach to chronicling the development of Japanese popular culture. Rather than being a conscious history of anime or manga, the book is a retrospective of Patten's own writing. Patten has been writing professionally about comics for nearly forty years and was one of the founding members of the Cartoon/Fantasy Organization, the first anime club in the United States. In his managerial role at Streamline Pictures, Patten helped establish anime as a commercial force in the U.S. video market. Over the years, Patten has written some of the most useful articles about the spread of Japanese comics and animation in the United States. Some of these articles are collected in *Watching Anime*.

Patten's book describes the development of anime and manga fandom over the last twenty-five years and discusses how manga and anime journalism has evolved. With the advent of the Internet, information about the latest anime and manga are so readily available (as are fansubs and scanlations of the actual shows and comics) that it is easy to forget that it was not always this way. Information about Japanese pop culture was often hard to find, and years could elapse between the time a show would air on Japanese television and when it might make

its way to the United States. Today, the latest anime shows are often available for download in subtitled form mere days after their broadcast. Within the anime fan community, there seems to be a diminished sense of institutional history that forgets the difficulties of being a Japanese media fan fifteen to twenty years ago. With so little written on anime fans and fan history, *Watching Anime, Reading Manga* provides essential context for how we in the United States have interacted with, adapted, and reshaped Japanese popular culture.

The first of the book's five main sections, "Anime Fandom," is one of the most useful to scholars investigating how anime and manga have proliferated in the United States since the 1970s. The section features Patten's landmark essays "Fifteen Years of Japanese Animation Fandom, 1977–92" and "Anime in the United States." The second section, "The Business of Anime," focuses on how the US. anime industry has developed and highlights some of the changes over the years. Of particular interest are two previously unpublished articles on controversies that arose in some fan circles about *The Lion King* and *Atlantis: The Lost Empire*. Disney was said to have taken unacknowledged source material from two earlier anime television shows (*Kimba the White Lion* and *Nadia: The Secret of Blue Water*, respectively). The third section highlights four influential creators: the anime director Miyazaki Hayao and the manga creators Tezuka Osamu, Ishinomori Shôtarô, and Nagai Gô. (Although Patten does not explain why he chose these artists, perhaps it is because they belong to a lineage of sorts. Ishinomori worked as an art assistant to Tezuka, while Nagai began his career as one of Ishinomori's assistants.) The fourth section, "Japanese Culture in Anime," is more about the development of anime and manga in Japan than about how anime could have transmitted Japanese thought and cultural practices. Several essays try to connect anime to other aspects of Japanese history. The book's final section focuses on specific anime

titles, from 1970s television classics like *Astro Boy*, *Gigantor*, *Mazinger Z*, and *Force Five* to more recent feature films like *Vampire Hunter D*, *Metropolis*, and *Cowboy Bebop: The Movie*.

The book does not merely reprint old articles. For each piece, Patten has written a few new paragraphs contextualizing the article. Sometimes these paragraphs explain the history behind the article, sometimes they defend an expressed point of view (such as Patten's argument that AnimeCon '91 was the first anime convention rather than the original A-Kon, which was held two years earlier but was not devoted exclusively to Japanese animation), and sometimes they correct some erroneous information in the original article. This last point emphasizes the book's historical nature, as the articles are presented as they were originally published, with corrections in the supplementary notes. Patten also helpfully provides an index that makes all sixty-three of his articles much easier to use for research purposes. Indeed, I found myself using the book as a reference tool from the very first day I bought it.

With all of Patten's obvious experience in writing about anime and manga developments in the United States, I was somewhat disappointed that the book was not a more developed history of anime and manga fan subculture. Very few people have the experience and knowledge to write such a text, and Fred Patten is one of them. Still, Patten picks and chooses his articles well, and one can piece together a fairly coherent picture of how far U.S. anime and manga culture has come in the last twenty-five years.

Writing a good history can be tricky. Perhaps that is why nobody has written a comprehensive English-language history for anime or manga. The subject is becoming even more complex, as the meaning of the terms *manga* and *anime* continue to change. Both Gravett's and Patten's books demonstrate that anime and manga cannot simply mean "animation and comics from Japan." As Gravett shows, manga has roots in U.S. popular culture and seems to have a strongly international future, while Patten illustrates the long history these "foreign" cultural products have in the United States. Each book makes its own sizable contribution to English-language scholarship on anime and manga, earning both books a place in the library of anyone researching Japanese popular culture.

References

Clements, Jonathan, and Helen McCarthy. 2001. *The Anime Encyclopedia: A Guide to Japanese Animation since 1917*. Berkeley, CA: Stone Bridge Press.

Comickers Magazine, ed. 2003. *Japanese Comickers: Draw Anime and Manga like Japan's Hottest Artists*. New York: Harper Design International.

Kinsella, Sharon. 2000. *Adult Manga: Culture and Power in Contemporary Japanese Society*. Honolulu: University of Hawai'i Press.

Schodt, Frederik L. 1983. *Manga! Manga! The World of Japanese Comics*. New York: Kodansha America.

———. 1996. *Dreamland Japan: Writings on Modern Manga*. Berkeley, CA: Stone Bridge Press.

Sugiyama, Rika. 2004. *Comic Artists-Asia: Manga manhwa manhua*. New York: Harper Design International.

Thorn, Matt. 2004. "A History of Manga, Part 1." October 25. Matt-Thorn.com, http://matt-thorn.com/mangagaku/history1.html (accessed January 23, 2005).

In the Sound of the Bells: Freedom and Revolution in *Revolutionary Girl Utena*

TIMOTHY PERPER AND MARTHA CORNOG

Saito, Chiho. 2004. *Revolutionary Girl Utena: The Adolescence of Utena*. San Francisco: VIZ Media. One volume. ISBN 1-59116-500-8.

*In the sound of the bell of the Gion Temple
echoes the impermanence of all things. The
pale hue of the flowers of the teak-tree shows
the truth that they who prosper must fall.
The proud ones do not last long, but vanish
like a spring-night's dream. And the mighty
ones too will perish in the end, like dust before
the wind.*

—Opening lines of the *Heike Monogatari*, written
ca. 1215 C.E., about the fall of the Heian dynasty
in 1186 C.E. (quoted in Totman 1981)

The film of *Revolutionary Girl Utena: Adolescence Apocalypse* opens with a carillon of bells. A man and a woman stand on the balcony of a white obelisk stained with crimson. The bells peal again, and now the woman is alone.

Throughout its three versions—Saitô's original five-volume manga, the television series directed by Ikuhara Kunihiko, and the film plus final volume of manga—*Revolutionary Girl Utena* tells of the destruction of one way of life and the beginning of another.[1] Along the way, Utena and Anthy encounter not only each other and their quite personal enemies but love, freedom, and the karmic undertow that shapes their destinies. All four versions are interconnected by webs of things past, memories that shift and are reborn.

Near the beginning of the five-volume manga, Utena remembers herself as a child walking along a culvert filled with rushing water. Her parents have just died, and despondently she lets herself slip into the water. But she does not drown. Instead, a mysterious prince rescues her. Kissing away her tears, he gives her a rose signet ring and promises that someday it will lead her back to him. Utena does not forget: she decides that she will live as a prince, with a noble heart filled with high goals.

As a teenager, she enrolls in Ohtori Academy (an alternate romanization of "Ôtori" Academy), an elite private school where she encounters a young woman named Anthy in a rose-filled dueling field. The arrogant Saionji,

school kendo captain, challenges Utena, and never one to turn down a fight, she defeats him in a duel—only to discover that she has now won Anthy, the Rose Bride, as her betrothed.

In all versions, winning Anthy as Rose Bride in a duel remains constant. But other elements shift, a penumbra of variable details surrounding an invariant center.

Gradually, Utena understands that Anthy is traded among the duelists as a trophy sex partner, and that behind her exploitation lie the malignant motivations of Anthy's brother, Akio, Anthy's own prince and the other figure with Anthy on the balcony of the white obelisk. The issue is power: Anthy can unlock the power to revolutionize the world, so that her ultimate owner will rule the world. Yet to those who seek such power, Anthy is surrounded by legends and dimly recollected history. Sometimes Anthy was a witch who killed the real prince; sometimes a pawn of Akio's sexual and political malevolence (he is sleeping with her); sometimes her power works through the Sword of Dios, which, with a kiss, she can make undefeatable. But never is the power Anthy's. It exists for others to use—or try to.

So, when Utena wins Anthy as Rose Bride, she disrupts an opaque political struggle. And when Utena decides to liberate Anthy, her decision destabilizes Ohtori Academy.

But another trap awaits. In the original manga, Utena ultimately confronts Akio in his persona of Dios, the god of dark. He taunts Utena, but she will not abandon Anthy. As the scene unfolds with escalating emotional power, Utena transforms. Awakened from Akio's spell, Anthy tells Utena that she needs not a prince but Utena herself. Although Akio wields the Sword of Dios, Utena crushes him to the ground, her own sword overhead, her white-feathered wings surrounding her. She has become a goddess. She heals Akio/Dios of his sundering from the god of light, gives the rose ring to Anthy, and vanishes. The original manga ends as a profoundly transformed Anthy leaves Ohtori to find Utena

and create the revolution that will occur when the two women are reunited.

Anthy has been liberated personally and sexually from her captivity to Akio's scheming. Nonetheless, she has been acted on and has not liberated herself. This karmic engine powers the next versions of the story.

The television series recapitulates Utena and Anthy's meeting and the duel, and ends by reiterating the Utena-Anthy-Akio confrontation. Akio, still as malevolent as ever, seduces Utena to obtain her ring, but Anthy's own emotions are beginning to stir. She is intensely jealous of Utena's hold on Akio and is torn between her own self-destructive love for her brother and her growing love for Utena. As Anthy vacillates between being suicidal and murderous, Akio easily manipulates Utena's hopes.

But Utena will not yield to Akio: they again duel, now with Utena wielding the Sword of Dios. But Anthy betrays her. Stabbed by Anthy and badly hurt, Utena loses the sword to Akio, who, in triumph, tries to open the Rose Gate behind which he believes lies the power to revolutionize the world. But the sword breaks on the stone gate, and Akio retreats in furious confusion. Utena stumbles forward, and just when we expect her to fall into Akio's arms, she shoves him aside, true as ever to her own loyalty to Anthy. Utena's power is no longer that of a sword-bearing goddess but a Taoist prince: she kneels before the entrance, and a single dropping tear opens the gate. The fragility of one tear can open the Way when swords cannot. It is Lao Tzu:

Nothing . . . is as soft and yielding as water,
Yet for dissolving the hard and inflexible,
 Nothing can surpass it.
The soft overcomes the hard;
 The gentle overcomes the rigid.
(Lao Tzu, section 78, quoted in Benfey 2003, 148)

Inside, Utena tears open a coffin where Anthy is hiding and gently reaches for her. But Anthy is afraid and falls away, lost to Utena. Yet not to herself: in the end, Anthy walks away from Ohtori to find Utena.

Although Utena cannot rescue Anthy, Utena's gentleness—her noble heart—opens the Way for Anthy to escape. Yet the karmic burden of Anthy's liberation remains unresolved.

And the film opens with bells. Impermanence indeed: this Ohtori Academy has hypermodernist architecture, with surreal platforms and stairs. Utena, older and taller now, tours the campus on her first day as a student. She encounters Tôga, her first love/lover, but that seems past. As rain falls, she kneels in a tiny rose garden, where a single white rose opens and drops the rose ring into her hand. Suddenly she is surrounded by crimson, drifting rose petals. Far above, cantilevered into open space, is a platform. She climbs up to it, and it is a larger rose garden. As she stands looking down at Ohtori, we hear Anthy: "Are you not afraid standing there?" Soon, Saionji (re)appears and once again Utena duels with him: when Utena loses her bamboo sword to Saionji's steel blade, Anthy flies to her and kisses her full on the mouth. A sword hilt appears between Anthy's breasts, which Utena takes. The chorus states the theme: *Yomigaere*—I am reborn.

The film and final manga deal primarily with Utena and Anthy's now clearly sexual and very deep friendship. Yet the karmic past throws long shadows: although Akio has vanished, Anthy is still enslaved by her prince, and Tôga still haunts Utena.

Utena's jealousy of Anthy's relationship to Tôga now triggers a crisis (reversing the jealousy theme from the second version). Horribly upset that Anthy has slept with Tôga, Utena confronts her in the Rose Garden. But instead of betrayal, they open up to each other and dance together under the stars in one of the most beautiful scenes in anime. Reciprocally, when Utena and Anthy climb to the balcony of the obelisk the next day, Anthy reveals that Akio tried to kill her. In the manga, Anthy

shows Utena her scarred breasts, but in the film, we see Anthy in silhouette, her wound the same crimson that stains all Ohtori. In a flashback, Akio rapes a drugged Anthy, and, when he discovers that she is not asleep and perhaps never was, he stabs her and kills himself in agony. Utena finds Tôga, and remembers that he died trying to rescue a drowning girl. Her realization that he is dead frees Utena from the last karmic link to her own past, but Akio's suicide does not liberate Anthy.

Growing below these scarred memories is Utena's absolute determination to free her beloved Anthy. In the film's climax, Anthy offers Utena herself and all Ohtori. Utena refuses: "No. Let's go. To the outside world." Anthy hesitates, as she did before in her coffin, but now she must choose. This time she goes with Utena.

But Anthy must still confront Akio. It is not enough for Utena the goddess to annihilate him, or for him to commit suicide. Now, as Akio arises reborn before her, Anthy rejects him: *I* make this choice, she asserts, and Akio is destroyed. The karmic cycle is fully broken, and both women are free.

Wagnerian? Yes. But, unlike *Götterdämmerung*, Brünnhilde does not die. At the end, Anthy and Utena are together, holding hands in a new world.

At the simplest, *Utena* describes how two women find their own identities. But *Utena* is no bourgeois bildungsroman of finding one's place in the world. Nor is *Utena* a linear narrative of events apocalyptic and otherwise. Instead, *Utena* delves into the nature of the past and its karmic hold on people, into the nature of corruption and sexuality, and into revolution (*kakumei*). Utena and Anthy are not passive observers of fate: first Utena, then Anthy seize control of their own lives. Ultimately, their enemy is not Akio himself but a system of relationships. No deus ex machina saves them. They free themselves, and behind them a dynasty ruled by princes like Akio crumbles—like dust before the wind.

Note

1. The creative team behind the original story concept, the television series, and the film calls itself Be-PaPas. The team includes director Ikuhara, artist Saitô, and animator Shinya Hasegawa.

References

Benfey, Christopher. 2003. *The Great Wave: Gilded Age Misfits, Japanese Eccentrics, and the Opening of Old Japan*. New York: Random House.

Totman, Conrad. 1981. *Japan before Perry: A Short History*. Berkeley: University of California Press.

トレンド
Torendo: A Series of Interviews

MICHELLE OLLIE

Lindsay Cibos is the creator of the *Peach Fuzz* manga graphic novel series, the grand prize winner in the "Second Rising Stars of Manga" anthology, published by Tokyopop. She also wrote and illustrated *Digital Manga Workshop* (2005), published by Harper Collins Design (www.jaredandlindsay.com).

MICHELLE OLLIE: What trends do you see with manga and anime fans (readers/viewers)?

LINDSAY CIBOS: Angels, maids, and plushy hats seem to be in. ^_^

Seriously though, the biggest trend I see with the fans is that there seems to be a lot more of them. The market has really expanded. Five years ago, manga and anime were practically unheard of as terms. Only devotees knew about this stuff and had to follow it through comic shops, Web sites, and college campuses. Today retailers like Best Buy devote entire aisles to anime, and some Waldenbooks locations claim upward of 20 percent of sales comes from manga. It's incredible how an American fan base that was seemingly always there but was never catered to has em-

braced manga and anime. The other trend I see with the fans has to do with specialization. We're in a marketplace with ever increasing choice. It's become impossible to buy all the merchandise and see all the shows. The fans are becoming more discerning. Overwhelmed, people are beginning to gravitate away from anime/manga in general and find particular niche interests within the market to focus on. Of course, recognition of these niche audiences has led to products that cater to ever more specialized fan interests. A good example of this would be TV anime shows like *Kore ga watashi no goshujin-sama* (*He Is My Master*), which is basically a harem show (already a niche) but clearly states it's made specifically for maid outfit fetishists. I think we'll continue to see more of this sort of pinpoint marketing when it comes to product development for the near future.

MO: Tell us about your soon-to-be-released *Digital Manga Workshop* book.

LC: There are plenty of books on the market that strive to teach people about how to draw manga. The art racks at bookstores are loaded with them. However, once you know how to draw your manga-style artwork, you've moved beyond the scope of most of these books. Using digital tools to color and manipulate art is something that's widely done in the anime/manga-style art community, but there's very little comprehensive information available in print for those interested in learning about using digital tools. Lacking any sort of guidance ourselves, for years we studied other artists' works, picking up bits and pieces as we went, and eventually developed our own techniques. *Digital Manga Workshop* is the culmination of these years of experience, presented in a step-by-step format. We attempt to detail everything involved in the digital artwork process; from tools, to image preparation, to techniques like digital inking, coloring in cel, airbrush, and painterly styles, along with use of special effects

and filtering to give your artwork that extra, professional shine. As a bonus, the book serves as a gallery for some of our best artwork.

From a College Student Perspective: Interview with Gregory John Pence

Gregory John Pence is a junior at Dartmouth College majoring in government with an emphasis on international relations. Gregory was the editor of the St. Paul's School *Horae Scholasticae*—the student arts/literature magazine—and the graphic editor/cartoonist for the school newspaper, the *Pelican*. Now a cartoonist for the *Dartmouth* and *Union Leader*, he aspires to save the comic strip from extinction. His strip, "Looking Up," is available at www.thedartmouth.com.

MO: Gregory, tell us about the "Manga Revolution."

GJP: No doubt Westerners co-opted conventions of manga prior to 9-11. Frank Miller's groundbreaking 1986 graphic novel *Ronin* drew upon the Japanese concept of samurai and transplanted it in a postapocalyptic Manhattan setting. However, American influence is currently working its ways into the Japanese creative community with even greater zeal, and the Japanese, in turn, are exerting greater influence—consciously or not—on American artists.

Economic incentives no doubt play a vital role in sustaining this East-West creative relationship. Simply put, manga are a hot commodity, outselling graphic novels with American-sourced content in the United States in 2003. Keenly aware of these developments, American distributors rush to conceive, produce, and sell manga comics (and their animated twin, anime animations).

Globalization—that is, the increasing economic integration and interdependence of

countries—contributes to the cross-pollination of Japanese and American creative forces. Marvel, one of America's largest comics companies, introduced Marvel Manga in 2004. DC followed suit only months later, publishing Japanese manga in English translations. America is easily the largest overseas market for Japanese manga. The Japanese likewise adapt American comic books into manga (*Spawn*, *X-Men*), and American authors write first-run series for Japan (*Morning and Afternoon*, magazines published by Kôdansha, issue regular installments from non-Japanese artist and writers). Meanwhile, Japanese creators publish comics directly in the United States (such as with Antarctic Press), and the American comic market increasingly incorporates manga styles (Cliffhanger comics). Perhaps the greatest indicator of cross-pollination and its profitability is this: Wal-Mart and Target recently launched Cine-Manga books, storyboard-style books. The manga comic represents a revolution in terms of transnational marketing and production.

MO: How popular is manga?

GJP: As a rational for the production of the manga, profits fail to explain the form's popularity. No doubt several explanations exist. First, the medium transcends many of the self-imposed barriers blocking (or used to block) the comic book's maturation; indeed, manga address controversial topics that include racism, sexuality, war, and religion. Second, the manga market's boom in the United States is due, in no small part, to the medium's celebration of strong females. Journalist Calvin Reid further contends manga's popularity is driven by teenagers, and the reason is obvious: manga feature dynamic, eccentric, and very often sexy illustrations in combination with fast-paced science fiction, adventure, fantasy, and martial arts stories. However, these explanations fail to explain "cross-pollination" and the ease by which once insurmountable cultural divides are now being bridged.

MO: What are your thoughts on 9-11's influence on creators and readers of manga?

GJP: 9-11, like the dropping of the atomic bomb on Nagasaki and Hiroshima, was a singular moment in history that inaugurated an epoch. The atomic bomb made the world accountable to the realities of the nuclear revolution. For the first time in history, man could eliminate all mankind. Governments wrestled with competing ideologies, advanced deterrence theory, and nearly destroyed the world several times over. Yet born from the Cold War was technology—specifically, the computer—meant to ensure survival through surveillance. Here another epoch, the digital revolution, began with connections made on the Internet. Increasing awareness of other cultures and traditions followed increased access to information expanding at an exponential rate. Then 9-11 happened.

9-11 proves a singular moment in history in that America, and the many other nations comprising the global village, realized the cost of fear. With the fall of the Soviet Union, and the rise of American hegemony, the United States enjoyed relative peace and economic prosperity; nevertheless, Americans collectively—as a nation, a state, a culture, etc. —continued to imagine the end. The fifty-year-old Cold War mentality of "jump under you desk and kiss your ass good-bye" never died. Fear of Y2K and predictions of the apocalypse sold movies and novels. Simply, Americans could not adapt to a unipolar world. America effectively transferred its Cold War fears of the Soviet Union to other villains, real or imagined, that included Satan, terrorists, and computer viruses. Americans imagined death and destruction in every conceivable way perpetrated by every conceivable enemy. Americans imagined the end. Then America waited.

Comic books attempted, albeit superficially, to satiate America's growing interest in the apocalypse. No doubt poor sales and fears of bankruptcy compelled the industry to sacrifice its most cherished heroes. DC killed and resur-

rected *Superman* (1993), then collapsed the DC universe in *Zero Hour* (1994). As the Cold War drew to a close, the highest profile superhero story lines disassociated completely from reality. Readers consequently identified less and less with their champions. They waged spectacular wars on alternate galaxies against convoluted adversaries for ambiguous reasons. They fought for the sake of fighting. They fought because they could fight. Comics hence appealed less and less to younger generations, partly because they discovered the Nintendo and partly because superheroes seemed irrelevant.

9-11 shocked the senses and horrified the mind. Nevertheless, Americans breathed a sigh of relief. The end had come. The global community, linked by telecommunications, awaited the American response and the inevitable mobilization of the "arsenal of democracy." More important, America's fear no longer remained imagined and elusive; the enemy was real and apparent. Now another problem arises: the enemy defies convention as a transnational terrorist. He targets soldiers and civilians; he operates in many different countries; his command and control proves highly fragmented; he subscribes to a fundamentalist ideology opposed to negotiation and deterrence; and he refuses to wear a uniform.

MO: You talked about a "creative gap between Japanese manga artists and American artists."

GJP: The popularity of manga represents a normative shift for Americans and the Japanese. Simply, America and Japan exist and connect as postapocalyptic cultures. No doubt Americans find the apocalyptic themes and issues prevalent in Japanese manga and anime entertaining. Yet entertainment value is not enough to explain the decision by artists to incorporate aspects of manga's style and content. Rather, this incorporation arises from the fact that the Japanese have existed as a postapocalyptic culture for fifty years. Thus, a "creativity gap" is

present; Japanese artists possess a huge creative lead in terms of reconciling the apocalypse with reality. Increased interconnection vis-à-vis telecommunications allows artists to bridge linguistic and cultural differences by imparting essential knowledge and preempting ignorance.

The Marvel *Ultimates Universe* represents the first significant manifestation of the postapocalyptic consciousness in the American comic book. In the *Ultimates Universe*, popular heroes like Spiderman, the X-Men, and Captain America confront reality head-on, fighting for good in the midst of terrorism and government corruption. The *Ultimates Universe*, coupled with Marvel Manga, is saving the comic industry, breathing new life into a form once bankrupt, literally and artistically.

Questions arise concerning the West's faithfulness to manga's highly kinetic form and highly understated content. One Japanese artist, Chad Kime, confronts this issue directly:

> This leads to the other question: will Americans ever develop a quality that will rival the Japanese? I am hardly unbiased when it comes to this question. From my days working on RIAP (Running Ink Animation Productions) projects in the Anime style (or some semblance thereof), we constantly struggled to emulate the Anime masters with really crappy budgets. Since we were actively involved in US productions, the answer to this question was of great importance to us. Naturally, as Anime fans ourselves, we would like the answer to be a resounding "Yes!" Personally, I believe that attention to detail and a strong sense of artistic, directorial, and animation style can produce a product that retains the essence of Anime, regardless of whether we are looking at a Japanese production with western influence, or an American attempt at Anime.

Kime ultimately concludes that a criteria, or guidelines, will help determine the authen-

ticity of manga. Personally, the imposition of standards on art itself demands hesitation; however, hope springs eternal from Kime's acceptance of the hybrid genre. This liberal attitude more concerned with the art's authenticity rather than its cultural significance flows from a postapocalyptic understanding of the world. Simply, man is what he pretends to be. Imagined differences among and between cultures, religions, and races have incited conflict since time immemorial; however, the atomic bomb effectively makes war absurd. Thus, Kime's concern for manga's creative direction, and the emphasis he places on the medium's integrity—itself intertwined with the consciousness of a postapocalyptic reality—is valid.

Interview with James Sturm

James Sturm's writings and illustrations have appeared in scores of national and regional publications including the *Chronicle of Higher Education*, the *Onion*, the *New York Times*, and on the cover of the *New Yorker*. James is also the founder and an active member of the National Association of Comics Art Educators (teachingcomics.org), an organization committed to helping facilitate the teaching of comics in higher education. He is cofounder of the Center for Cartoon Studies (cartoonstudies.org), a two-year cartooning school located in White River Junction, Vermont.

MO: Has manga influenced your work?

JS: When I was working on my book, *The Golem's Mighty Swing*, I turned to manga to learn how to choreograph baseball scenes. Despite baseball being "America's Pastime," there are very few well-executed baseball comics created in the States. The Japanese baseball manga I looked at were quite deft in the way they visually depicted the game. I learned a lot about storytelling from reading them.

MO: Will manga "style" be in the curriculum at the school?

JS: There is no style taught at CCS. CCS is most concerned with helping each student tell the story they want to tell as honestly and clearly as possible. Whatever type of comics a student grew up reading will certainly leave an impression on the way they approach their own work.

MO: What trends are you seeing in student work?

JS: Several CCS students are clearly inspired by manga. This is most prevalent in the younger applicants.

Interview with Russell Hrachovec

Russell Hrachovec is the proprietor of compoundEye, a graphic design studio specializing in publishing, Web, and identity solutions. Russell's book designs include *How to Draw and Sell Digital Cartoons* and *How to Draw Manga*.

CompoundEye is located in the United Kingdom (http://www.compoundeyedesign.com).

MO: What was your approach with designing the book *How to Draw Manga*?

RH: The aim of the book is to be a practical and diverse "how-to" manual, focusing primarily on technique and meaning behind various rendering styles.

The design needed to be flexible for different types of content. There were a lot of step-by-step instructions on some pages, and other pages there might be a few images that focus on one particular aspect of manga-like facial expressions. Once we had a layout structure that

could accommodate all this, then we could play around more with colors and manga imagery.

MO: What trends influenced your design?

RH: Certainly the featured manga work provided a visual cue to the styling of the book—there's a lot of energy, drama, and humor there. I tried to get that same feeling to come out of the typography, colors, and other styling, yet still allow the imagery to be the center of attention.

I had to keep an idea of the audience in mind and the type of visual language they might be accustomed to. The reader is most likely a young person. So I was thinking of other objects, interests, and background knowledge that may inhabit this reader's world—my short list was: Xbox, Japanese neon signs, and comic books. Maybe that's an easy stereotype, but I tried to translate some of the visual language of those things into the visual language of this book.

References

Barefoot Gen. *The Black Moon: Art, Anime, and Japanese Culture*, 2005. http://www.theblackmoon.com (accessed April 27, 2005).

Breuilly, John. *Nationalism and the State*. Manchester: Manchester University Press, 1993.

"Century of American Humor." Munsey's Magazine, July 1901.

"DC Comics Launches Manga Imprint." *Publisher's Weekly*, June 28, 2004. http://www.epnet.com (accessed April 27, 2005).

Daniels, Les. *Marvel: Five Fabulous Decades of the World's Greatest Comics*. London: Virgin Books, 1991.

Gustines, George. "Girl Power Fuels Manga Boom in US." New York Times, December 28, 2004. http://www.epnet.com (accessed April 27, 2005).

Goodwin, Robyn. "Women's Suffrage Movement." In *Comics and Ideology*, ed. Matthew McAllister. New York: Lang, 2001.

Hodges, Jared, and Lindsay Cibos. *Digital Manga Workshop: An Artist's Guide to Creating Manga Illustrations on Your Computer*. New York: Harper Collins Design, 2005.

Ito, Kinko. "A History of Manga in the Context of Japanese Culture and Society." *Journal of Popular Culture* 38, no. 3 (2005). http://www.epnet.com (accessed April 25, 2005).

Kime, Chad. "American Anime: Blend or Bastardization?" The Online World of Anime and Manga. http://www.ex.org (accessed April 23, 2005).

Lent, John. "Far Out and Mundane: The Mammoth World of Manga." *Phi Kappa Phi Forum*. Summer 2004. http://www.epnet.com (accessed April 25, 2005).

Life. March 25, 1909.

MacDonald, Heidi. "Manga Sales Just Keep Rising." *Publisher's Weekly*, March 17, 2003, 3. http://www.epnet.com (accessed April 27, 2005).

"Manga." *Kôdansha Encyclopedia of Japan*, 2005. http://www.ency-japan.com (accessed April 25, 2005).

Mannix, Brian. "American Comic Books from 1946 through 1954: The Later Part of the Golden Age," 1995. http://hompages.ius.edu (accessed October 15, 2004).

"Mid-Year Anime and Manga Market Updates." This Year in Manga. http://www.icv2.com (accessed April 23, 2005).

Monahan, Kathy. "More Than the Lone Ranger or Uncle Sam, Comic Book Superheroes 'R' Us." *History Channel Magazine*, July–August 2003.

Reid, Calvin. "Got Teen Readers? Manga Does." *Publisher's Weekly*, January 6, 2003. http://www.epnet.com (accessed April 27, 2005).

Senate Committee on the Judiciary. "Comic Books and Juvenile Delinquency." Interim Report. Washington, DC: United States Government Printing Office, 1955.

Smith, Anthony. *Nationalism: Theory, History, and Ideology*. Oxford: Blackwell, 2001.

Wolk, Douglas. "DC, Marvel, Go for the Book Trade." *Publisher's Weekly*, October 20, 2004. http://www.epnet.com (accessed April 25, 2005).

CONTRIBUTORS

ANNE ALLISON is professor and chair of the Department of Cultural Anthropology at Duke University. She is author of *Millennial Monsters: Japanese Toys and the Global Imagination* (2006), *Nightwork: Sexuality, Pleasure, and Corporate Masculinity* (1994), and *Permitted and Prohibited Desires: Mothers, Comics, and Censorship in Japan* (1996).

WILLIAM L. BENZON has published extensively on literature and on cultural evolution. He is author of *Beethoven's Anvil: Music in Mind and Culture* (2001).

CHRISTOPHER BOLTON is assistant professor of Japanese at Williams College.

VERN L. BULLOUGH was a State University of New York Distinguished Professor Emeritus of history and sociology as well as professor emeritus at California State University at Northridge. Once introduced by a colleague as "the historian who specialized in whores, queers, and perverts but who could also do some 'real' research occasionally," he was a founding figure and breakthrough scholar in the history of sexuality, authoring or editing more than fifty books on sexuality, history, and nursing. He was our colleague and friend, and he will be missed.

MARTHA CORNOG has written articles on manga for the sexology literature and together with Timothy Perper is editing a forthcoming book on graphic novels in libraries. She writes the graphic novel column for *Library Journal*.

PATRICK DRAZEN is author of *Anime Explosion! The What? Why? and Wow! of Japanese Animation* (2003).

MARC HAIRSTON is a professional space physicist at the University of Texas, Dallas. He wrote for *Animerica* and is a regular speaker at the Schoolgirls and Mobilesuits workshops at the Minneapolis College of Art and Design.

MARI KOTANI is a science fiction film critic and author of *Techno-gynesis: The Political Unconscious of Feminist Science Fiction* (1994).

THOMAS LAMARRE is a professor at McGill University and author of *Shadows on the Screen: Tanizaki Jun'ichirô on Cinema and Oriental Aesthetics* (2005) and *Uncovering Heian Japan: An Archaeology of Sensation and Inscription* (2000).

ANTONIA LEVI teaches Asian studies and popular culture at Portland State University. She is the author of *Samurai from Outer Space: Understanding Japanese Animation* (1996).

THOMAS LOOSER is associate professor of Japanese studies at New York University. He is author of *Visioning Eternity: Aesthetics, Politics, and History in the Early Modern Noh Theater* (2006).

FRENCHY LUNNING is a professor at the Minneapolis College of Art and Design and codirector of SGMS: Schoolgirls and Mobilesuits, a weekend workshop there.

SUSAN NAPIER is professor of Japanese studies at Tufts University and author of *Anime from "Akira" to "Howl's Moving Castle"* (2000) and *The Fantastic in Modern Japanese Literature! The Subversion of Modernity* (1991).

MICHELLE OLLIE is cofounder and managing director of the Center for Cartoon Studies.

TIMOTHY PERPER has written articles on manga for the sexology literature and together with Martha Cornog is editing a forthcoming book on graphic novels in libraries.

SARA POCOCK is a recent graduate of the Minneapolis College of Art and Design, where she studied animation. Her work has been showcased on Nickelodeon, and she recently illustrated a full-length comic, *The Hydrologic Heist*, soon to be published by Aha! Process Inc.

BRIAN RUH is author of *Stray Dog of Anime: The Films of Mamoru Oshii* (2004). He is working on his PhD in communication and culture at Indiana University.

TAKAYUKI TATSUMI is professor of English at Keio University and author of *Full Metal Apache: Transactions between Cyberpunk Japan and Avant-Pop America* (2006), *Cyberpunk America* (1988), and *New Americanist Poetics* (1995), as well as editor of *Science Fiction Controversies in Japan, 1957–1997*.

TOSHIYA UENO is a professor in the Department of Expressive Cultures at Wako University.

THERESA WINGE is a professor of fashion design and theory in the Department of Apparel Merchandise and Interior Design at Indiana University, Bloomington.

MARK J. P. WOLF is associate professor of communication at Concordia University, Wisconsin. His books include *Abstracting Reality: Art, Communication, and Cognition in the Digital Age* (2000), *The Medium of the Video Game* (2002), *Virtual Morality: Morals, Ethics, and New Media* (2003), *The Video Game Theory Reader* (2003), and *The World of the D'ni: Myst and Riven* (2005).

WENDY SIUYI WONG is associate professor of design at York University, Toronto. She is the author of books on the visual culture of Hong Kong, including advertising images and comics. Her most recent book is *Hong Kong Comics: A History of Manhua* (2002).

CALL FOR PAPERS

 The goal of *Mechademia* is to promote critical thinking, writing, and creative activity to bridge the current gap between professional, academic, and fan communities and discourses. This series recognizes the increasing and enriching merger in the artistic and cultural exchange between Asian and Western cultures. We seek contributions to *Mechademia* by artists and authors from a wide range of backgrounds. Contributors endeavor to write across disciplinary boundaries, presenting unique knowledge in all its sophistication but with a broad audience in mind.

The focus of *Mechademia* is manga and anime, but we do not see these just as objects. Rather, their production, distribution, and reception continue to generate connective networks manifest in an expanding spiral of art, aesthetics, history, culture, and society. Our subject area extends from anime and manga into game design, fan/subcultural/conspicuous fashion, graphic design, commercial packaging, and character design as well as fan-based global practices influenced by and influencing contemporary Asian popular cultures. This list in no way exhausts the potential subjects for this series.

Manga and anime are catalysts for the emergence of networks, fan groups, and communities of knowledge fascinated by and extending the depth and influence of these works. This series intends to create

new links between these different communities, to challenge the hegemonic flows of information, and to acknowledge the broader range of professional, academic, and fan communities of knowledge rather than accept their current isolation.

Our most essential goal is to produce and promote new possibilities for critical thinking: forms of writing and graphic design inside as well as outside the anime and manga communities of knowledge. We encourage authors not only to write across disciplinary boundaries but also to address readers in allied communities of knowledge. All writers must present cogent and rigorous work to a broader audience, which will allow *Mechademia* to connect wider interdisciplinary interests and reinforce them with stronger theoretical grounding.

To reveal the connections between various communities of knowledge, each issue of *Mechademia* will have a theme yet keep the opportunity available for new or unique analysis. This inaugural issue, "Emerging Worlds of Anime and Manga," contains essays that show how manga and anime are at the center of a nexus of connections, creating and constructing networks, groups, practices, communities, knowledges, and even worlds. We feature essays that connect these particular aesthetics, now referred to as "art mecho," to broader practices as well as social and cultural considerations.

January 1, 2007 "Limits of the Human"
January 1, 2008 "War/Time"

Each essay should be no longer than five thousand words and may include up to five black-and-white images. Color illustrations may be possible but require special permission from the publisher. Use the documentation style of the *Chicago Manual of Style*, 15th edition. Copyright permissions will be sought by the editorial staff of *Mechademia*.

Submissions should be in the form of a Word document attached to an e-mail message sent to Frenchy Lunning, editor of *Mechademia*, at frenchy_lunning@mcad.edu or posted to www.mechademia.org. *Mechademia* is published annually in the fall.